Artisans
and Sans-Culottes

Artisans
and Sans-Culottes

———————

Popular Movements
in France and Britain
during the
French Revolution

Second edition

Gwyn A. Williams

Libris

First published by Edward Arnold, 1968
Second edition, with new preface, introduction
and bibliography, first published 1989

Libris, 10 Burghley Road, London NW5 1UE

British Library Cataloguing in Publication Data
Williams, Gwyn A. (Gwyn Alfred), 1925–
Artisans and sans-culottes:popular movements in France
and Britain during the French Revolution.—Rev. ed.
1. England & France. Crowds. Political behaviour, 1730–1848
I. Title
306′.2
ISBN 1-870352-80-7

New material set by Wyvern Typesetting Limited, Bristol
Produced by Cinamon and Kitzinger
Printed in Great Britain by Redwood Burn Ltd, Trowbridge

For RAIMUNDO FERNANDEZ

obrero consciente

CONTENTS

PREFACE

When this book first appeared in 1968, a distinguished British historian of the French Revolution called it a Vulgate to the Authorised Version.

Since he was talking about France, I was happy to accept the role. To quote from my original introduction – 'To many interested but English-speaking readers, French doctoral *thèses* seem a deterrent more effective than the *force de frappe*. On the sans-culottes therefore I act as a simple latimer to Albert Soboul, Richard Cobb and Käre Tønnesson. The work of George Rudé spans the Channel; he and Edward Thompson are inevitably my chief victims this side of the water.'

Since then, in France, the Authorised Version has been banished to the Index. Twenty years of work, ironically building on the major advances made by Marxists, have displaced the old unholy Sorbonne trinity of Mathiez, Lefebvre and Soboul. What has been displaced is the idea of a 'bourgeois revolution' in which 'capitalism' overthrew 'feudalism'.

My original text, I note, was steeped in doubt and scepticism about the relevance of ideas of 'class' derived from an industrial society to a society we feebly call 'pre-industrial'. There was obviously a need for Marxists to develop a distinctive analysis of such societies which had freed itself from the overriding pre-occupations of Marx himself.

To this end, I was wrestling with some of Marx's essays on societies which did not fully engage his mind, and with the preliminary notes towards the history of the French Convention which he never wrote, when I read Alfred Cobban, that English trumpeter to the revisionist school in France. To my astonishment, the People's Alfred and the Workers' Karl seemed often to

sound the same note. I was driven to the suspicion that French Marxists might not be 'Marxist'. Hard on the heels of this trauma came an analysis of the 'bourgeois revolution' in nineteenth-century Spain by a structural Marxist which provoked such homicidal rage among less beetle-browed colleagues that I began to wonder whether Spanish Marxists were 'Marxist' either.

Then along came George C. Comninel to declare that, so far as the 'bourgeois revolution' is concerned, Karl Marx himself was no Marxist.

In his seminal book, *Rethinking the French Revolution* (1987), Comninel demonstrated that in analysing these elusive 'pre-industrial' societies, Marx remained imprisoned within *liberal* notions of class and evolutionary progress. There was a contradiction between the enormous wealth of new evidence which their doctrines inspired Marxists to assemble and the inadequate interpretation they imposed upon it. One must accept the basic argument of the revisionists: there was no 'capitalist' overthrow of 'feudalism' in a 'bourgeois revolution' of that specific kind.

The revisionists, however, fail to offer any credible alternative explanation of why and how the French Revolution developed as it did; such interpretations as they advance are inadequate. There is an important theme here crying aloud for a new approach: Comninel outlines a possible Marxist interpretation which is truly 'Marxist' even if it commits parricide.

The analysis of the sans-culottes and the popular movement, which has been largely Marxist in inspiration, has been immune from this conflict, because it is not concerned with huge abstractions but with a specific sector of 'pre-industrial' society and the popular political movement it engendered. The most the revisionists have done is to discount its importance and to dismiss it as a *dérapage*, a 'derailing'. On this issue, their somewhat metaphysical argument often slithers into triviality and sometimes into repulsive social prejudice.

In Britain the climate has been appropriately milder though the intellectual arguments in play seem similar. This kind of history was relatively more novel here and the work done on it has

consequently been even more extensive. The reaction against it has been concerned to challenge not so much the picture it has painted as the way it has interpreted the scene.

In consequence, I have decided to let my original text stand, though I have corrected some misspellings. The new introduction, whose title I have borrowed from Alexandre Dumas, serves as a running commentary to the 1968 text; page-references within it refer to pages in that text. It might make more sense if you read the original first.

In 1968, I confessed myself too cowardly to tackle 'comparative' history and offered the book as a study in 'parallel' history. I am still in the same condition, though the new examination of cultural conflicts which accompanied the intrusion of the 'people' tends to be comparative by nature.

I still feel insufficiently educated to make a serious study of Irish and Scottish Jacobinism though the former looms even larger here.

In 1968, I wrote: 'French historians of these islands nearly always use Welsh evidence, English historians hardly ever; I find this eccentric.' I no longer find it eccentric; I find it intolerable. The most recent essay on the 1790s, which is an able work, calls itself a history of *British* radicalism. In its 'Britain', Scots appear only when they are relevant to English politics, the Irish make their customary entry like the Demon King catapulting on stage, and the Welsh do not even exist. On the Welsh experience, therefore, to cite a distinguished Marxist precedent, I have 'bent the twig' in the cause of elementary human decency.

I finished the original book in houses in Providence and Philadelphia in the USA, an appropriate locale for a Welsh historian of the Atlantic Revolution. It was published in the astonishing year of 1968. We were then living through a revolution in the writing of history which made the study of the past central to the growth of people's critical self-understanding. It was my hope that this little book would serve the cause. I believe the human advance which history has achieved is now irreversible.

We are today living through a Thermidor of the spirit in which

people are trying to stop that advance, to return history to a prison and to impose an Authorised Version. They will fail. This is one battle which the powers of darkness are going to lose.

Gwyn A. Williams
Cardiff, 1988

INTRODUCTION

Twenty Years After

The spectre which haunts Europe in the first sentence of the Communist Manifesto of 1848, says Conor Cruise O'Brien, stalks for the first time through Edmund Burke's *Reflections on the Revolution in France* of 1790.

'No matter how radical the differences between the two countries,' I wrote in 1968, 'in both Britain and France, it was in 1792 that "the people" entered politics' (p. 4). Edmund Burke perceived that entry as a hideous birth conjured by impious intellectuals; the Parisian army of sans-culottes and its British brothers were 'a species of political monster, which has always ended by devouring those who have produced it'.

It was this image which democratic writers of the revolutionary decade in Britain felt they had to neutralise. The publications of the popular societies are charged with the impulse; so, in a much more confident and uninhibited manner, are those of Thomas Paine, who wrote some of their foundation texts. So are those of intellectuals more detached from the popular movement but no less committed, advocates of democracy, freethought, women's rights like William Godwin and his wife Mary Wollstonecraft. It was their daughter Mary Shelley, however, who transformed the image into a myth which has proved imperishable. In 1818, she published *Frankenstein or The Modern Prometheus*.

By that time, popular movements in Britain and France, driven underground twenty years earlier, were re-emerging; indeed in Britain they had been battling to the surface again since the revival of radicalism in 1807 and the crisis of state and society over 1810–12. Their resistance to the regime which William Pitt's successors had established turned 1818 into yet another post-war year of incipient British revolution.

Mary Shelley's flawed but hypnotic novel, in its original form secular, dedicated to Godwin, tense in the dialogue between Frankenstein and his creature, was quintessentially a novel of the 1790s. It was immediately and universally interpreted as a political allegory; her monster was the symbol of an irresistible outbreak of popular energy. Tory reviewers found it subversive, radicals praised it for taking the side of the Monster.

This response proved prophetic. Canning in 1824 was to oppose the emancipation of slaves in the West Indies as a recreation of the Monster. Elizabeth Gaskell saw her Chartist trade unionist John Barton in such terms. *Punch* cartoons repeatedly broadcast the nightmare vision of a gigantic and menacing proletarian as 'The Brummagem Frankenstein' or 'The Irish Frankenstein', the creature beginning to assume his creator's name, the contemporary embodiment of the latter figuring as a pigmy middle-class radical thinker with the features of a John Bright or a Charles Parnell.

In 1831, Mary Shelley revised her novel in that third edition which has become canonical. This, too, was a year of crisis for the British state following hard on the French Revolution of 1830 when both revolutionary tricolour and 'Marseillaise' were resurrected. The year in Britain was characterised in particular by a fierce struggle between radicals who had become self-consciously 'middle-class' or 'working-class'. It followed a generation of religious revival and the assimilation of high German Idealism.

Mary Shelley desecularised and depoliticised *Frankenstein*. The villain–victim remained the scientist in the mould of Faust or that hero of the young Karl Marx, the Prometheus who stole fire from the Gods, but in several new soliloquies he drowns in remorse over his presumption in trying to usurp the role of the Almighty. The author was adjusting to a climate created in part by the stage adaptation which she had initially scorned – Richard Brinsley Peake's *Presumption: or the Fate of Frankenstein* of 1823 which had Christianised the fable.

The impact of the original novel had been very different, intensely secular and highly political. Not only was the creature a

vivid symbol of the explosive entry of 'the people' into politics and
of the terror it ultimately provoked in liberal sympathisers; his
creator was located among the radical intelligentsia whose child
Mary Shelley had been. Frankenstein was born into a mildly
liberal aristocracy of bourgeois origin, the son of a Syndic of
Geneva, the city which served as a Utopian model for both
Voltaire and Rousseau. He had attended the Bavarian university
of Ingolstadt, home of the *Illuminati* or *Illuminés*, a freemasonry of
intellectuals whom the Abbé Barruel had denounced as the very
authors of Revolution. The *Illuminés* were simply one of a clutch of
sparse but influential networks of dissident, occult and millena-
rian thinkers, mixed in social origin and internationalist in
temper, who exercised some influence over 'organic intellectuals'
of the popular movements.

Mary Shelley's original novel, however slewed, was an authen-
tic response to some realities of the revolutionary decade. Her
revision of 1831 half warranted its emasculation in Peake's stage
adaptation which became the point of departure for a tradition
which has found memorable expression in the Boris Karloff films
of our own times.[1]*

One excision is critical. In the stage version, the dialogue
between creator and creature disappears because the latter cannot
speak. He can therefore evoke terror and pity, but not social
tension. The Monster is silenced.

Burke's Monster was never silent. In the beginning, we have it
on the highest authority, was the word. To try to establish priority
between word, deed and circumstance in the revolutionary 1790s
would be a bedlam job. In both Britain and France, whole new
vocabularies emerged, old words acquired new meanings; dren-
ched in new forms of discourse, the 'traditional' rapidly ceased to
be traditional as it was forced into the market place and the
political cockpit. One of those old jingles suddenly swelled into
loud and discordant crescendo – 'the voice of the people'. Could
this newly audible 'people' with its myriad tongues find a voice?

* See notes on p. xliii.

Could it be given one? Above all, in both France and Britain after
1795, could it be silenced?

For, if in France there was a seizure of power, there was also a
seizure of speech, *la prise de parole*, a struggle for the control of
discourse. In the total collapse of the old regime and its ideologies,
there was a desperate need for a new discourse to express a new
legitimacy. The People's Will was now sovereign; its language was
therefore totalising, rich in neologisms, new coinages which left no
corner of life unexplored, and heavy with resonant abstractions. It
abhorred the politics which registered the conflict of sectional
interests; public language was to be the expression of the General
Will of unanimous assemblies. In consequence, it politicised
everything, as public and even private debate became a struggle of
discourses for legitimacy. Central was the conflict between
assemblies of *representatives* claiming to speak for the people and
those popular societies of the sans-culottes who claimed to be its
very *embodiment*.[2] As political, social and military realities brought
the popular movement into being and made it the very dynamo of
the Revolution until the defeats of 1794–5 (Chapters 3 and 5
below), those same realities enabled it to commandeer the
language of that Revolution.

My 1968 text noted the moral totalitarianism, so well adapted
to the Terror, which characterised sans-culotte discourse (pp.
46–7, 82–5). It was the morality of a new way of thinking and
speaking, which as early as 1789, could transform 'traditional'
crowd actions into 'revolutionary' acts (pp. 23–4). And whereas it
is true that much of this discourse was the rationalisation of
necessity and that Rousseau, no less than Thomas Paine in
Britain, often told people what they already 'knew' (pp. 31–2),
they still needed those *words* which could be supplied, by and large,
only by the wordsmiths, the journalists who were veritable
artisans of revolution.

Out of the propagandists pullulating around the Palais-Royal of
Philippe-Égalité, formerly Duke of Orleans, came Nicholas de
Bonneville whose 'Cercle Social' was a major force in the
formation of sans-culotterie (p. 28). Dedicated to a millenarian

ideal of equality and the creation of a 'republic of letters' which would be a democratic elite, he sponsored circles of the like-minded throughout western Europe.[3] The revolutionary press was to create a universal language of liberation. Bonneville was the first to call 'Aux armes, citoyens!' even before the fall of the Bastille. In his papers *Le Tribun du Peuple* and *La Bouche de Fer*, he was the most ardent in pressing on the sans-culottes a new discourse grounded in pure origins and simple speech; he it was who first displaced *vous* with *tu*. Around his 'Iron Mouth' he grouped like-minded writers, those masters of the picaresque, Restif de la Bretonne, who coined the word 'communism', and Louis-Sebastien Mercier who created a dictionary for the new language. Varlet the *enragé*, he of the portable tribune, was one of the circle, so was Sylvain Maréchal the stammering atheist who was the theorist of Babeuf's Conspiracy of Equals of 1796; so was Babeuf himself (pp. 112–13).

All distanced themselves from the dominant Jacobins. Bonneville drifted toward the Girondins, was jailed in the Terror and on his release set up in a *ménage à trois* with Thomas Paine. But he never lost his commitment to equality, informed by the millenarianism of the *Illuminés* and the more radical freemasons – 'Assemble the citizens and face the sun!' – which ranged him with the atheists, deists, feminists and proto-'communists' of the *enragés*. No one answered his call to 'seize the forbidden word' more ardently than Hébert who became the very voice of sans-culotterie. The sheer *vulgarity* of his *Père Duchesne* was deliberately designed to break the grip of the aristocratic and refined (p. 20).

Nor was it only a matter of the word. The great cycle of festivals, particularly those of the Republic organised by the painter David, were a street theatre of unprecedented scope and ambition, mobilising every device of the mind and spirit and employing every symbol which seemed suitable. Music – song, dance, chorus, Gossec's radicalised orchestra – moved like the 'Ça Ira' from the salon to the street.[4] This was the emotional world the sans-culottes inhabited, a world of image and sound where the word was power.

It was the world Thermidor destroyed, driving its inhabitants into a shadow-land of occult beliefs, political folklore and conspiratorial organisation which nevertheless persisted, to be resurrected in succeeding generations in recurrent exercises of the historical imagination. The republic which the Directory tried to create was built precisely upon the exclusion of this 'people'.

This book's first edition took note of one truth that had been overlooked: in the emergency measures it was forced to take against an ambitious 'people' of its own, the British government of the 1790s, no less than its mortal French enemy, was itself 'revolutionary until the peace' (p. 102). It was not solely a matter of government. The mobilisation of public opinion in the loyalist associations and the Volunteers, their ostentatious ceremonial, the pageantries of patriotism, with *God Save Great George Our King* battling to victory over its rivals in the cockpits of the theatres, were as radical an innovation as any French festival. Conservatism, hitherto content to be customary, had to equip itself to fight for a mass audience. The liberal effort to create an art for the people of the early 1790s, which had stimulated the genius of William Blake, was stopped in its tracks; it was the black John Bull populism of the caricaturist James Gillray which was to be the 'voice of the people'. Counter-revolutionary Britain, in defence of its glorious constitution, created a discourse as replete with negatives as the French with their 'anti-republicans' and 'de-Christianisers'. A characteristic journal was Canning's *Anti-Jacobin* which sponsored Gillray. This, too, was a struggle for mastery over a language.[5]

The late eighteenth century was a great age for dictionaries and grammars in England. Most European states at the time were striving to standardise a national language and to eliminate dialects and minority tongues, none more so than the new French Republic with its 'language of liberty'. In counterpoint, the romantic 'discovery of the people' and of a popular culture considered healthily simple, pure and peculiarly spiritual, stimulated by Herder's influential works, was running into confluence with a literary turn to the commonalty exemplified in England by

Wordsworth and his friends. These instincts were in the last resort conservative, but their initial expression in old regime Europe could be radical in effect, as Wordsworth's early career testifies. From the end of the decade, their penetration among small, submerged peoples – Czechs, Serbs, Catalans and their ilk – generated a romantic nationalism which, while resisting French hegemony, often copied French practice and in some regions created a climate in which to publish a dictionary could be a revolutionary act. Though normally invisible to a cultivated eye, such peoples existed in the west, not least in the Wales which is conspicuously absent from English studies of the period which call themselves histories of Britain.[6]

In the developed, complex and relatively open society of that Britain, the standardisation of a national language assumed distinctive form. Towering over the torrent of grammars and dictionaries were a trinity of texts – Bishop Lowth's comprehensive grammar of 1762, James Harris's theory of universal grammar of 1751 and Samuel Johnson's *Dictionary* of 1755. Powerful, abundant and detailed, these governed the cultivation of 'good English' in an increasingly literate and book-reading country. They made the 'national language' into a class language. Grounded in a theory of a universal grammar which reflected qualities of the mind and in a veneration of Latin and Greek, they rigorously defined a 'refined language', strong in abstraction; it alone could be the vehicle of intellectual endeavour, including the political. Spoken English and the 'vulgar' in general was dismissed as the reflection of inferior minds, incapable of expressing anything of consequence, certainly of nothing political – 'cant' as Johnson called it. In an England where social distinctions were multiplying and intensifying as social mobility accelerated and in which the all-embracing veneration of a Glorious Constitution, dating from 1688 and enshrining a peculiar English liberty, had been strongly reaffirmed in the aftermath of American Independence, this conception of language achieved a hegemony of unparalleled power (pp. 5–8).

Dissidents were trapped within the very words they had to use.

If they resorted to the 'vulgar', as they often did, they simply validated their own exclusion. William Cobbett's struggle with 'grammar' was an exemplary epic. This was a 'national language' which enforced submission and dependency upon most of those who used it. It was what drove Blake to denounce 'mind-forg'd manacles' and Paine to complain of being 'immured in the Bastille of a word'.

It was Thomas Paine himself, of course, who stormed this particular Bastille. He was not quite the innovator the English hailed or denounced. The shift towards plain speech had created a popularising movement on the fringe of the Scottish Enlightenment which was influential in America – and it was in America that Paine, like Cobbett after him, found his true voice. Dissent, too, with a long tradition of constitutional opposition and a developing democratic temper sympathetic to the American cause, was a formative influence. Nor was this man, whom the establishment tried to make an un-person, at first aiming at a new audience. Nevertheless, by any standards one cares to apply, the impact of Paine on the English of England was shattering (pp. 14–18).

My 1968 text which recorded this impact, however, had also to record that, while the popular radicals hailed Paine as a prototype, few of them tried to write like him. Daniel Isaac Eaton's *Hog's Wash: Politics for the People* of 1793, the first genuinely popular journal of substance, was so remarkably urbane in tone that comparison with the working-class journals of the 1830s might suggest an intervening disintegration of a common culture. A recent study in depth of the politics of language during the French Wars suggests that this was largely a consequence of the success of the loyalist Association in its campaign of mass popular pamphleteering from 1792 (pp. 74–6). It cites in particular the endless radical parodies of the loyalist *John Bull Family* series, which parallels the artisans' obsession with Burke's 'swinish multitude'.[7] There may be some truth in this, but it seems limited. The success of the 'wholesome reading' campaign is more visible among its producers than its intended consumers. Like the allegedly

representative nature of Gillray's caricatures, it is contradicted by a myriad testimonies and by the widespread disaffection which convulsed whole regions during the late 1790s, made permanent an atmosphere of strain, fear and tension, and helped to drive Pitt's government twice to seek peace terms from the French.

What the loyalist campaign, with massive governmental assistance, did was to mobilise a bloc of respectable power and opinion which, within Parliament and without, drove opposition into the margins. The popular movements were thrown on the defensive in 1792–3. Their revival was checked by the Treason Trials of 1794; the Two Acts of 1795, coupled with sustained official repression, threw them out of public life altogether. Olivia Smith's valuable study is on stronger ground when it cites this outlawry and couples with it the initial uncertainty and diffidence of writers like Eaton as they approached an audience they did not know (not until the reception of Part II of Paine's *Rights of Man* in 1792 could they have known that it even existed) and an audience presumably drenched in the prevailing attitudes towards language.

There are two missing political dimensions. Unlike France where everything had been thrown into the melting pot in 1789, there was no simple and crude division in England between the 'refined' and the 'vulgar'. Dr Samuel Johnson himself, arbiter of immaculate English, had told the Earl of Chesterfield in no uncertain terms what he could do with his patronage – and had he done so orally would have spoken in a broad Staffordshire accent. The Dissenters and other middle-class reformers had for years used the 'refined' language, spiced with some 'vulgarity'. There were plenty of middle-class people, sometimes quite radical in attitude, who clutched at 'correct English' in the cause of social advancement; as early as the 1800s the grammar schools were opening to them (and closing to their original clients) in a process which anticipates the shaping of the public schools. Moreover, from the blizzard of hostility they were struggling through, the popular radicals could find a shelter within the renewed campaign against the slave trade dominated by Dissenters and middle-class

men – their victory in this cause in 1807 heralded a general radical recovery. In many ways, it was necessary for the popular movements to try to adapt to a received English.

For this was a movement which had two faces. Most British histories of the 1790s remain what they have always been – irredeemably insular. What made 1792 a miraculous year for British popular politics was the *coincidence* of Paine and the second French Revolution of 10 August, the bloody advent of democracy and the surge forward of the sans-culottes (p. 70). From that moment, among themselves, French styles were common. At times of crisis and under repression, there was wholesale resort not only to the 'vulgar', but to direct translations from the language of the sans-culottes (pp. 98, 108–10). This, while their formal voice assumed proper English tones.

The men among them who broke decisively with current assumptions about language were those who most resemble their French counterparts. Thomas Spence, the gentle five-footer from Newcastle, 'unfee'd Advocate of the disinherited seed of Adam' with his commitment to women's rights, his vision of a pluralist society of communes taking over the land and a 'beautiful Republic' scalping tyrants of their revenues, would have been at home among the French *enragés* and it was he who devised a phonetic alphabet to break the hold of class on the English language (pp. 108–9). Far more effective was one of their middle-class men, John Horne Tooke, frondeur of every radical movement who, for all his wit and gamin quirks, was a seriously subversive Englishman. Across the turn of the century, he completed his politicised dictionary, *The Diversions of Purley*, which tackled received opinion to decisive effect, established a material-ist basis for language, abolished the distinction between the refined and the vulgar and legitimised an English language for the English people.

These men in the wilderness of the late 1790s were riding a wave of the future. The one publication of the decade which closely resembles Paine's, indeed is visibly derived from him, was *The Soldier's Friend* of 1791, denounced as a republican tract. Its author,

shrouded in a self-serving smokescreen, was William Cobbett. Like Paine, he found a voice in America where, as a John Bull Tory, he helped to create an American popular press. His conversion to radicalism added immeasurable power to the democratisation of the language. This did not break the hold of class over English style, but demotic English, dammed up in the 1790s, broke irresistibly over the nineteenth century. It may not have been King's English but it was certainly a language for an English nation.

'We were men while they were slaves,' said Thomas Hardy, chairman of the London Corresponding Society, comparing British and French history. The theme is central to this book. Movements emerge on both sides of the Channel which in terms of membership, political belief, social attitude and practice are strikingly similar. They work within radically different contexts. In the total crisis of French society, popular movements assume a central political role, dominate the very life of the Revolution and then abruptly disappear into an underground; their 'legacy' seems to be a matter of repeated exercises of the historical will in recovery of a historical memory. In Britain, popular societies clamber awkwardly out of earlier libertarian movements, struggle against an encompassing hostility inescapably enmeshed in the confrontation with France, and succumb as clumsily as they emerge. In their half-world, however, their 'legacy' seems to be a face-to-face transmission which constitutes the starting-point of a tradition.

The struggle over language would seem to support this interpretation. It is less easy to be assured, however, about another cultural earthquake which accompanied their entry – the veritable explosion, on both sides of the Channel, of spiritual unorthodoxies of every kind. Bonneville's 'Cercle Social' was also the hub of clusters of revolutionaries devoted to a quasi-religious ideal community serviced by an elite of the instructed, which drew heavily on a variety of religious beliefs and the practices of freemasonry, and organised itself in an occult hierarchy of orders equipped with a mystic symbolism – squares, circles, triangles, the sun as a focal point of illumination – of 'Pythagorean' character.

These circles, spilling out of France, could draw on a tradition as old as the Renaissance, when thinkers like Giordano Bruno and Dr John Dee had used the Hermetic philosophy, the Jewish Cabala and an amalgam of science and magic to try to create a humanist religion, transcending Catholicism and Protestantism and reaching back to a libertarian and unitarian creed coeval with the Patriarchs (and often identified with idealised Druids) served by a devoted elite of the enlightened. Driven underground and finding some kind of home in Rosicrucianism, this set of beliefs had helped to constitute a radical and minority tendency within the scientific revolution. The English Deist John Toland (a great admirer of Druids), working with like-minded men in the Netherlands, turned this thinking towards science and republicanism and the infiltration of an eighteenth-century freemasonry growing prematurely respectable.[8]

This ensemble of ideas, interacting with marginally differing creeds like those of the *Illuminés*, shaped an occult but powerful trend within the eighteenth-century Enlightenment which broke to the surface in the French Revolution. Counter-revolutionaries like Barruel and Burke, in an exaggeration bordering on the hysterical, conjured its adepts into the very demiurges of subversion, but a recent and well-documented study, rescuing them from historical oblivion, agrees to the extent of identifying them as the true bearers of a 'revolutionary faith'.

In a revolutionary France whose assemblies were deeply anti-clerical and Voltairean and who created the Constitutional Church as a necessary compromise, such men were at home; their ideas figure in the rag-bag ritual of every group trying to create Rousseau's civil religion. They had little in common, however, with the wave of de-Christianisation which broke over much of France at the moment of Jacobin-sans-culotte triumph in 1793 and whose burlesques and Festivals of Reason (which at one moment commandeered Notre-Dame itself) so alarmed Robespierre that he launched the cult of the Supreme Being as a counter-offensive (p. 56). Thermidor, destroying Jacobins and sans-culottes, retained the civic religion. Theophilanthropy, the

official religion of the Directory, drew heavily on the ideas of the Illuminist-Pythagoreans; one core of it derived from the Deist liturgy of David Williams, the Welsh freethinker who was a friend of Condorcet, an honorary French citizen and adviser on its new democratic constitution. He belonged to Bonneville's circles in both Paris and London.[10]

Napoleon's Concordat with the Pope restored Catholicism and is said to have swept all these *Infidels* into oblivion. In fact, over great tracts of France, particularly in the south and west and among the men, the Church permanently lost hold. Where the Pythagoreans and Illuminists survived was in the world of the secret societies which became a permanent feature of both Napoleonic and Restoration Europe. The Babeuf Conspiracy of 1796 was steeped in their thinking; its apostle Buonarroti carried it over Europe (pp. 112–14). Increasingly sceptical but increasingly romantic, it dominated revolutionary practice until the intrusion of working-class militants and the revolutions of 1848.

There were certainly men like Bonneville in London among the entourages of William Blake, whose imagination was deeply affected by such ideas and the London-Welsh Jacobins who fed that imagination. They and their kin in provincial towns and some villages were ready to respond to a millenarian faith. Some of Blake's artisan Swedenborgians had made contact with an unusual bunch of *Illuminés* in Avignon, and William Owen, a great dictionary-maker among the London-Welsh, became secretary to the Prophetess Joanna Southcott. Rarely do such thoughts or their thinkers figure in the histories, but to judge from the tone of much popular and working-class discourse then and later, they were a good deal more numerous than we have allowed.[11]

They lived in a Britain, however, where 'nonconformity' had long been licensed. In terms of a popular movement, the prime differentiation from French experience was the rooted presence and power of Dissent (with its American brothers creating their own Republic) whose struggles had virtually shaped the English libertarian tradition (pp. 12–13 and Chapter 4 and 6). The language of the popular movement was steeped in the Bible and

Bunyan; its records often read like those of a Sunday school of one of the more liberal sects. In the generation after 1790 Dissent, old and new, grew so rapidly, particularly in the industrialising North and Wales, that over whole regions it prised loose the grip of the Establishment. In social terms it was riddled with contradictions. Methodism was officially quietist and Tory, so were many within Old Dissent, but the old saw that Methodism stopped revolution in Britain has long since been proven inadequate. How do the 'Tom Paine Methodists' fit (pp. 12–13)? The politically soporific effect of evangelicalism in every denomination was certainly a powerful force, but there were trends within Dissent, notably the liberal Presbyterianism which debouched into Unitarianism, which worked to opposite effect.

That interpretation which sees evangelical religion as the resort of the politically defeated carries more weight, but in truth the situation was extremely fluid. People moved into and out of Jacobinism and Methodism as the climate changed and Dissent, by its very nature, bubbled with heresies. The 1790s were punctuated by explosive schisms, by prophets like Richard Brothers and Joanna Southcott. All of them found popular supporters and all were potentially subversive. Government certainly thought so.

Within Dissent, over and above any residual commitment to the Old Cause which survived the repression, there were trends of opinion which could carry their adherents close to freethinking radicals. Millenarianism was by no means the monopoly of Pythagorean dreamers. The French Revolution, coming so hard on the heels of the American and bringing the overthrow of Catholic absolutism, put many in mind of the Last Days of Biblical prophecy. The conversion of the Jews became a preoccupation of many. Joseph Priestley himself, hero and martyr of democracy, was a serious advocate of this respectable form of millenarianism. The Baptists, strong in both popular support and American connection, seem to have been peculiarly prone. One Welsh Baptist, Morgan John Rhys from Pontypool, became so seized by millenarian belief that he mobilised the Baptists of west Wales to

produce French translations of an old and heretical Puritan Bible and crossed to France to preach Protestant liberty. Within eighteen months, he was a close ally of bohemian London-Welsh romantic, republican and millenarian nationalists, a republican himself and the editor of the first political periodical in the Welsh language. He and most of his friends ended up in America.[12]

Powerful and contradictory currents like these turned the popular societies into cauldrons of competing ideologies. There seems to have been a decisive shift after they were driven into a semi-clandestine existence in 1795. The retreat into an examination of 'first principles', pressed by Francis Place, led to Christian secessions and the growth of Infidelity, freethought of every description (pp. 99, 109–10). Their attempt to build what they called a Common Wealth of Reason was almost wholly French in inspiration. They published Paine's *Age of Reason* but their staple diet was d'Holbach, Helvétius, Voltaire and Volney, often in penny weekly parts. A hidden power in many areas and underestimated by historians, these men and women created a tradition, revived by the republicanism of Richard Carlile after the war, which was to prove a permanent presence within the British labour movement.

The history of one book can illustrate the ironies of connection and contradiction between British and French. Constantin François Chassebeuf de Volney was a much-travelled Orientalist, a protégé of d'Holbach and Helvétius who served as a deputy in the National Assembly. He was jailed during the Terror, taught history at the École Normale created by the Convention, went into exile in America, to be driven out by the anti–alien legislation of 1798. He served as adviser to Buonaparte and became a Napoleonic count, to break with the Emperor and die a respected scholar in 1820.

In 1791 he published *Les Ruines, ou méditation sur les révolutions des empires*. Its hero, meditating on ancient ruins in the East, is wafted by a rationalist Genie into outer space, to survey the progress of the human race towards emancipation. All the religions of earth are mercilessly dissected and the truths of science proclaimed. A

classic of popular Enlightenment, it is also drenched in the newer
romanticism. Its fifteenth chapter took the form of a dialogue
between the People and the Privileged which was susceptible to a
collectivist interpretation.

This book, one among others in France, scored a spectacular
success in Britain. Between 1792 and 1822 there were at least
eleven different English editions. Joseph Priestley felt compelled to
challenge Volney to a debate which continued through their joint
exile in America. The fifteenth chapter was perfect pamphlet
material and in 1792 started on its long career within British and
American popular movements. It was translated into Welsh two
years before the appearance of the first effective English version, to
be reprinted in the Welsh Chartist press of the 1840s. *Volney's Ruins*
came to enjoy a supremacy in the world of popular sensibility not
unlike that of William Morris in a later generation. It was a
standard text for popular and working-class movements to the
Chartists and beyond. In its own way, among them, it was the
most enduring legacy of the French Revolution.[13]

War against that Revolution, a war that lasted a generation,
was an experience common to both peoples and it was a war
without precedent. Both Britain and France waged war on a scale
hitherto unknown. Losses in Britain were proportionately greater
than those of the First World War; at critical moments, one man in
every ten was under arms. Government raised £1,500,000,000 in
loans and taxes of an infinite variety, including the dread income
tax. The draconian measures taken by the revolutionary govern-
ment in the crisis years of 1792–4 apart, France did not resort to
such exceptional fiscal measures and could command the
resources of annexed territories, but conscription drained the
country of men. The losses were so heavy that they had a
long-term impact on population trends.[14]

It was during the two astonishing years of 1792–4 that France
achieved a total mobilisation for war which was not to be equalled
before the twentieth century.[15] This crisis was the very 'point of
entry' for the sans-culottes. War psychosis turned their opponents
and even the indifferent into traitors; war crises, one after another,

jacked them into power, a 'people's war to the death' generated that atmosphere in the Sections in which one can actually see the humblest people taking possession of their nationality (pp. 32–8, 55–7). At the climax in 1793, the *levée en masse*, followed by conscription, drafted nearly a million men into the armies and a whole new war industry sprouted to service them. In Paris, there were 258 forges working 14 hours a day, producing 700 muskets a day, with wages fixed by a tribunal controlled by elected workers. A similar intensity directed the war effort in seaports and inland cities, the drives for supply and price-control which convulsed rural areas, the effort, through sans-culotte militias, to impose revolutionary discipline on the whole country. After the victory of the Jacobin-sans-culotte alliance in September 1793, with its sweeping purges, half a million new people moved into government posts.

This incorporation into the Jacobin war-machine stifled the sans-culottes; in the spring of 1794, Robespierre broke them as a movement (pp. 81–7). Thermidor left them helpless before the reaction even as the dismantling of the Jacobin machine and the return to the market plunged them into the misery and humiliation which provoked the last awe-inspiring but desperate revolts of Germinal and Prairial of 1795. Something of their spirit survived for a while in the armies which had recruited many of them. Buonaparte's Italian campaign of 1796 has gone into history and literature as a revolutionary war and there was to be a curious last flicker during the Hundred Days, but after 1795 sans-culottes disappear. The people they had sought to personify were left to savour a few of the splendours and most of the miseries of the Napoleonic regime.

To cross the Channel is to encounter a mirror-image. The loyalist campaign in Britain over the winter of 1792–3, which climaxed in the outbreak of war, defined the popular movements as traitors, their upsurge in 1794 was clobbered by the Treason Trials, the grain crises of 1795–6 with whole regions in riot and incipient revolt brought the Two Acts on their heads and the withdrawal of their few possible friends from Parliament. For most

of the time, popular societies lived in a half-world of illegality, provisional or total, which they shared with struggling trade unions (pp. 104–6, 110–11). During these years, and for a generation and more, most attempts to create popular or working-class organisations ended as prisoners' aid societies.

Yet it was the war which brought them recruits. The iron and textile trades boomed, Birmingham small-ware suffered at first, agriculture grew into a major capitalist industry, but in many regions there was dislocation, whether from growth, as in the penetration of Lancashire capital into the cloth trade of rural Wales, or from depression as in the Midlands. And endlessly there came the levies of money and men, press-gangs, quota acts, militia ballots, inflation. There were outbreaks of fervid patriotism over 1792–3 and during the invasion scare of 1797–8, but it was not a popular war. Not until the tribal rally against Napoleon over 1803–5 did it assume that heroic character cherished by historical memory.

When this society was hit by severe grain crises precipitated by the advance of the capitalist market in wartime conditions, the disruption was severe. During 1795–96, many districts were driven to riot and some to the brink of insurrection; half the navy was tied up and Pitt sounded the French on peace. The popular movement was unable to hold its new recruits or to integrate 'economic' grievances into a political attitude as sans-culottes, invested with some temporary power, could. The British Jacobins were hammered and lost whatever toehold they had in conventional politics (pp. 99–102).

From that moment, the British state waged a kind of guerrilla war against popular movements of all kinds.[16] With London and Dublin combining into a single intelligence agency, it built a reasonably efficient apparatus of social control, a veritable 'counter-insurgency' machine, occasionally hindered but never deflected by parliamentary surveillance and episodic eruptions of the 'freeborn Englishman' mentality. That machine was tested to the limit over the following six years, a time of increasing tension, with the Irish crisis thrusting itself into the home island: the bank



crisis, French landing at Fishguard and naval mutinies of 1797, the Irish rebellion of 1798, and the grain crises of 1799–1801, even worse than those of 1795–6 because people believed they had been created by naked greed unleashed by the dismantling of the old defences of the trades and the old customs of the 'moral economy'. The British government engineered the war of the Second Coalition as an unprecedentedly ideological war, in a 'strategy of overthrow' which blew up in its face. The convulsions of 1800–1802 were critical, as a revival of conventional opposition and a substantial threat of insurrection loomed among a people who were utterly war-weary. Settlement in Ireland, Pitt's resignation and the Peace of Amiens bought a respite which was desperately needed.

When war was renewed, it was a more circumspect government which had to summon a people to confront the threat of invasion, this time not from an embattled French republic but from the tyrant Napoleon; the political climate was transformed. The system could not prevent the re-emergence of radicalism from around 1807, but it was able to blunt and deflect its challenge with relative ease. What emerged was a socially regressive and politically repressive regime which fused a new 'war establishment' with an older mercantile order grounded in a modernised agriculture, and established a firm grip on parliament and the counties. It rode the 'bourgeois' crisis of the Orders in Council and a 'working-class' crisis of Luddism over 1810–12, to come triumphant as a world power out of the war, to pass the Corn Law, and get rid of income tax, and to make the post-war years a black legend in British working-class history. That legend had been born in the late 1790s when British popular and labour movements became what one of their favourite songs said they were – John Bull's Youngest Bastards.

These were times of trouble, often harsh trouble, for many of the common people. Those who suffered most, as usual, were the women. My 1968 text could not fail to note the role of women in many of the *journées* in France and the quite spectacular *leadership* they exercised in the last revolts of Germinal and Prairial (pp.

91–94). Twenty years on, however, I cannot fail to note, in pain and shame, the barely concealed *surprise* which informs my writing at that point. Self-criticism was being practised in the Paris of 1793 long before any Russians caught on to it; it cannot be evaded here. It has taken the rise of 'women's history' out of the women's movement to make me aware that there was even a problem.

The exclusion of women is often written into the very records historians have to use. It became clear recently, for example, that many of the violent and protracted rebellions in north-east Wales during the 1800–1801 crisis were in fact led and inspired by women; by the time the cases got to court, it was their husbands or fathers who had to face the charges. I would not have realised this had I not been prompted by a woman researcher. It is certainly the advance of women's history which is beginning to transform our understanding of the popular movement in France.

The last twenty years of work on the French Revolution have seen a sustained and successful assault on the Marxist interpretation which had become conventional wisdom. The popular movement, however, is the one area of largely Marxist analysis which has not been called into question. The most the revisionists have done is to dismiss and discount it, often reverting to some traditionally prejudiced nonsense and, embracing with abandon the very teleology they denounce in Marxists, to try to describe it as a *dérapage*, a 'derailing' of the Revolution – presumably from the tracks which their own historiography has laid down. The analysis of the popular movement enjoys this immunity because it is not concerned with the opposition between 'feudalism' and 'capitalism', but with the sans-culottes as a specific category of the old regime and the Revolution; in itself it bears witness to the failure of both the Marxists and the revisionists fully to explain the society they analyse.[17]

In consequence, I feel no call to revise my 1968 text in any fundamental sense. We know a great deal more now about the formation of sans-culotte mentality and practices, about the wide regional variations and the role of the popular movement in the Terror. Our understanding of the experiences of those ordinary

people, probably a great majority, to whom the Revolution was something external, marginal or something they experienced as they experienced rain, has been enormously widened and deepened – and much of this, of course, has been 'women's history' *malgré soi*.

Curiously, it has been a distinguished British woman historian who has so far done most to bring to life those women of the *menu peuple* who suffered everything and who ended the Revolution with that cry which echoes from Prairial 1795 – 'on les a trop souvent trompées'.[18] French women historians seem to have been preoccupied with a somewhat Whiggish concern for precedents and precursors which is perhaps inevitable at this stage.[18] They can certainly find them, notably in the *Société des femmes républicaines révolutionnaires* of May 1793, several hundred sans-culotte women, strongly political, who in the critical summer of 1793, aligned themselves with the male *enragés* (themselves often advocates of women's rights). They and their leading figures were demonstrating feminism in action rather than proclaiming it as a principle, though Etta Palm drafted a specific programme of marital, legal and educational reforms. Pauline Léon, a chocolate maker, was an active revolutionary from Year I and was a leading advocate of an armed and trained legion of women. In this she was supported by Claire Lacombe, an actress, who had herself joined the attack on the Tuileries in August 1792 and by Anne Théroigne de Méricourt, formerly a singer and courtesan in Paris, London and Rome, who killed a royalist in that attack.

These women, fierce in their assertions of female equality and uninhibited, often flamboyant in their demonstration of it, provoked hatred among the unshakeably macho Jacobins and sans-culottes who, officially cherishing political women, preferred them respectful. Théroigne de Méricourt drifted towards the Girondins and was beaten up for her pains, but the others threw themselves into the *enragé* campaign and were pursued with a peculiarly masculine malice by the Jacobins, who destroyed their movement as soon as they could (pp. 53–4).

One weakness of the *Républicaines Révolutionaires* was their

doctrinaire alienation from working women; they fought pitched battles with market women over the wearing of the *bonnet rouge*. The women leaders who were both more socially aware and more specifically feminist were less involved with the political extreme. Louise Kéralio, daughter of a minor Breton noble, was an accomplished journalist, a believer in direct democracy and an organiser of popular clubs. She, like most of the more populist militants, circled around the Cordeliers and was active in the first society to admit women as equal members, the *Société fraternelle des deux sexes*. She called for all titles of address to be replaced by *frère* and *soeur*, but her connections were with Danton and she faded out under the Republic.

The most remarkable of all the revolutionary women was Olympe de Gouges, born in the south, a courtesan in Paris during the 1780s and a talented playwright, whose ten plays, novel and countless pamphlets advocated the cause not only of women, but of blacks, the old, widows and abandoned children. She linked feminism with a comprehensive radical programme she had begun to advocate before the Revolution. Appalled by the male exclusiveness of the Declaration of the Rights of Man . . . 'Men, are you capable of being just? What has given you the power to oppress a sex which has all the intellectual faculties?' . . . she drafted a Declaration of the Rights of Women, prepared a law on contractual marriage, led processions of armed women and helped to form the *Républicaines Révolutionnaires*. Her sense of justice drove her to volunteer to defend King Louis XVI and growing disillusionment with the Republic made her an enemy of Robespierre, whom she persistently attacked. Her call for a popular vote to determine the form of government in France got her arrested, her skilful guerrilla resistance maddened her jailers and she died under the guillotine in November 1793.[20]

In Britain, too, the full effect of women's history has yet to be felt. There has been the same concentration on exemplary individuals like Mary Wollstonecraft and a tendency, common to much British historiography, to treat the 1790s as a phase or starting-point in a sequence. But work is being done at the

grass-roots and here, as in France, we await a major revaluation.

The last twenty years in Britain have seen a considerable extension of knowledge, of relatively greater significance than that in France, possibly because this kind of history has seemed more innovative here. The 1790s repeatedly figure as some kind of conceptual starting-point for a chosen sequence, but historians who treat the decade, or perhaps the war of 1793–1815, as a human experience in its own right, have greatly enhanced our understanding. Effective historical syntheses have begun to appear.

We evidently find it difficult to escape from an inherited insularity. Much of this scholarship apparently sees no significant American dimension to British life and no specific conjuncture linking British and French popular movements in 1792. At a time when what is called a 'Celtic fringe' accounted for nearly a half of the home population, Britain is often identified with England. The most interesting work has been done on three aspects of British experience – the American dimension, the temper of the late 1790s and the Jacobinism of a Wales which has hitherto hardly figured in the record.

The major role which the American achievement of independence and a republican constitution played in British political thinking and the Anglo-American character of much British Jacobinism are familiar. So, at least in outline, is the modest but highly politicised emigration of the late 1790s (Chapter 1 and pp. 80, 102–3). Recent studies, particularly a massive work on a somewhat earlier period, indicate the sheer scale of what appears to have been a continuous movement, and document an essential human context to the politics of the 1790s.[21] By 1760, some 700,000 people had crossed to British America; between 1760 and 1775 the annual rate of migration quadrupled, as some 220,000, ten percent of the total American population, crossed to provoke some panic at home. For they were nearly all from the British Isles and many moved in groups – 55,000 Ulster Protestants, 40,000 Highland Scots. There were two migration streams – ambitious, often penniless, young, bachelor artisans from London and the

Home Counties who signed on for a stint as servile indentured labourers alongside the convicts and vagabonds and whole farming familes from the north of England and western Scotland seeking a new life and escaping the attentions of modernising landlords.

While the later years are nothing like so well-documented, there is every reason to believe that this pattern persisted, particularly as accelerating modernisation during the war years ran into the crises of 1795–6 and 1800–1801. The Irish, as one would expect, emigrated in droves; during the 1790s three to four thousand arrived in American ports every year. But from 1794 or earlier, thousands of British crossed and the movement was highly political. The distinction between 'those seeking a republic and those seeking bread' is unreal, most viewed America in both ways. Of the several hundred from Britain who took out citizenship papers in Pennsylvania between 1795 and 1802, hardly one was illiterate, a third affirmed rather than take an oath and most were artisans. A detailed analysis of 66 leading figures among them paints a vivid picture of talented men who could get nowhere at home – which was certainly one driving force behind the popular movement.[22] They were a power within the Jeffersonian Democrats and Federalists regarded them as a fifth column. The Welsh who took out papers usually called their birthplace 'the kingdom of Wales'; their movement resembled that of the farming families of Yorkshire and it was charged with a kind of nationalism which Welsh Jacobinism engendered. America was a presence in the 1790s in the political mind but also as a physical reality offering some refuge and hope; it was not only Botany Bay which lurked at the end of every mean street.

They were running away not only from wartime miseries but from a political climate which had become dangerous. Our knowledge of the revolutionary underground and the government's response to it is much fuller than it was in 1968 (pp. 107–11). It is now clear that the United Irishmen were working with underground British revolutionary movements from the first stirrings on the main island during the crises of 1795–6. By 1797, a

network of United Scotsmen (some 10,000 sworn and drilled around Dundee and Perth alone), United Englishmen (with eighty lodges in Lancashire alone and more in the Midlands and London), together with other societies were locked into a wide-ranging republican and insurrectionary project which tried to coordinate action with the Irish and the French. The Irish presence was pervasive but there was plenty for the British revolutionary movements to work on. These conspiracies, which at moments of crisis could ride convulsive popular outbreaks in region after region, run like a red thread through the grain actions of 1795–6, the naval mutinies of 1797, the attempts to support the Irish rebellion of 1798, above all through the mass revolts and impatient war-weariness of 1800–1801, which debouched into the abortive rebellions of Colonel Despard in London and Robert Emmet in Dublin in 1802–3.

Government, building up a powerful secret service, using spies and provocateurs, extending its actions to Europe through the espionage centre at Hamburg, struck time and again, in a kind of guerrilla war, now driven into premature action by the parliamentary time-table for the renewal of repressive legislation, now holding back deliberately, now waging a black propagandist campaign, now itself succumbing to 'alarm'. There is evidence that by 1801 it felt it was losing grip: the Union with Ireland and the Peace of Amiens brought reprieve.

Two major studies have transformed our understanding, a comprehensive analysis of the relations between the United Irishmen and France[23] and, above all, a massive and meticulous examination of the years from 1795 to 1803 which works through them almost day by day, piecing together the construction of a state apparatus of surveillance and coercion and probing in detail in region after region the interplay between popular discontent, riot, group mentalities, conscious political action and the multiple levels of response by authority.[24] This study achieves resonance in its analysis of the complex situation in 1800–1801 when a major effort to revive conventional political activity by democrats like John Cartwright and moderates like Christopher Wyvill resulted

in a mass petitioning campaign against the war and the ministry, and in attempts to reconstitute a Whig opposition and to create a new democratic party, even as in London, the North and Scotland there was a recrudescence of insurrectionary movements which plunged the Midlands into prolonged instability. The rage over the terrible dearth and misery in many areas generated a rebellious, sometimes insurrectionary temper which activated trade unions – made illegal along with the London Corresponding Society and the United Englishmen in 1799 – no less than Jacobin clubs. Uniform handbills – 'Drag the Constitution from its hidden place!' – were distributed to the crowds in widely separated places and there were industrial activists in the Black Lamp underground in Yorkshire, and other secret movements which seem to have been meshing into a nation-wide project focused on Despard's plans for a coup.

By this time, factory operatives, 'mechanics' and industrial workers were active in the shadowy popular societies and it was in this dense and dark atmosphere, under a cloud of hostility and repression, that artisan Jacobinism was transmitted face-to-face to workers beginning to think of themselves as a class.

One of the centres of this underground was the novel iron and coal community of Merthyr Tydfil in south Wales. Jacobinism in Wales (which seems to have disappeared from British history) was distinctive in that it displayed tendencies more common among small European peoples than on this offshore island.[25] Half a million people in what had become a backward region were in the eighteenth century largely recruited into an export sector of the mercantile economy of Great Britain. Ninety per cent of the copper industry was located there, iron production grew from a sixth to two-fifths of the British total, western and rural Wales went over to cloth. Most of this production was directed to Atlantic export as the 'lower-middle' classes created by merchant capitalism multiplied and the numerous lesser gentry lost their footing. Magnates and gentry went through a rapid turnover of families, shed their previous Jacobitism and, committed to the 'blue-water' strategy of British commercial imperialism, actively

prepared their societies for the abrupt incursion of English industrial capitalism into the eastern coalfields in the last quarter of the century. A gulf in language and religion opened between gentry and people; the former were accused of abandoning their traditional defence of a distinct Welsh identity.

Into this vacuum flowed a rising tide of popular literacy, stimulated by an evangelical crusade which rooted the culture of the printed book in Wales; by the last quarter of the century a majority of adults had probably become literate in Welsh. This serviced the Methodist movement, independent in origin from that in England and the long established Old Dissent. It powered a slow but accelerating revival in Welsh literature and history, largely directed by effervescent Welsh societies in the capital immersed in the radicalism of artisan London. From about 1780, as the population explosion began to register in the rural areas, there was an abrupt acceleration. The iron industry penetrated deeply into the coalfields of north-east and south-east; Lancashire capital moved into the rural cloth trade, to raise factories and turn farmer-weavers into proletarians. As traditional society was disrupted, the advance of both Dissent and Methodism became so rapid that, in little more than a generation, it was to turn the majority of the Welsh into Nonconformists, one of the most swift and profound transformations in the history of any people.

The cultural revival moved to a climax. Out of the literate and bilingual Glamorgan which had produced Dr Richard Price the Dissenter democrat and David Williams the Deist, came the Morgan John Rhys who was to launch the first political periodical in the language, and Iolo Morganwg (Edward Williams), stonemason, poet, antiquarian and fabricator extraordinary in the style of Ossian, who invented a poets' guild – the Gorsedd (Order) of Bards of the Island of Britain – said to be Druidic in origin and intended to serve a renaissant nation as a democratic elite. Out of industrialising Denbighshire came the men who staffed the energetic London-Welsh society of the Gwyneddigion and poured out texts in an increasingly millenarian temper. One of their leading men, William Owen, in the style of Horne Tooke and the

American Noah Webster, tried to transform Welsh into the language of liberty and produced a Welsh dictionary which was nearly twice as big as Dr Johnson's. These men, joined in the 1790s by Iolo Morganwg, went over to the French Revolution.

Politics in Wales had begun with the American Revolution; the Welsh were over-represented in America and most of them were Dissenters; there was a trans-Atlantic Baptist international linking Philadelphia and Wales, with its own ships. Political publications in Welsh multiplied sixfold as did masonic lodges. A Patriot opposition emerged in the more developed counties which was disrupted by the crisis of 1792–3. The Gwyneddigion took up the cause. They revived the eisteddfod as a vehicle for Jacobin propaganda, with appropriate competition titles and medals struck by M. Dupré who became official engraver to the French Republic. They sponsored Jacobin journals and pamphlets and charged them with a new Welsh nationalism. When Iolo Morganwg launched his Gorsedd in a ceremony on Primrose Hill, London in 1792, he launched it as an order of people's remembrancers to a Welsh Republic.

They were drowned in the reaction, the repression and the rising tide of Methodism and the more conservative Dissent. But they found allies among the more radical Dissenters, Unitarians in particular, and in the terrible crises of the late 1790s, they found recruits. The crisis hit the cloth country to the west hard, in an arc of disturbance running from Cardiganshire up into north Wales, with riots, rebellions, outright disaffection convulsing places like Machynlleth and Bala, armed crowds taking over Denbigh and people praying for a British defeat in the war. It was even worse in 1800–1801, when the new industrial areas broke into insurrection and a popular uprising was feared in north Wales. Through the riots and the redcoats marching and counter-marching across rural Wales, hundreds of families threaded their way to the America boats while thousands more trapped in poverty clamoured to get away.

Their migration was informed by a millenarian spirit. At the height of the political excitement, news of the discovery of 'white

Indians' (the Mandans) on the Spanish Missouri revived the old legend of Madoc, a twelfth-century Welsh prince who was said to have discovered America three hundred years before Columbus and to have left a tribe of 'Welsh Indians' there. This was the equivalent of the myth of the Norman Yoke and the Freeborn Saxons of the English. One young Welshman from Caernarfon, sponsored by the London-Welsh Jacobins, crossed in the steerage and, in Spanish service, became the first white man to reach the Mandans on a quest for the Lost Brothers. After him went Morgan John Rhys, to go on an epic horseback tour of the American republic, to fight for a black church in Savannah and Indian rights on the Ohio, and to launch a Free Cambria in Beula, Pennsylvania. After both went Welsh families by the hundred, making their way through frightful crossings, Algerian corsairs and a hostile Royal Navy, to struggle, and fail, to make it a reality.

And after the stormy decade had passed, it left a new tradition in Wales, carried by clusters of radical Independents, Baptists, Unitarians and Deists in the south-west and the southern coalfield. There was a direct transmission of a quasi-nationalist Jacobinism to the newer working-class movements, led largely by Unitarians who brought out the first workers' journal and the Chartist press in Merthyr Tydfil and duly reprinted material from the 1790s, including the Welsh Volney.

Iolo's Gorsedd lasted longer. Suppressed as Jacobinical, it resurfaced in 1819 and made its first entry into an eisteddfod. In the 1850s it lodged firmly there and, in the end, adorned with lavish costume and ceremonial, came to dominate it and to serve as a symbol of Welsh nationhood. In the first week of August every year, learned and often reverend gentlemen, in Druidic garb, assemble to face the sun and rehearse the rituals of an eighteenth-century Deist republicanism whose spiritual home is the France of Nicholas de Bonneville.

Since I have recently been elected into this august body, I find myself even more alert to the ironies of a transmission of tradition in Britain and France than I was in 1968 (pp. 112–14). In the Britain of 'continuity', Richard Carlile who re-engaged the Paine

tradition after the war, complained bitterly about new-fangled words like 'radical' and 'liberal' and new-fangled notions like 'moderate reform'. What he saw was the fragmentation of the one true doctrine of democracy as, under the hammer of class formation, British society ground apart like some clumsy cast-iron mechanism. Volney's fifteenth chapter could be transformed into a collectivist text, but there remain unsolved problems inherent in the reception of the individualist democracy of artisans by an industrial working-class. The working-class press of the early nineteenth century was still haunted by the French Revolution and Pitt's 'war against liberty'. George Julian Harney fancied himself as the Marat, and Bronterre O'Brien, who translated Buonarroti's history of the Babeuf Conspiracy, as the Robespierre of the English Revolution. And in the France of 'rupture', the true custodians of the revolutionary tradition were the victims of Prairial rather than Thermidor, the *Père Duchesne* reappeared in every nineteenth-century revolution, the survivor of the Commune of 1871 who wrote the words of the *Internationale* belonged to a Parisian trade which had been 'revolutionary' since 1793. There were even 'sans-culottes' in full kit in the May Events in the Paris of 1968.

What *is* certain and what twenty years of research have confirmed, is that in both Britain and France – and in many parts of Europe and both Americas – the nursery of the democratic doctrine was that distinctive sector of a society we call, for want of a better word, 'pre-industrial'. A range of people from journeymen to the liberal professions (pp. 4–5) could achieve a kind of political unity which we can no longer easily assimilate. Its core, however, the people who gave it its voice, its tone and its image are clearly recognisable. The original conclusion of my book bears repeating. The ideology of democracy was pre-industrial and its first serious practitioners were artisans.

NOTES

1. Chris Baldick, *In Frankenstein's shadow: myth, monstrosity and 19th-century writing* (Oxford UP, 1987); review by Marilyn Butler, *London Review of Books* (5 May 1988), 12–13.
2. François Furet, *Penser la révolution française* (Gallimard, Paris, 1978), translated as *Interpreting the French Revolution* (Cambridge UP, 1981).
3. James H. Billington, *Fire in the minds of Men; origins of the revolutionary faith* (Maurice Temple Smith, London, 1980), Book 1.
4. Equally characteristically, the British army stole the 'Ça Ira' for a regimental march.
5. Marilyn Butler, *Romantics, Rebels and Reactionaries: English literature and its background 1760–1830* (Oxford UP, 1982), Chapter 2.
6. Peter Burke, *Popular Culture in early modern Europe* (Maurice Temple Smith, London, 1978), Chapter 1.
7. Olivia Smith, *The Politics of Language 1791–1819* (Oxford UP, 1984).
8. Frances A. Yates, *The Occult Philosophy in the Elizabethan Age* (Routledge and Kegan Paul, London, 1979) and her other volumes on the theme; Margaret C. Jacob, *The Radical Enlightenment: Pantheists, Freemasons and Republicans* (Allen and Unwin, London 1981).
9. James H. Billington, op. cit.
10. *Dictionary of Welsh Biography*, ed. J. E. Lloyd and R. T. Jenkins (Hon. Soc. Cymmrodorion, London, 1959). The entry by the late Professor David Williams draws together material from a scatter of sources.
11. J. F. C. Harrison, *The Second Coming: popular millenarianism 1780–1850* (Routledge and Kegan Paul, 1979); Marilyn Butler, 'Romanticism in England' and Gwyn A. Williams, 'Romanticism in Wales' in *Romanticism in National Context*, ed. Roy Porter and Mikuláš Teich (Cambridge UP, 1988).
12. Gwyn A. Williams, *The Search for Beulah Land: Wales and the Atlantic Revolution* (Croom Helm, London, 1980).
13. Gwyn A. Williams, 'Morgan John Rhys and Volney's *Ruins of Empires*', *Bulletin of the Board of Celtic Studies*, xx, pt. i (November 1962), 59–73.
14. Clive Emsley, 'The impact of war and military participation on Britain and France 1792–1815', in *Artisans, Peasants and Proletarians*

1760–1860: essays presented to Gwyn A. Williams, ed. Clive Emsley and James Walvin (Croom Helm, London, 1985).

15. Geoffrey Best, *War and Society in Revolutionary Europe 1770–1870* (Fontana, London, 1982).

16. Roger Wells, *Insurrection: the British Experience 1795–1803* (Allan Sutton, Gloucester, 1983).

17. George C. Comninel, *Rethinking the French Revolution: Marxism and the revisionist challenge* (Verso, London, 1987).

18. Olwen Hufton, 'Women in Revolution, 1789–1796', in *French Society and the Revolution,* ed. Douglas Johnson (Cambridge UP, 1976).

19. For a survey, see Dorinda Outram, 'Le langage mâle de la vertu: women and the discourse of the French Revolution', with the texts she refers to, in *The Social History of Language,* ed. Peter Burke and Roy Porter (Cambridge UP, 1987).

20. *A Biographical Dictionary of Modern European Radicals and Socialists,* vol. i, ed. David Nicholls and Peter Marsh (Harvester, Sussex, 1988).

21. Bernard Bailyn, *Voyagers to the West: emigration from Britain to America on the eve of the Revolution* (I.B. Tauris, 1987)

22. Michael Durey, 'Trans-Atlantic Patriotism: political exiles in America in the Age of Revolutions', in Clive Emsley and James Walvin, op. cit. (note 14).

23. Marianne Elliott, *Partners in Revolution: the United Irishmen and France* (Yale, London, 1982)

24. Roger Wells, op. cit. (note 16).

25. Gwyn A. Williams, *The Search for Beulah Land: Wales and the Atlantic Revolution* (Croom Helm, 1980); 'Druids and Democrats' in *The Welsh in their History* (Croom Helm, 1982) and 'Romanticism in Wales,' in *Romanticism in National Context,* ed. Roy Porter and Mikuláš Teich.

Artisans
and Sans-Culottes

———

When Death was on thy drums, Democracy,
And with one rush of slaves the world was free . . .

 G. K. Chesterton, *The Revolutionist*

When you play the fiddle at the top of the state, what
else is to be expected but that those down below dance?

 Karl Marx, *The Eighteenth Brumaire of Louis Bonaparte*

CHAPTER ONE

Men and Slaves

'DUMOURIER is at BRUSSELS and DEMOCRATS *everywhere* STAND FORTH!' It was a Londoner speaking, or rather shouting, in the autumn of 1792, in a jubilant (but anonymous) letter to the newly-formed Association for the Preservation of Liberty and Property from Republicans and Levellers. In the streets of Sheffield that November, 5,000 'republicans and levellers' in the guise of cutlers, paraded posters showing Edmund Burke riding a pig, the Home Secretary as half-man, half-ass, the Angel of Peace offering Tom Paine's *Rights of Man* to a stricken Britannia; it was Valmy they were celebrating.

For across the Channel, in the terrible and exhilarating days of August and September, the French monarchy, the constitutional monarchy which 1789 had created, went down before the 'people of Paris' and provincial *fédérés* led by the Marseillais with their new marching song; and a new political man confronted a startled and largely horrified Europe. He was the *sans-culotte*,[1] a man of the *menu peuple* – in his uniform: short *carmagnole* working man's jacket, plebeian trousers, *bonnet rouge* of the freed slave, artisan's pipe, revolutionary moustache and people's pike – in his style: title *Citizen*, second-person-singular *tutoiement*, speech of equality, bloodthirsty zest to be done for ever with 'aristocracy' – in his democracy:[2] total and literal popular sovereignty, direct, continuous and utterly egalitarian – and in his success, for with France prostrate before the 'leagued despots' of Austria and Prussia, betrayed by her king and queen, half her generals, many of her privileged, her clergy, her men of '89, it was armies everyone called 'sans-culotte', under a man everyone called a 'valet de chambre', who stopped the 'uniformed butchers' in their tracks and rolled back the armies of the old régime.

Nine months earlier, in England, Thomas Hardy, a Scottish shoemaker of Piccadilly, had met a handful of friends in the Bell off the Strand and over pipes and porter solemnly debated whether they, as mere 'tradesmen, shopkeepers and mechanics'

had a right to obtain a parliamentary reform; they decided that they had, and little groups of men in Sheffield, Norwich and a score of other places were coming to the same decision at much the same time. In their first tentative but unprecedented popular societies, they demanded universal suffrage and annual parliaments, a democratic régime as nearly direct as they could make it and a democratic society as nearly egalitarian as they could conceive. And in the autumn, as 'respectable' sympathisers in their thousands recoiled from France, thousands of artisans, shopkeepers, journeymen, the 'inferior people' unknown to political life, joined the societies in such numbers that the comfortable squirearchy of England, perhaps the most secure class on earth, were alarmed and enraged. The new 'uncommon reformers' in their unprecedented clubs, their mouths full of the equally unprecedented insolence of Thomas Paine, corresponded like Jacobins, planned a British Convention, hailed the French, ran about collecting shoes for sans-culottes; there had never been anything quite like it. For their 'dawn' was not Wordsworth's; theirs had come three years later. No matter how radical the differences between the two countries, in both Britain and France, it was in 1792 that 'the people' entered politics.

If it were possible to cut these 'peoples' free from their distinct national experiences and traditions, they would seem uncannily similar. Both the sans-culotte movement in France and the so-called *Jacobin*[3] movement in England disengaged themselves from a broad but distinctive sector of that society we tend to call, with total ambiguity, 'pre-industrial'. Setting to one side the 'honorary' sans-culottes or radical Jacks on both sides of the Channel who were unmistakably bourgeois or 'middle class', there remains a range of social experience, wide and minutely differentiated, which yet possessed a unity which is no longer easily assimilable; it is difficult to find an adequate descriptive term for it – Marxists rather enjoy the 'contradictions'. Small merchants, petty entrepreneurs, small masters, shopkeepers, the lower ranks of the liberal professions, certain kinds of teacher, of petty bureaucrat, journalists, veterinarians in France and former naval surgeons in England, the socially displaced and mobile, actors on both sides of the Channel, above all, artisans, journeymen, *compagnons*, could generate a movement which to a modern mind seems riddled with contradiction and which was, in truth, loose-jointed, but which possessed a very real – in France,

ferocious – unity. The sans-culotte movement created in the passion of revolution is so vivid and tragic, so impressed itself on the minds of observers, that it is very difficult not to treat it as some kind of 'prototype'. This it was not. The British movement was not a 'failed French Revolution'; it was not revolutionary and it was a British democratic movement.

Nevertheless, anyone who moves from the records of the Sections of Paris under sans-culotte control to the minutes, letters and pamphlets of British popular societies, particularly during 1795, when England suffered a food crisis not unlike the eternal French *crise des subsistances*, is not merely impressed, but overwhelmed – often against the grain – by the similarity. In their conception of democracy, their attitude to leadership, property, social morality, their idea of unity and correspondence, their suspicion of the 'respectable' and the 'hommes à talent', their continuous expectation of betrayal, above all in their feeling for equality and craving for recognised manhood, sans-culottes and artisans are so similar that they sometimes seem identical. The differences in tone and temper – quite radical – can often be explained by the brute distinction between a situation which was revolutionary and one which was not.

But this, of course, is the crux; there could be no greater difference. After its seventeenth century English society was qualitatively different from French. Its monarchy breathed a different air. Even its oligarchical politics and the muddle of precedent and pragmatism which was its parliamentary system were absorbent. The export boom after the American peace seems to have been the first to register the effect of the new technology. Already the major mercantile power, its industrial society in some areas was beginning to pass beyond common contemporary experience. And after a brief 'reform' – more accurately 'reorganisation' – interlude in the immediate aftermath of the dissolution of its American empire, its political society became at once more conservative and, within the strict limits of the 'political nation', more effectively experimental. It could be shaken by severe crises, as in 1795 and 1797, but it was never in any danger of revolution. Its popular movement took its colouring from its environment.

Central to England's reaction to the French Revolution was its reassertion in ideologically conservative terms, *as early as 1785*, of faith in its 'constitution', which was revered as a 'miracle' of human ingenuity, in a manner to which only the Americans, after

their Philadelphia convention, offer any parallel. The conflict over 'constitutions' between the essentially American Thomas Paine and his opponents was one of absolute moral certainties.[4] After 1785 the steam went out of the reform movements. At their peak, in the closing years of the American war, these had embraced both pragmatic 'moderates', like Wyvill's county associators, and a handful of doctrinaire democrats, linked to a liberal wing of Dissent, who had formed the Society for Constitutional Information[5] in 1780 and published a programme which the Chartists fought for over fifty years later.

It was the effort of Dissenters, inspired by the dazzling new constitutional liberties of France, to renew the campaign and to win full rights of *citizenship* (the word was used) during 1789-90, which raised again the kind of uncomfortable and basic 'theoretical' issues which the American argument had raised. It provoked the first of the many 'reactions' of these years. In some localities, particularly those where Dissent, the new industry and coteries of intellectuals often grown out of a Dissenting milieu, posed a threat to local powers, the struggle over the Test and Corporation Acts produced in 1790 an often violent Church-and-King reaction and a climate which anticipated by several years the embattled and inquisitorial 'loyalty' of the French war. In many places 'memories' of the seventeenth century came bubbling to the surface – 'Did not their sires of old murder their king?' When John Reeves formed his Loyalist Association[6] as late as November 1792, to combat *French* influence among the *plebs*, many of his correspondents sent in furious scrawls denouncing *Dissent*, in terms which must have gladdened the shade of Charles I. Reeves himself, in one pamphlet, seemed to advocate a return to those happier, disciplined times and in some more remote areas, like South Wales, several local powers during the war years made the effort to do so.

Burke's classic statement of the conservative case, his *Reflections on the Revolution in France*, came out in November 1790, and its remarkable success parallels Paine's on the other side, in that it expressed in memorable language what its audience already 'knew' in their bones. Note its *early* date. The *Fédération* of that summer in France was probably the peak of ecstasy in the 'honeymoon' for those many and volatile sympathisers with France among the intellectual, the poetic and the respectable, whose ejaculations and books against Burke fill the textbooks. At first

glance, conservative England seems to have reacted against the French Revolution before there was anything serious to react against. This is because the English quarrel had, in truth, not much to do with France. The excitement generated by the dramatic cross-Channel experiment focused attention precisely on those basic 'theoretical' questions, which the American struggle had raised so sharply and which Wyvillites and 'economical reformers' like Burke in the 1780s had blurred, sometimes deliberately. The conflict over the Test Act put the miraculous constitution on trial. The struggle which ensued in some localities, sometimes fierce as in Manchester and Birmingham, was in terms of pure logic the kind of conflict which 'ought' to have broken out in England in 1776 (when the first democratic pronunciamentos, like Major Cartwright's *Take Your Choice* did appear). American public philosophy at the time of the revolution was, in essence, the projection of what was a minority sensibility at home, and in 1790 in some areas, the 'British civil war' which the American revolution could have been actually broke out. Thomas Paine himself, author of that *Common Sense* which helped precipitate the crisis of 1776 and of that *Crisis* which immortalised Valley Forge, emerged from this kind of confrontation, though he carried the argument to a different plane. His brief friendship with Burke shows how much he, misled by American experience, misread his man. He actually asked Burke to call a Convention to do what the American had done – give Britain a 'constitution'. Paine's *Rights of Man*, though universal in its resonance, is in its Part II (which did the damage) much more 'American' than 'French'. In this sense, Dr. Richard Price, a typical Dissenter-democrat and the very occasion of Burke's *Reflections*, was perfectly correct in his refraction of light from an American dawn through a French filter to a benighted Britain. In the famous Priestley Riots of 1791 members of the Birmingham Establishment, manipulating a traditional mob (some of them shouting 'No Popery!' and some, workmen turned conservative against *Jacobin* employers) politically destroyed a nucleus of Dissenters, intellectuals and radical industrialists as 'French traitors'; it had precious little to do with the French Revolution. It was America which had first exposed men like these as 'traitors' – and which damned Paine as a 'traitor' as soon as he opened his mouth. America, because it raised *British* constitutional issues, was still an intimate and painful experience in a way that France could not be[7].

Before 1792 revolutionary France was many things to Englishmen; what it was, above all, was a glorious or horrible myth. But the Dissenters' campaign and French-influenced intellectuals' talk of rights and representation brought back again those very issues which America had made painful. For the author of *Common Sense*, hob-nobbing with Jefferson, author of the Declaration of Independence, in France, to insult the king and press a Convention on British artisans, with pointed comparisons between George Washington and *Mr. Guelph*,[8] was the last straw.

It is important to realise that this reform campaign of 1789–90, led by Dissenters and intellectuals among the literate and the educated, men within the 'political nation', had already been contained and defeated, sometimes with violence, *before* any popular societies appeared. The men of the revived Revolution Clubs, who hailed France as many of them had hailed America, got the same dusty answer as their spiritual brethren across the Atlantic. The verdict delivered in 1785 was decisively confirmed in 1790; Burke elevated it into a philosophy. Church and King had already mobilised in some areas before any of the 'new people' entered politics. Moreover the defence of the miraculous constitution had been conducted, as in the earlier crisis, in terms of a peculiar British liberty. It is impossible to escape the long shadow of the seventeenth century. This is the decisive difference from France. British politics, even the conservative, were drenched in the rhetoric of liberty, constitutionalism and the free-born Englishman.

Thomas Hardy, president of the London Corresponding Society,[9] most celebrated of the artisan clubs, tried to make the difference clear. The aim of British and French, he agreed, was the same – egalitarian democracy. But the seventeenth-century English had conquered some basic rights of free speech and assembly. They had taken a great step towards the original democratic constitution lost over centuries of oppression. What was needed now was an educational campaign to create 'uniformity of sentiments' in favour of universal suffrage and annual parliaments, which would finish off Old Corruption. The French had begun with nothing but Catholic tyranny. Revolution was a necessity and the Terror, therefore, comprehensible. The difference was written in history – 'We were men while they were slaves.'

The crisis in France in 1789 was total. Social realities were complex and contradictory and have been muffled by concen-

tration on *Estates* and the employment of a meaningless word like 'feudal'. But the Ancien Régime seems to have reached the point of breakdown almost simultaneously in social, political, economic and intellectual terms. From 1787, a chain of 'revolutions', royal renovation, aristocratic reaction, bourgeois revolution, popular rebellion, Great Fear, hunger riots, municipal coups, peasant revolts, swept to a climax in 1789, when a National Assembly, apparently overnight, began a total reconstruction. The popular movement emerges with similar abruptness, wholesale insurrection in 1789, which seems an exaggeration of traditional riot, rapidly acquiring political colour and developing through revolutionary and war crises in conditions of almost permanent dearth into a powerful, vivid and effective force which, in its supreme crisis, gives the Revolution much of its tone and colour – only to disappear with equal suddenness in the wretched year of 1795. Conquerors of the Bastille seem to spring out of the ground; a couple of years of severely practical 'education' and they are a sans-culotte movement; two years later survivors trail back to workshop and shop-counter and nothing more seems to be heard from their like for a generation. In England popular societies wrestle awkwardly out of older libertarian movements, lumbered with irrelevance, struggle against an engulfing hostility and succumb in as unsymmetrical a way as they began, going underground with trade unions and men of the factories; it was a movement of far less power but, it seems, far more continuity.

Research in progress may change the picture, but in France one has, at present, little sense of that sheer 'pre-political' complexity one finds in England. Crowd actions, which have their exact counterpart in England, seem to lack the 'free-born Englishman' tone. The king has to be rescued from evil counsellors; for a time, during the 'pre-Revolution', Henry IV is a hero. *Père Duchesne*, the journal which appealed directly to sans-culottes in a version of their own speech, represents an honest, fierce, uncompromising, pipe-smoking old artisan, full of *grandes colères*, *grandes joies* and earthy commonsense, who was presumably some kind of archetype. The peculiar tone of England's *Tyburn Fair*,[10] which a people one third of whom were always outside and often against the law made into a kind of moral occasion with 'sub-political' meaning, seems to have had no exact equivalent in France. Traditional attitudes towards authority, towards 'them' and 'their' morality, bandit-heroes, and so on,

seem to have been much the same, but English rioters found a
political 'warrant' denied the French, who were often almost
'medieval' in their political reference.

This is all the more striking because such crowd actions, a
characteristic expression of the non-political 'people' before the
revolutionary period, were notably similar in both countries. In
this kind of society, it was not the strike, but the food riot and the
price-fixing crowd action, *taxation populaire*, which were typical.
There were scores of them, in both countries, during the century.
The last killing famine in France was that of 1709, but dearth
nearly always provoked riots, to prevent the movement of grains,
to lower prices to a traditional level, often accompanied by wild
rumours of a plot to starve the people – *pacte de famine* – and of
speculation by *accapareurs*. Turgot's attempt to impose free trade
on the grain trade in a time of shortage provoked the widespread
guerre des farines in 1775, as serious as many such movements during
the Revolution. A crisis of this character coincided with the
political paralysis in 1789 and made the Revolution possible. The
crise des subsistances was a near-permanent feature of the Revolution
itself, when traditional price-fixing remedies, expressed in the
new terms of popular sovereignty, developed into sans-culotte
demands for a *Maximum* and internal militias, the *armées révolution-
naires*.

In England, despite differences in the structure of the grain and
victualling trades (London was never as vulnerable as Paris) the
food riot was similar. The 1766 riots in south-western and mid-
land England were as massive as the *guerre des farines*. If anything,
they were more frequent, for England was pre-eminently the
country of the eighteenth-century mob.[11] It is often difficult, in
the ill-policed England of the squires, to find a year free from mob
outbreaks. London was peculiarly turbulent, perhaps the most
riotous city in Europe. There were riots, sometimes on a large
scale, against all kinds of grievances – Irishmen, gin taxes,
Catholics, the press gang, Methodists, the militia. The notorious
Gordon Riots of 1780 ran through every conceivable phase of a
crowd action, from parade and petition against Catholic relief,
through 'freedom' riots against authority, to wild, drunken
anarchy. The memory of them may have been a factor in English
response to the French Revolution. Paris, while it saw some not-
able days, was nothing like as dangerous. English country riots,
in which industrial workers were far more prominent than in

France, which still had 'peasants', were still very like the French
in that both found a *warrant* in conceptions of a 'just price' and a
'fair wage' – what has been happily called a 'moral economy',[12]
often at odds with both the realities of the old régime and the
market economy of the newer liberal doctrines. It reflected the
traditional defence of a customary standard of living which seems
to have been deep-rooted and permanent in both countries.

But Englishmen often had a more specific 'warrant'; they were
freeborn Englishmen whose right of resistance had been confirmed
in 1688. Before the City of London acquired a radical temper and
before the John Wilkes imbroglio, most city riots were obscurely
'traditionalist'; a defence of 'natural' order against the consti-
tution's myriad enemies (hence, possibly, the 'No Popery!' of
Birmingham in 1791). Many were 'mobs' in the strict sense –
hired groups employed by some faction; Methodists seem to have
been the most frequent victims of these. Both Church-and-King
crowds and hired mobs appeared in the 1790s in action against
Jacobins, particularly in provincial towns and urbanised villages.
But they could be as dangerous as any Gordon drunks. Magis-
tracies of the localities, without police, could normally depend on
a thoroughly deferential attitude, particularly in 'politics', but if
a crowd really took to the streets, they simply had to play along
until soldiers came. Partly for this reason, partly because many
J.P.s shared popular prejudices against free commerce in food-
stuffs, partly from the 'free-born' myth, English rioters often
enjoyed a sense of 'licence' and the 'political' climate of many
English localities could be described, without too much exag-
geration, as deference punctuated by occasional half-tolerated
anarchy. The 'people' of course, except for a few freak constituen-
cies like Westminster, whose elections before the revolutionary
period they turned into Eatanswill orgies, were excluded from
political life. But the unenfranchised had that curious device, the
Hustings, where occasionally they could make their rulers jump.
The Hustings were the English mob institutionalised.

The two most formidable enemies of this traditional mob were
those two characteristic *minorités agissantes* – Methodists and
Jacobins. The latter's democracy required a clean break with this
world. Men must be brought off the streets into the committee
room and must stop looking for a warrant to their 'betters'. The
first unambiguous evidence of change dates from the American
War.[13] It was during this crisis that men like Priestley, Price,

David Williams, Cartwright and the circle that had focused on Benjamin Franklin, began to advocate political democracy. The doctrinaires of the Society for Constitutional Information disseminated political information among the poor and humble. John Horne Tooke, the gentleman *frondeur* of Wimbledon, who had figured in the Wilkes movement, was prominent, as he was to be in the first formation of popular societies twelve years later. One of the intellectuals of the group, James Burgh, in his *Political Disquisitions* urged the formation of societies linked by correspondence and the calling of a manhood-suffrage Convention as a kind of anti-Parliament. The book had an impact in America and its plan was in fact adopted by the popular societies in the next decade. Thomas Brand Hollis, a benefactor of American libraries, gave the society's entire library of cheap publications to Thomas Hardy. There were certainly debating societies in London, and probably elsewhere, in which working men discussed the issues. In Welsh-speaking Wales, the first faint tremor of anything remotely resembling 'politics' dates from the ballads of the American war.

What we are dealing with here are tiny self-conscious minorities. A good deal more influential, in terms of number, was Dissent, peculiarly affected by the American struggle. The language of the popular societies, when they emerge in the 1790s is at times as full of the Bible and Bunyan as of Paine and the Saxons. This was particularly true of the humbler, more inarticulate men who tried to put pen to paper – their sheets tend to run to the – 'O ye that grindeth the face of the poor . . .' – style. Sheffield artisans, who in tone were at times nearer to the sans-culottes than anybody else in England, nevertheless enjoyed a Baptist sermon against the war in 1794, which was punctuated by chapter-and-verse reference to the Good Book and full of *hwyl* – George III had as much chance of stopping sans-culottes as Pharaoh had with the Red Sea – 'France is a furnace heated by the Almighty to purge the world of tyrants . . . The stars in their courses fight for her . . .' When Thomas Hardy wished to summon men to the cause, he knew what language to use – 'To your tents, O Israel . . .'

It has been argued that the massive growth of Dissent, old and new, during the generation following 1790 resembles the de-Christianisation movement among the *menu peuple* in France. In the sense that both represented a rejection of an Establishment,

this is true; in a weaker sense, it has some weight in that many liberal Dissenters abandoned doctrinal creeds and preached a social and civic religion. Liberal *Presbyterianism* and its derivative Unitarianism offered an umbrella to free-thought. But the comparison can hardly be pressed very far without losing all contact with human reality. What is one to make of the Kilhamites of 1797 – the 'Tom Paine' Methodists?

This legacy, like so much that the popular movements inherited from their reforming predecessors, was ambiguous. Dissent had lost much of its crusading zeal; many congregations were comfortable, conformist and quick with protestations of loyalty. Many more were frightened by the reaction to their campaign in 1790. Methodism, truly popular and proselytising, was officially Tory. One can only report that, while many Dissenters and Methodists rendered unto Caesar, many others, not excluding Anglicans and Catholics, but particularly Baptist and *Presbyterian*-Independent ministers, called themselves 'sans-culottes'[14] and went forth with God's sword to build an egalitarian Jerusalem. In its last days the artisan movement was thoroughly deist and free-thinking, but at its peak it was full of Dissenters and Methodists and often used a language which many learned in Sunday School. It was hardly a language sans-culottes would have understood.

Yet more ambiguous were some of the doctrines these men learned from the sci and respectable tutors – if that was where they learned them. What they seem to have grasped above all was the *historicism* of democratic criticism, whose proximate origin was the seventeenth century. Briefly, this identified an original and highly democratic constitution shaped by the originally pure English spirit in the days of the Saxons with their direct democracy of the *Witan*, their people's militia of the *fyrd*, their people's king chosen for ability and their scorn for aristocracy except a non-hereditary aristocracy of service. Alfred became a popular hero and remained one for a very long time.[15] Corruption set in with William the Bastard (this they tended to roll lovingly round the tongue) and his Norman bandits and periodic upsurges of the free Saxon spirit at Magna Carta and the Great Rebellion had finally been perverted at 1688 by a *coup d'état* of landowning malefactors.

Some people took the history seriously; some worked very hard at it. Most treated it as political metaphor. The real enemy was aristocracy and hereditary privilege, but like good free-born

Englishmen, they grounded the argument in precedent and historical continuity. It is difficult to overstate the force of this kind of thinking; it ran through most of their publications even after Paine had been assimilated. It made many of the leaders erudite men, familiar with Blackstone and all sorts of histories, commentaries and analyses. But the 'usable past' was not really very helpful; property loomed too large in English representation. They could argue, as they did, that a man's labour was his property and entitled him to a vote; one of them derived the right of armed resistance from Saxon precedent. But in accepting an *historical* approach they were in fact looking for a 'warrant' from their 'betters'. The psychological need was for someone with nerve enough to tell them, what many of them evidently already 'knew', that the past was a tale told by an idiot, that what they needed was common sense and resolution to act as their kin were acting in America and France.

This was what Thomas Paine told them. 'I am contending for the rights of the *living* and against their being willed away, and controuled, and contracted for, by the manuscript-assumed authority of the dead.' About the time he wrote the *Rights of Man*, Part I, Paine, with Jefferson, was wrestling with the problem of defining a 'political generation', beyond which no present law should carry. His book was not really an 'answer' to Burke. He had begun to write his book before he learned that Burke was busy with his. In one very real sense, however, the book *was* such an answer, for to precedent, organism and social mysticism he opposed the primacy of the present.[16]

Part I, of course, has been much discussed, sometimes at the expense of the more significant Part II. Sometimes ill-ordered, full of long digressions, it is often extraordinarily effective, brimming with quotable punchlines. Even today it produces, in parts, a 'Hemingway' effect. France's Declaration is expounded and her actions defended; the 'dying bird' confronted with the 'plumage' of Burke's Dulcinea-Antoinette. But the heart of the book is a terrific onslaught on the hereditary principle and precedent in general. Most shattering is the tone; probably most effective of all was the *contempt* and jovial ferocity, very proper to a former secretary to that victorious Congress which knew how to handle kings and their 'Lo here! Lo there!' 'Kings succeed each other not as rationals but as animals . . . an hereditary governor is as inconsistent as an hereditary author . . .' And what was this

precious 'constitution'? English history suddenly becomes a
nightmare of ruffians and armed banditti seizing power and
calling the criminal syndicate which results a 'constitution'. The
Bill of Rights is a bill of wrongs, English government was 'political
popery . . . a sepulchre of precedents'. In so far as the book has a
positive line, it is practically anarchist. 'Government' before this
age of common sense has been all force and fraud. Get rid of it
and society will begin to act sensibly through representation.

In truth, however, it was almost certainly the negative and
destructive force of Part I which mattered. It blew like a trans-
atlantic gale through the Saxons. Paine was no more consistent
than anybody else; there are plenty of echoes of the Norman Yoke
in him, and many of his admirers, with a familiar human scorn for
logic, managed to combine both. But Paine was essentially anti-
historical. His insolence was the best cure for deference. Moreover,
he had his own 'precedents' which he never ceased to remind his
readers of, in a pride which was often arrogance. A self-made man
himself, he had helped to create one republic based on natural
rights and common sense and was now busy about another. It was
probably this very cocksureness which did the trick. The book
came out in 1791; in a matter of months, the first of the British
popular societies emerges into visibility, at Sheffield. It was built
around the book and had 2,000 members in a few weeks. But it
was in the following year, in Part II, that Paine really got down to
cases.

Part II is a speculative exercise in government as a mechanic
art, designed to demonstrate the felicitous consequences of
political rationality. The monstrous and peculiarly *stupid*
inequality and irrationality of British life exist only because the
country has no constitution. Its appalling political and social
structure (complex because corrupt – all good things are simple)
is simply the systematisation over time of brute usurpations by an
aristocratic Mafia[17] and an hereditary monarchy, ridiculous in
principle and doubly idiotic since 1688, when it was made mer-
cenary and staffed by hired foreigners. The first need is a con-
stitution to get rid of this antiquated rubbish. Britons must call a
Convention and return the country to the political state of
nature (the political state of nature is America at the moment
she threw off British rule – and how splendidly that has turned
out!) Much of the book is a primer in the craft of constitution-
making on the principles of democracy, utility and equity. The

problem of democracy in large states, hitherto thought insoluble, has been solved by America. France is but now engaged on the same job, sometimes wrong-headedly, but will probably be sensible in the end and pension off her king. After all, the craft of government 'is but now beginning to be learned'.

As an example of the miraculous effect one can expect (America produces such miracles daily) he takes the fiscal system. The more spectacular idiocies are paraded. There must be peace first, so that the shocking waste of arms expenditure can be stopped. So Paine proposes an alliance between the new Britain, France and America; this naval club, monopolising world maritime power, can forbid the proliferation of fleets in Europe and force the liberation of South America, opening the world to freedom, trade and common sense. With peace, a start can be made.

Sinclair's history of the revenue shows a tax revenue of £17 million for 1788. Before that foreign parasite Dutch William, of course, it was only £1½ million – still six times America's taxes, with English local government unpaid, too – what else can you expect from Old Corruption? Slaughter the farcical civil list and all the other stupidities of monarchy and pare the armed forces to the bone. What could be done with all this money? The chief officers of state (no elaboration) should not need more than £10,000, particularly if we stop expensive foreign imports. The legislature? – say 300 Members in one, two or three houses as the Convention decides; pay them, but tightly, say £500 a year each, with deductions for absence from the job. Government officers should not need more than £500,000 a year, though after reform it will be hard to find work for them to do. Now, the poor rates: these, at £2 million, are crippling, particularly for men of the middle classes in places like Birmingham. A labourer with three children pays a quarter of his wages in indirect taxes as it is. Get rid of them, and remit twice the amount to the poor. People should rely on themselves and join benefit clubs; children over 14 go out to service or an apprenticeship. So, pay £4 a year to every child under 14, provided he learns his three R's (education will itself reduce the number of the poor) and give pensions of £6 and £10 to old people at 50 and 60. There are also those 'not properly of the class of the poor', but unable fully to educate their children, about 400,000 of them – ten shillings a year per child. Give small grants, too, to women in childbed who ask for one, to newly-weds – and, *as burial money, to artisans on tramp who die far from their*

friends (an example of Paine's almost uncanny knack of touching on a desperately serious problem among people no one paid any mind to. As with Marat in France, it was this impression of 'caring', far more than any political specific, which counted). In London, petty crime is a problem – 'hunger is not among the postponable wants'. So, open public workshops and admit all without humiliating interrogation; conditions should be 'at least as good as a barracks'. Finance them out of the Duke of Richmond's lunatic levy on coals.

Get rid of the window tax – it hits the 'middle class of people'. Away with primogeniture – 'a sort of privateering on family property'. We must have a progressive income tax, but be careful not to set bounds to industrial property. The aim is not revenue, but justice, since men of small and middling estates are useful and industrious people. Make the tax light up to £3,000 a year, stiffer after £5,000 and confiscatory at £23,000. Let us not inquire any more into the origin of these vast estates; we know it. They simply must not continue. Get rid of wage regulation – let wages find their market level: that is the way to raise them. Preserve the National Debt, it is useful (like the American Bank, which he had defended). But tax the interest and try to squeeze the foreigners out. With the money left over, pension off most of the armed forces and raise the pay of the rest – their job is not their fault. Finally, give grants to deserving cases – to the lesser revenue officers (Paine's first cause) and to the lower clergy. Never argue about denominations and religious affiliations. My religion is to do good. If a clergyman does the job, give him the money.

But we must trust in ourselves, says Paine, warming to his climax, and in nobody else. Without help and without money, for I gave the enormous profits of my remarkably successful books to Congress and have but a small place in Bordentown, I caused the revolution in America and serve liberty now in Europe. If we wish to be free, we have but to will it, for the age of reason has at last arrived and we are the Adam of the new world.

In the England of 1792, writing like this had a quite shattering effect in many quarters. Paine's eye for social realities invisible to the official world, his racy assimilation of principle and practice, his genuine compassion, above all his percussant style and quotable pungencies, won him an audience among the humblest. But it was not the factory proletarian or the propertyless who really

felt Paine along their nerves. It is no accident that the most
thorough-going 'Painite' in England was his friend and the former
pupil of James Burgh, Thomas Walker, the radical manufacturer
of Manchester. For Paine's compassion, his arrogance, his im-
patient contempt, even his quick and shallow verbal facility were
perfectly tuned to that group in society we so struggle to define.
The target Paine hit every time with unfailing accuracy, even in
his subordinate clauses, were the small master, the journeyman,
the small manufacturer, the shopkeeper, of questioning and
ambitious temper. Universal in its resonance, *The Rights of Man* is
in essence a manifesto of the man of small property, big aspiration
and broad sympathy.

The success of Part I had been striking; that of Part II was
phenomenal. In the course of the next nine months a score or so
popular societies appeared in big cities and small towns. On 21
May 1792 a royal proclamation was issued against seditious
writings and the first reports of 'subversive' activities came in from
magistrates. In a few months, Paine was summoned for trial and,
as the Pas-de-Calais elected him to the French Convention, out-
lawed.

But, for all the echoes he sent reverberating around Britain, he
was not enough. The new societies were unprecedented in their
plebeian membership, their independence, their near-total
rejection of customary politics. But, outside a few unusual places
like Sheffield and Norwich, they were still small, face-to-face
affairs. It was in the autumn of 1792, and quite suddenly, that they
grew to be a movement. For, if the 'men' were wrestling out of
their cocoon of precedent, across the Channel the 'slaves', in one
bold action, entered full manhood. In August and September, in a
crisis whose drama transfixed European observers, the sans-
culotte emerged as a central figure in the French Revolution.
Henceforth, the fate of the British political artisan was to be partly
dependent on his.

CHAPTER TWO

Sans-Culottes

'*Reply to the impertinent question: but what is a Sans-Culotte? ...* A Sans-Culotte, *messieurs les coquins?* He's a man who goes everywhere on his own two feet, who has none of the millions you're all after, no mansions, no lackeys to wait on him and who lives quite simply with his wife and children, if he has any, on the fourth or fifth floor. He is useful, because he knows how to plough a field, handle a forge, a saw, a file, to cover a roof, how to make shoes and to shed his blood to the last drop to save the Republic. And since he's a working man, you'll never find him in the *café de Chartres* or the stews where they plot and gamble or at the *théâtre de la Nation* when they show *L'Ami des Lois* or the *Vaudeville* for *La Chaste Susanne* or in those *cabinets littéraires*, where for two of your precious sous they peddle Gorsas's muck with the *Chronique* and the *Patriote Français*. In the evening, he's at his Section, not powdered and perfumed and all dolled up to catch the eye of the *citoyennes* in the galleries, but to support sound resolutions with all his power and to pulverise the vile faction of *hommes d'état*. For the rest, a Sans-Culotte always keeps his sword with an edge, to clip the ears of the malevolent. Sometimes he carries his pike and at the first roll of the drum, off he goes to the Vendée, to the *armée des Alpes* or the *armée du Nord*.'[1]

This engaging sermon, characteristic in its tone and its total assimilation of political, economic and moral virtues, dates from May 1793, the eve of that *journée* which purged the Convention and gave power to the Jacobins. This was the climax of the Revolution, the year of Robespierre and the great Committees, of Terror and civil war and desperate struggle on the frontiers, the year in which the popular movement of Paris, capturing the Sections, becomes visible – or rather audible. In the tumult which rises from those Sections, it is the voice of the artisan which rings loudest.

Sans-culottisme was a species of morality. Inevitably, it was a concertina word. One is constantly reminded of those stalwart 'sans-culottes', Santerre, hero of the Bastille, who was a wealthy brewer and Duplay, with whom Robespierre lodged, a 'cabinet-maker' who never ate with his men and made 10–12,000 livres

annually from rents. There were certainly men of substance
among the militants of Year II of the Republic (1793–94). One of
them, Mauvage, from northern Paris, employed sixty men in a
factory. At an opposite pole and probably more typical was
Pierre Ducroquet, a celebrated food commissioner of Section
Marat, who lived in misery. When arrested as a *Hébertiste* in 1794,
he was 700 livres in debt and his deathbed letter to his wife
chronicles a desperate struggle for mere decency; they were at
their wits' end to find clothing for an expected child.

For this morality had a firm social anchorage. The heart and
core of *sans-culotterie* was an artisanry of small masters, tradesmen,
compagnons and journeymen; the further one moves from this base,
the more 'honorary' do sans-culottes become. The archetype
recurs constantly in petition, resolution and newspaper. It finds
its embodiment in Hébert's *Père Duchesne*, that brilliant ventrilo-
quist's act, a journal which tried to catch the very rhythms and
intonation of popular speech. It is that of an artisan on the poorer
side of the mean, the independent craftsman or smallest of small
masters – a *pauvre bougre* who gets up at dawn, sweats blood and
tears at his craft to feed his family, puts in a couple of ferociously
uncompromising hours at the Section for the egalitarian
Republic, eats like a horse and must have his bread-bin full, takes
a patriotic glass and enjoys his day in the cabarets of Courteille
and revels in the *grandes colères* and *grandes joies* of the *Père Duchesne*
(particularly the former). At all times he cherishes, with his
brothers, the frugal virtues and fierce *collective* independence of the
craftsman.

The rank and file were generally wage-earners of one kind or
another, but they were small-shop men not factory hands, their
wage was often a 'price' and was related to the cost of living and
traditional standards rather than to labour. Men at some social
distance could respond. Very active in the popular societies were
many *employés*, petty officials often at 1,700 livres a year, men of
some capacity and considerable self-esteem who were poorly paid
and often wretched; there were teachers of humble status. The
work of such men approximated more to a craft than a profession;
they, too, could set a certain sense of their own worth, of a calling,
against a maddening social frustration. The sans-culotte's passion
for instruction, coupled with his ambivalent attitude towards the
literate and the *hommes à talent*, is almost quintessentially artisan.
The *quarante sols* – those poor men who were paid 40 sous for their

attendance at Section assemblies by order of the Convention after September 1793 – encountered hostility, not only from *notables* who looked on all sans-culottes with horror, but from many of the militants themselves. One of those popular societies which were the hard core of sans-culotte resistance, even to Robespierre, demanded compensation for a baker in January 1794 – 'Les petites fortunes acquises par travaux utiles à la société ne sauraient être trop fortement respectées et préservées de toute atteinte.' At the heart of sans-culotte sensibility was the spirit of the artisan.

In the Year II the *comités révolutionnaires* of the Paris Sections were the vanguard of revolutionary action; of these *commissaires* over 450 can be placed. No more than a score lived off their own income, manufacturers and retired tradesmen; there were 22 *employés* and 52 teachers, painters, sculptors and musicians. Wage-earners were only 10% of the total; among them domestic servants numbered 23. Over 60% of these most militant of sans-culottes were craftsmen and shopkeepers. Ten wine-merchants were characteristic figures among the traders, of whom perhaps forty were something more than simple shopkeepers. Over 200 of these men were craftsmen. The most cohesive group were 28 tailors, but there were 42 men from the skilled crafts of the art trade, 37 building artisans and 29 timbermen and furniture-makers; cabinet makers and wigmakers/hairdressers were well to the fore.

Among men who were active in popular societies and assemblies some 500 can be traced. The wage-earners were a more varied group and, counting 40 servants, shop assistants and odd-job men, were twice as strong as on the committees; 45 *employés* were a distinctive group. Once again, however, the artisan and the trader predominate. Ten wine-merchants head the list of some 80 traders, with the grocery trade well represented. Of 214 artisans no fewer than 41 were shoemakers; there were 30 builders, 20 from the furniture trades, 24 hairdressers and 20 tailors, but only 23 from the art and luxury crafts. At the other extreme, the administrative *comités civils* of the Sections, which were less exposed to political gusts, included many more men of substance (over a quarter lived off their own income) though the range of occupations was much the same. In this same period, of 132 councillors of the Commune whose occupations are known, 82 were small manufacturers, craftsmen and traders, while 31 belonged to the professions.

This whole situation, naturally, was the world turned upside down to the conservative wealthy and moderate bourgeoisie[2] of Paris, but the hierarchy is familiar. To a degree, of course, it reflects the structure of Parisian society. Even in the northern districts, where new textile factories could employ from 400 to 800 men and where wage-earners and their families were accounted two-thirds of the population in 1791, concentration was limited. Among traditional crafts in Section du Faubourg-Montmartre in 1793, one carpentry concern employed 31 men, another 14, and seven others between 3 and 7. Of 23 wheelwrights' shops the largest employed 24, three had about a dozen, but two wheelwrights worked alone, two had only one employee, and three only two; many were partners. In 19 joinery concerns and 25 lockmakers the average number of *compagnons* was 5 and 2 respectively, and many men worked alone or with a single colleague.

The most celebrated revolutionary centres were the faubourgs Saint Antoine and Saint Marcel to the east and south-east; Réveillon's factory (350), a glassworks, the Gobelins tapestry and a few other big enterprises were located there, but these were pre-eminently quarters of small crafts, particularly in furnishing and upholstery, with masters, journeymen and shopkeepers living cheek by jowl in the courts, alleys and tenements (graded vertically from ground-floor comfort to attic penury). Wage-earners were little more than a third of this population in 1791, but the destitute were nearly one in three two years later. These wretched people, whose presence can be sensed in the almost permanent crisis over food supplies from 1792 on, were also numerous, up to 1 in 6 or 8 of the population in the densely packed centre, where 180,000 people crowded twelve Sections on the right bank of the Seine, and 70,000 four on the left. Here perhaps half the population were wage-earners, ranging from colourful groups like the fishwives and *forts de la halle* to the anonymous hordes of casual labourers floating in and out of lodging-houses and *chambres garnies*, the porters, carriers and riverside workers, often immigrant like the feared *savoyards*, and the legions of building workers (immigrants here too – *limousins* and others) who were thought to be a third of the total labour force in 1791. Near by was the crowded warren of Gravilliers, with a Section of 25,000 people, teeming with poverty-stricken domestic workers. The artisanry was an élite here. It was only in the north that something like a 'working class' of operatives appeared. Some notable militants

came from their ranks, but as a group these people were far less revolutionary than the men and women of the centre and, particularly, of the big, shabby, eastern suburbs. Faubourg Saint Antoine, in particular, from the Bastille to Prairial 1795, made itself a legend.

'You have not had much experience of revolution,' said a man of Saint Antoine to a youngster on the night of Thermidor, 'and you cannot realise what it means in a commune when they beat the *générale* and ring the tocsin.' Such men are most familiar as revolutionaries of the street. The *journées*, or great popular insurrections, created their own mystique and bequeathed to this and succeeding generations a whole calendar of memorable Days. They were the very motor of the Revolution. Moreover, particularly in 1789, it is difficult to unravel motives. The traditional popular passion over the price of bread, the traditional resort to *taxation populaire*, were as central as more overtly political emotions. The multiple revolutions of 1789 would have been impossible without the fury of people with families to feed.

In 1789, the severe economic crises and the terrible *crise des subsistances* precipitated by the miserable harvests reached their paroxysm at the very point of maximum tension between Court and Third Estate. Labrousse has estimated that an artisan normally spent half his wage on bread; by the summer of 1789 bread prices would have eaten 80% of it. The traditional focus of city 'political' riot had been the *parlement* and it was during the aristocratic revolt of 1787–88 that crowds first surged into action, but during the winter of 1788–89, the conflict resolved itself into a struggle between the feverishly propagandist Third Estate and Privilege. As widespread *taxation* outbreaks caught the political fever, the *pacte de famine* was linked in popular psychology to the aristocratic plot against the Great Hope of the Estates-General; the Réveillon riots in the Faubourg Saint Antoine in April, which had nothing to do with political affairs, were loud with cries of 'Vive le Tiers État!' Political crisis ran through and into everything and Necker's dismissal, with its threat of an imminent military coup, convulsed Paris. In the communal revolt of 14 July perhaps half the population were under arms, as the men of Saint Antoine, in the search for weapons, led Parisians against the Bastille; in that same crisis the *menu peuple* lynched municipal officers and bakers as agents of the aristocratic conspiracy. Similar fears fuelled the incredible, mushrooming Great Fear in the

countryside which brought the régime crashing, as municipal revolutions broke out across the provinces, most decisively in those areas where the *menu peuple* were in arms against starvation and conspiracy. In October another deadlock was decisively broken by the hunger march of women to Versailles to fetch the 'Baker', which again roped in some of the respectable, assumed a communal character and acquired political meaning. Throughout this incredible year 'traditional' crowd actions were drenched in the new rhetoric of revolution and, in effect, ceased to be 'traditional'.

The inevitable argument over 'spontaneity' and 'exploitation', the 'economic' and the 'political', over who 'intervened' in what, is really irrelevant. Some distinctions can be made: one can try to 'place' in the crises Siéyès and the pamphlet war, the Duke of Orleans' agents directing men against specific targets, the tactics of the Patriot party during the march on Versailles, but if lines are drawn too hard, we turn men and women into sentient metaphors or objects responding to stimuli like Pavlov dogs. The *subsistances* actions were not some background or context to less visceral political debate; they became the very stuff of *political* crisis. The essence of this year was the *total* nature of the crisis. The revolution which resulted seemed equally total, in its new Nation and Assembly, its Declaration of Rights and night of 4 August, in the tricolour and the federations. The emigration began at once and even the non-political were at once *penetrated* by a consciousness of total change. People were calling 1789 Year I of Liberty almost immediately. Such a year could not fail to become a myth.

But partly for that very reason, this miraculous year, with its Patriots of '89 and Conquerors of the Bastille, served henceforth as a point of reference, like some secular Incarnation. To sans-culotte militants of Year II (of the Republic, that is; it was, of course, Year V of Liberty) this point of reference was a *point de départ*. The Nation had been proclaimed but it still had to be realised. It was what a man had done after the first year of liberty that counted, and in the questionnaires with which they tested a citizen anxious to join the select fraternity of true republicans the succession of Days rolls out like the *générale* – 14 July, 10 August, 31 May–2 June, 5 September – a veritable apostolic succession in revolution.

By this time, 1793-94, the movement these men led, however primitive and precarious, was recognisably a political 'movement', organised in and operating through popular societies,

Section assemblies, *comités révolutionnaires*; many local leaders had become 'ward politicians' of no mean capacity. Responding to the daily exigencies of revolutionary war, they were consciously trying to realise a blurred but very real *programme* of their own, in some respects quite alien to that of the Committee of Public Safety. Consequently, while from one point of view *sans-culotterie* was simply the marching wing of *Jacobinism*, in terms of very practical politics, it was a semi-independent force. It enjoyed what power it had, of course, only because the Jacobins had seized national power, but that coup itself owed everything to the armed action of sans-culottes. Relations between these unequal partners at the crisis of the Revolution largely decided its course. The essential point is that concentration on the street and the *journée* can deceive. From at least the summer of 1793 onwards, to some extent from the summer of 1792, what we are dealing with is a political *movement*. In the Year II, indeed, to a sans-culotte militant, there was nothing that was *not* politics, even a preference for republican cats over aristocratic dogs.[3] There was a constant reference to first principles, an obsession with sovereignty, equality, 'honorable médiocrité'. After immersion in the records of the Sections of Paris under sans-culotte control, one emerges with a vision of a city taken over by workshop Rousseaus.

It would have taken a clairvoyant or perhaps a Marat to foresee this in 1789. For they appear to have reached this destination by a process of escalation from *journée to journée*. From the turmoil of 1789 emerged a constitutional and would-be liberal monarchy which firmly excluded the *menu peuple* from the political nation. This 'censitary régime' based its electoral system on a hierarchy of wealth and restricted minimal rights of franchise to those 'active' citizens who paid three days' wages in annual taxation. Bourgeois in its reform zeal and genuinely humanitarian, it was totally hostile to any popular political pretensions and reacted to them with nervous ferocity. A central feature of sans-culotte psychology was its permanent anticipation of betrayal and treachery. The fevers of war and civil war were proximate causes, but the source is surely to be found in that conflict which splintered the former Third Estate after the first aristocratic counter-attack had been beaten. At the Champ de Mars on 17 July 1791 the Assembly shot down demonstrators against a defector king who had betrayed its own constitution. It crushed democratic clubs and prints in a repression which drove men like

Danton and Marat into hiding and exile. The symbolism of vengeance which characterised the later execution of Bailly, the mayor who ordered out the National Guard on this occasion, is eloquent on the role of the Champ de Mars 'massacre' in the formation of popular sentiment.

With the massacre the atmosphere of the *journées* returns; henceforth the course of the Revolution is to be punctuated by them.[4] In 1792 the *crise des subsistances* reappeared; from this point on the price of bread and other necessities, dearth, speculation, hoarding, the dislocations of war and inflation and an unprecedented popular mobilisation for the armies were a permanent agony. In the spring of 1792 a wave of scarcity riots, as severe as those of 1789, broke over many areas, particularly the Beauce, while in Paris the depreciation of the paper assignat and colonial disruption produced the first major outbreak of *taxation populaire* since 1775. It was in this crisis, which merged into the patriotic exaltation of war, the rage and panic at the first disasters and betrayals, that men began to voice those demands – for price control, the death penalty for speculators, social revolution and terror – which became so characteristic. Military collapse made faction a matter of life and death and in the bitter crises it was the political *journées*, with sans-culottes as their marching battalions, which were decisive. On 20 June 1792, against a king visibly sabotaging the war effort in defiance of an apparently helpless Assembly and a clutch of Brissotin leaders[5] in a Saint Vitus' dance of indecision, men of the eastern faubourgs led the invasion of the Tuileries to the cry of 'Tremblez, tyrans, voici les sans-culottes!' On 10 August a setpiece insurrection concerted between sans-culottes, provincial *fédérés* and democratic politicians broke the monarchy; in September the prison massacres inaugurated the first Terror. The whole nature of the Revolution changed. Refugees flooded over the border and washed up on British shores as bourgeois revolutionaries struggled, in the teeth of invasion and rebellion, to create a democratic republic, whose image, to Europe, was increasingly 'sans-culotte'.

Through the winter and spring, as conflict between Jacobins and that medley of enemies which the guillotine amalgamated into the *Girondins* drove to the point of civil war, the *crise des subsistances* took another twist. The attention of the *menu peuple* riveted upon it; with every tightening of the screw, every new treachery, their demands ranged wider until they covered the

whole field of military necessity, economic action and social relations. It was the tentative, temporary and reluctant Jacobin 'conversion' to some measures of discipline demanded by spokesmen of the sans-culottes which made possible the *journée* of 31 May–2 June 1793, when a popular insurrection, under Jacobin manipulation, secured the expulsion of Girondins from the Convention. Even so, through that murderous summer, as enemy armies closed in, departments broke away in the 'federalist' revolt, the Vendée burned and patriot heads began to roll, the government committees hesitated, until the subsistence crisis tightened yet again at the very time when people learned that a new set of traitors had sold Toulon to the English. It was the popular demonstration of 4–5 September, escalating into a managed *journée*, which finally made Terror the order of the day and cleared the way for 'Revolutionary Government'.

Moreover, while the men of the *journées* practically all fall under the classification of 'sans-culottes', there were some significant variations. Those which were essentially *taxation* operations were more spontaneous; women, cooks and servants, were far more prominent in them; the wage-earners involved were more often unskilled labourers than craft-journeymen who were more prominent in the political *journées*. Before the summer of 1793 there was little connection, in terms of personnel, between the radicalism of the street and the radicalism of the Section assembly. It was only in the desperate summer of 1792 that 'passive' citizens got into the assemblies in the first place; during most of the summer of 1793 there was a fierce struggle in the Sections, often a physical one, with chairs flying and noses bleeding. It was in this conflict and through it, that the sans-culotte 'machine' was made. After the *journée* of 5 September sans-culottes made a clean sweep in an overturning of the 'natural' order which was to cost many of them dear after Thermidor. The victory of the Jacobin-sans-culotte forces meant the end of the *journées*; they did not return until after Thermidor.

This pattern of evidence suggests a Parisian populace in the main committed to the radical wing of the revolutionary leadership, but quick to respond to crises with 'traditional' action; out of it a conscious minority were evolving into a political group. Many interpreters, therefore, make a clearcut distinction between the 'political' and the 'non-political' – or that useful if somewhat elusive term, the 'sub-political'. A sufficient number of individuals

from those social groups which produced the 'crowds' begin to 'learn' slogans, to pick up ideas, some Rousseau here, some Mably there; master-craftsmen and those perennial philosophers, the wineshop-keepers, are said to 'channel' bourgeois notions to their journeymen or their clients. The process reaches a climax in 1793–94 in the appearance of a political movement among people who, in the politics of earlier régimes, simply did not exist.

To this argument, clearly, the events of 1791 are crucial. If a popular movement was 'educated' into existence, it was presumably at the Cordeliers Club it went to school. One of the two major societies, the Cordeliers during 1790–91 became distinctly more plebeian than the powerful Jacobins; it lowered its subscription to 2 sous a month. Danton, with his instinct for the popular nerve, was already creating his left-bank fief in its vicinity. There were others. Marat's paper was beginning to project its author. *La Bouche de Fer* of Bonneville (Paine's friend) and the *Cercle Social* were committed to popular 'instruction'. The first of the specifically popular societies, the famous *Société Fraternelle des Deux Sexes* began operations in 1790, and after an outcrop of royalist-émigré conspiracies and the sharpening of conflict with the refractory clergy over the Church settlement such societies multiplied and grew muscular. The Cordeliers came to preside over a ring of dependent organisations. By May 1791 the clubs had a central committee, under François Robert, who ran a journal open to popular causes.

In the spring of 1791 those causes multiplied. The growth of unemployment, particularly severe in the luxury trades which were to provide so many militants, filled the Paris public workshops with 30,000 malcontents who waged a kind of guerilla against the city and the bourgeois National Guard. In February a thousand men of Saint Antoine marched against Vincennes prison as a second Bastille. In May and June Bailly and the Assembly forced the closure of the workshops and set off street skirmishes and a vociferous press campaign. About the same time, spurred on by the first serious inflation, many of the crafts pressed demands in one of the few serious wage movements of the Revolution. Carpenters were followed by hatters, typographers, locksmiths, joiners and others until by early June, master-farriers were shouting about a *coalition* of 80,000 workers and good bourgeois were calling for cannon to teach the *canaille* a lesson. It

was in this climate that the abolition of the old corporations went into effect and the Assembly passed that *Loi le Chapelier*, banning associations and strikes, which no revolutionary politician, not the fiercest Montagnard, ever challenged.

The Cordeliers and their allies moved into this conflict. The democrats' support for journeymen and the unemployed was political and sentimental. Robert rejected the very notion of a minimum wage and no one opposed the *Loi le Chapelier* save Marat, and he solely on political grounds. He was also the only one uneasy over the abolition of the guilds, advocating legislation to safeguard the threatened interests of apprentices and journeymen. He opened his paper to wage-earners, printed a building-workers' manifesto. Robert, too, though he opposed the carpenters' theory, backed their practice. Their *union fraternelle* was an affiliate of the clubs' central committee. Another Cordeliers affiliate, the *Point Central des Arts et Métiers*, sponsored a petition on behalf of the unemployed, while Desmoulins presented another which he said had the support of Robespierre.

Through days of increasing tension arrests multiplied and news of the king's flight to Varennes, which bankrupted the constitution, carried the crisis to its climax. The Cordelier campaign for a revision of the constitution split the Jacobins and stung conservatives into a violent reaction. The democrats were able to secure a 'petition of 30,000' which Saint Antoine supported in full strength, and after the Assembly's decision to renew confidence in Louis over 50,000 people went to the Champ de Mars. Of some 6,000 who had signed the petition before the National Guard opened fire, many were obviously poor and barely literate. The central Sections were there in force, and while Saint Antoine was not very prominent, it was now that Saint Marcel really began its revolutionary career; names which were to loom large in Year II – Hébert, Chaumette – appeared. Of some 250 arrests made in the course of this summer practically all were of men and women who would be calling themselves sans-culottes within a year. In the reaction which followed, the constitutional monarchists, the *Feuillants*, not only suppressed papers and personalities but further restricted the franchise and explicitly excluded 'passive' citizens from the National Guard. In the autumn with the convening of the Legislative Assembly, there was a visible reaction against this attempt to halt and turn back the Revolution. A new left of Brissotins began to make the running, the Jacobins revived and,

recovering their national strength, opened their sessions to the public and admitted passive citizens to membership.

The year 1791, then, fits neatly into a scheme of explanation which links the 'spontaneous' upheavals of 1789 with the 'movement' of 1793. One can see a certain *trajectory* in the history of the sans-culottes. Popular protest and resistance, taking traditional and 'sub-political' form, is trained and given direction by bourgeois leadership until an 'active minority' of the conscious, a political movement, takes shape as a junior partner of the revolutionary government. Once deprived of bourgeois leadership by the elimination of the Robespierrists at Thermidor, the movement reverts to the incoherent spasms of Germinal and Prairial in 1795.

The thesis is plausible; indeed it is difficult to find any alternative. But some of the arguments used seem to have little connection with the world of living men. The role of 'ideas' (generally treated as a species of free-floating bacteria) in such movements – or any movement – is, to employ a defensive understatement, ambiguous; historians are reduced to words like 'osmosis'. Among the militants of Year II, not for a moment can one escape Rousseau; their ideas of sovereignty, morality, education, property, seem pure Jean-Jacques. Naturally, one looks for 'influences' and 'channels'.

It is clear that many of the militants who exercised local power in Year II were almost or quite illiterate; this was certainly true of many localities in the provinces, Bourg and the Allier, Moulins, Rennes; at Pont Audemer in Normandy a justice of the peace could read only with difficulty and the inferiority complex of sans-culottes in face of the *hommes à talent* was a political factor in such districts.[6] In Paris, historians find a low level of 'active' literacy among the rank and file, though practically every militant was at least technically literate. In the early *journées* some two-thirds of the participants (at least those of them who were arrested) seem to have been literate in this sense, a proportion which rose to 80%, perhaps significantly, at the Champ de Mars. Of direct reference to Rousseau in such circles there is little; those quoted tend to be people like the actress-*enragée* Claire Lacombe, rather than the *pauvres bougres* themselves.

On the other hand Mercier and other writers testify to reading habits among the common people. The fact that Hébert and some pamphleteers should write in a popular style speaks for itself. 'Dame! j'savons lire, j'espère', says a *poissarde* to a *fort de la halle* in

one sheet; Constance Evrard, a cook arrested in 1791, read Marat, Desmoulins and other journalists. The *colporteurs*, itinerant booksellers, were clearly men of significance. Their saints' lives disappeared, but dream-books, fortune-telling manuals and Gothic novels remained popular. Racine, *Les Liaisons Dangéreuses* and *Tom Jones* were being hawked around Section de la Montagne by one Buy in January 1794. A major 'channel' for doctrines was the almanach – a sort of *Reader's Digest* Enlightenment; Collot d'Herbois, the future terrorist of the Committee of Public Safety, brought out his famous *Almanach du Père Gérard* in 1792; songbooks were also effective. Jostling Rousseau and other *lumières* in these boxes, however, were volumes of *civilités*, books on manners, sometimes echoes of Émile, but just as often highly practical guides to the social frontier – 'Mouche, tousse, crache sans affecter de faire de bruit. . . . Mets le moins possible le doigt en dedans de ton nez . . .' From the *colporteurs* a sans-culotte would get as much of Franklin's *Poor Richard* as Jean-Jacques (not that the two are incompatible, quite the contrary).

What must strike one about manifestations of *philosophe* influence is how *late* they were. Rousseau's publication history is itself interesting. After the initial publication of the *Du Contrat Social* in 1762–63, there was only one new edition before 1789; there were then no fewer than 32 in the next ten years, including a proliferation of pocket editions from 1792. One is tempted to think that it was the Revolution which 'made' Rousseau! Of course there was always oral transmission. Marat and Desmoulins are said to have read Rousseau to the people.[7] Varlet, the *enragé*, trundled a portable tribune through the streets; one Collignon called himself 'lecteur publique des sans-culottes'. Newspapers were read to groups. Most effective of all were the popular societies. Here, in regularity and some ceremony, drenched in the visual symbolism of the Revolution, people were truly *instructed*; decrees, letters, journals were read and debated; children and wholesome young maidens would recite moral and political lessons or pipe the Declaration of Rights; there was song, ritual, a certain religiosity.

These practices, however, operated in a context which was *already* revolutionary, whose character had been fixed by the apparently total breakdown of 1789. And for all the 'channelling through' and 'filtering down', for all the credulity with which sans-culottes accepted the word of men they trusted, there was a

certain natural selection of ideas. No one could have been more idolised than Marat, but his demands for a dictatorship fell like lead balloons. In fact, their political ideas seem to have formed largely in response to the pressures of actuality. Their reception of Rousseau was very like British artisans' reception of Paine – it was a 'shock of recognition'. Rousseau himself came from an artisan family whose style marked them off a little from the 'people'. Experience of artisan movements leads one to wonder (since, given the right circumstances, even English and American artisans could talk 'pure Jean-Jacques')[8] how much of Rousseau's politics was simply the systematisation (to use the word loosely) of artisan attitudes. Sans-culottes responded to immediacy with immediacy, but they were acting in a psychological climate which had been transformed by 1789 and its consequences. Familiar with certain modes of action and accustomed to certain traditions, they were now also members of a new nation, grounded theoretically in popular sovereignty. Responding to the daily experience of war and revolution, they acted like themselves and talked like Rousseau.

Central to their experience, as it had to be, was the war. No one familiar with the records of sans-culotte Sections will question any longer whether *nationalism* was the distinctive legacy of the Revolution. In the early months of 1794 people even 'below' sans-culottes, women and young boys, were earnestly discussing in the assemblies the collection of saltpetre for the war factories (presented with Stakhanovite emulation to the Convention), the arming of a *cavalier jacobin*, whether Citizen X did or did not deserve a *certificat de civisme* – one can actually *see* people emerge from a political non-existence to *take possession of* their nationality. It was the war which did it, for granted eighteenth-century conditions, this was the first 'total war'. War identified patriotism with the Revolution. There were severely practical reasons. With the outbreak of war against Austria and Prussia in April 1792, French regular forces, except for some key units like the engineers, the artillery, the sergeants' corps, crumbled, partly from demoralisation, mainly from treason. Emigration cut a swathe through officer ranks; there were a whole series of spectacular sellouts on the field of battle itself. The volunteers who rushed in draft after draft to plug the gap were overwhelmingly 'sans-culotte' from 1791 on; by 1793 the *levée en masse* was calling half a million men to the colours. Even after Thermidor had turned civilian politics

sour and meaningless, the armies remained for a long time strongholds of the revolutionary spirit. To defeated English artisans Napoleon's ragged but brilliant Army of Italy looked like a sans-culotte *armée révolutionnaire*. How could the saviours of the Republic be denied political existence? The war, with its endless succession of betrayals, 'unmasked' their enemies and demanded their immediate extermination. There was a blood debt which could not be repaid except by Terror. By 1794 economic dislocation and dearth had imposed on France a war economy which systematised sans-culotte *taxation* instincts. The new *nation* created itself, disciplined itself and triumphed in an atmosphere of class war.

The very 'point of entry' for sans-culottes was the first war crisis.[9] The decisive 'constitutional' instrument was the proclamation, on 11 July 1792, of *La Patrie en Danger*; this, calling on every Frenchman to fight in the last ditch, suspended the Feuillant constitution. In these circumstances of mortal peril, how could you give a man a pike and not give him a vote? King and Brissotins had engineered the war to resolve the political deadlock. The prompt and treasonable collapse of the French front left the latter exposed. King and queen, in touch with the invaders and the émigrés, encouraged by royalist plots in the provinces, kept regular forces near the capital, mobilised the considerable Feuillant and mercenary strength at their disposal in Paris and waited the right moment for a coup. Brissotins, galvanised by desperation, whipping up popular patriotism, denouncing the Court and its 'Austrian committee', sent out their famous call for provincial *fédérés* – the men who knew how to die – to march to a camp of 20,000 near threatened Paris. The Court responded with a dismissal of Girondin ministers and a veto on vital war measures. It was July 1789 all over again with German 'bears' lumbering over the frontier as well. With more and more of their patriotic blood being demanded by Girondin recruiters flourishing the *bonnet rouge* of the freed slave, the *menu peuple* burst angrily and desperately upon politics.

'Nous leur livrâmes l'État et ils en profitèrent pour éteindre . . . le flambeau de l'égalité. C'est alors qu'on les vit adopter l'uniforme, inventer le titre de citoyens actifs . . . Ayant perdu par là la confiance du peuple, ils se reconcilièrent avec leurs anciens tyrans. . . .' In the angry petitions of 25 June from Sections des Gobelins and des Quinze-Vingts in the two eastern suburbs,

directed against the treacherous men of '89, the collective
mentality of the sans-culotte revolution was already a reality.
Their enemies were coming into the open. Immediately after the
decree summoning the *fédérés* on 8 June, the royalist staff of the
National Guard had literally drummed up a *Petition of 8,000*
against it. The Guard, still organised in its original 60 battalions,
escaped from the control of the more recently created 48 Sections
and cherished some socially exclusive élite units. With the Depart-
ment of Paris and many of the long-seated councillors of the
Commune, they were conservative. Military and para-military
forces were mobilising around the Tuileries, and on 13 June
Louis dismissed the Brissotin ministers. Girondin journalists like
Louvet, influential in Section des Lombards, fanned the real fears
of a second Champ de Mars massacre.

The Parisian elections of 1791–92, in reaction against that
killing, had installed the popular Pétion as mayor, with Danton
himself as deputy *procureur*; their police agents penetrated the
Tuileries. But the initiative in the counter-attack came from below
– from the Gobelins Section of the Faubourg Saint Marcel,
where men like Guillaume Bouland, in Year II an *exalté* very hot
against merchant 'egoists', took the lead. They tried to organise a
demonstration on the anniversary of the Tennis Court Oath in the
teeth of opposition from the Department and with the dithering con-
sent of Pétion. On 20 June the 'infected' Guard of the two faubourgs,
with a crowd of men carrying pikes, of women and children,
marched to the Assembly and then broke into the Tuileries, where
they cornered Louis, plonked a *bonnet rouge* on his head and
demanded withdrawal of his vetoes.

Reaction was swift. A police committee at the Tuileries by-
passed the Assembly and hunted men like Bouland, using the
National Guard. They secured the suspension of Pétion, whose
continuous speechmaking on 20 June was widely believed to have
averted a second Champ de Mars. An effective propaganda
campaign drenched Paris and the departments. Lafayette,
leaving his army in face of the enemy, made a whirlwind visit to
Paris to call for a coup against the democrats. *Notaires* were
mobilised and a *Petition of 20,000* got up against the demon-
stration. These two petitions, of 8,000 and 20,000, were to be the
identification cards of their worst enemies to sans-culotte mili-
tants of Year II.

For in the two faubourgs there was tumult. Section assemblies

were crowded with people 'sans distinction d'age, de sexe et de section'; the *menu peuple* there, according to the police, considered themselves 'le peuple, populus, ce que nous appelons universalité de citoyens'. 'Passive citizens' disappeared as the mobilised sans-culottes (defiantly adopting the jeer as a title) established their moral hegemony and tried to extend it over Paris. Section Mauconseil tried to abolish the uniform of the National Guard and merge it into the armed people. The arrival of the *fédérés* was decisive. In an atmosphere of patriotic-revolutionary exaltation which one can still catch in *Marseillaise* and *Carmagnole* these formidable men, infinitely more radical than their Girondin sponsors, began to 'contaminate' the National Guard. The air was loud with collective oaths to 'vivre libre ou mourir'. This molecular process was the most decisive of all; it is practically 'invisible' and would require the revolutionary-historical genius of a Trotsky to recapture it,[10] but when at the end of July two Sections formally abolished the distinction between active and passive citizens, and were acknowledged by the Assembly, it was merely the 'phonetic shadow' of a deed which had already been done in the streets and in men's hearts.

Equally crucial was the desperate Assembly's decree, on 11 July, of *La Patrie en Danger*. At the prompting of the Commune's radical group they dramatised it. Platforms were erected in the streets for public recruitment; the effect was electric. Between 12 and 22 July some 350 volunteers had come forward. Within three days of the new publicity's going into effect 4,500 men had volunteered in four centres alone. In scenes of mass enthusiasm women offered themselves for the armies and 15,000 men were raised. The logical consequences of the decree followed inexorably. All administrative bodies were declared *en permanence*; they had already been opened to the public – *publicité* was a shield against the fifth column. The Sections sprang into life. Attendances shot up as sans-culotte militants and 'passives' moved in to take control – often in the evening, when the weary 'respectables' had trailed home. Many assemblies were plunged into that confused, frenetic activity which was to be so characteristic of Year II, in resolution, annulment, reaffirmation. Decree after decree flowed from 'regenerated' Sections, with the Assembly trailing patriotically behind. On 25 July, as the men of Brest marched in (Gobelins changed its name to Finistère in their honour), Section du Palais-Royal ordered the manufacture of pikes for men without firearms;

the Assembly opened the National Guard to all citizens and on 3 August specifically offered rights of active citizenship to all men who joined the war. The most powerful thrust came from Théâtre-Français, home of Danton and the Cordeliers. On 30 July, as the men of Marseilles came in singing with the cannon they had man-handled across France, the Section withdrew its armed force from the control of the National Guard staff and, in a declaration signed by Danton, Chaumette and Momoro, asserted that 'après que la patrie a été déclarée en danger par les representans du peuple, le peuple se trouve tout naturellement ressaisi de l'exercice de la souverain surveillance'; it proclaimed manhood suffrage. Two days later Croix-Rouge publicly purged itself of the odious shame of having been accomplice to the crime of 'lèse-égalité social' and abolished passive citizenship. Section after Section followed suit, some 'provisionally'; the Assembly bowed.

It was the Girondins, in their intellectual dervish-dance, who precipitated the final crisis. On 15 July the Assembly had prised regular troops from the Court and ordered them to the front. The royal position deteriorated and ministers resigned. The Depart-ment of Paris disappeared in a shower of resignations as Pétion was reinstated. Fiery Brissotin patriots thought the game won. They opened negotiations with the Court and from 26 July tried urgently to stop the oncoming insurrection. Within a few days news of the Brunswick manifesto, the enemy threat to raze Paris, reached the city. The moral shock was total. To men who felt in their bones that *hommes à talent* were not to be trusted the Brissotins became the worst traitors of all; there was a violent revulsion against them, which Robespierre and his friends hastened to exploit. *Fédérés*, almost since their arrival, had been enmeshed with Robespierre, with the Cordeliers, the men of the Gobelins and the Théâtre-Français. The Incorruptible, shining all the more brightly as energumens of the Revolution wrote their little notes to the Tuileries, urged the people to settle with the king first. How could they move out and leave wives and children at the mercy of another Lafayette and Champ de Mars? The men from the departments were the first to demand the deposition of Louis. From the end of July there was a rapid polarisation. 'Minorités agissantes' of sans-culotte militants, riding the tide of opinion, backed by regenerated battalions of the National Guard and the armed representatives of provincial France, guided by bourgeois democrats, began to carry much of Paris with them.

Men who were to be *modérés* within weeks were under arms on 10 August. A *bureau de correspondance* was set up in the first days of August; assemblies of delegates grew into a revolutionary Commune alongside the legal municipality and after a couple of false starts no fewer than 47 Sections answered the call of Fontaine-de-Grenelle to prepare addresses to the Nation and the Army. A formal ultimatum to a paralysed Assembly preceded the insurrection of 10 August. Fighting was fierce. Hundreds of men died, again in an atmosphere of treachery. Swiss, sans-culottes and *fédérés* displayed their remarkable 'feudal' 'revolutionary' and 'patriotic' heroism. The sans-culottes' mouths were full of blood, their own and their enemies', when the monarchy died and a Convention elected by manhood suffrage was summoned.

The war crisis worsened daily. The by-passed Girondins were inflamed. The revolutionary Commune, with Robespierre, but not yet 'sans-culotte', acted like a sovereign authority. Widespread security measures and popular demands for payment of the blood debt (300 Parisians alone had been killed) generated a civil-war atmosphere. By the end of the month the enemy were at traitor-ridden Verdun. The Assembly proclaimed them at the gates. The tocsin rang. Danton thundered out his tremendous speeches and something like 20,000 volunteers, in dramatic scenes, were leaving for the front. The maddened, frustrated fear of the fifth column came to focus on a prison plot (not in itself implausible) among arrested suspects. In the early days of September groups of men moved from prison to prison, butchering the inmates. Some trusted men managed to get kangaroo courts going, which saved perhaps half the prisoners, but around 1,200 people were killed.[11] A quarter of the victims were political; there were many priests, prostitutes and young delinquents. The killers themselves were few in number, but their bloody business attracted sadists, and alongside tearful and hysterical 'acquittals' there were ghastly scenes of mutilation and atrocity. The *menu peuple* applauded the massacres without the slightest hesitation, and indeed seem never to have regretted them. Their attitude to the legality of killing was one some cultivated minds find hard to understand. It is perfectly evident that they equated, simply and directly, killings like this with the killing of their own men at the front by treason and at the Tuileries by mercenaries. The Commune was clearly in at least some collusion. Marat and Fabre d'Églantine actively encouraged the massacres and urged the remedy on the provinces.

Very many patriots at the time, far removed from sans-culotte mentalities, accepted them as necessary. But the Brissotins (the arrest of whose leaders was attempted at the peak of the killing) were now deadly enemies and an equally murderous fear of the people of Paris gripped whole regions and classes. These massacres, which more than anything else repelled romantic and respectable sympathisers abroad, particularly in England, were accepted by sans-culottes as a form of public hygiene; some men demanded compensation for pay lost on public business between 2 and 7 September. They were confirmed in their attitude when the assembly of the Convention of the Sovereign People was followed by the victory of Valmy and the salvation of France. It was in blood, terror and total war that democracy and democrats entered European history.

CHAPTER THREE
Terroristes

Buveurs de sang their enemies called them, after September and the Terror of 1793–94. Some were affronted, but most sans-culottes were unmoved, for their political temperament was naturally violent. The Barbot sisters, haberdashers in Gravilliers, who wanted a guillotine on every street-corner, so that aristocrats, moderates and merchants could be brought to swift justice, were typical. Anger, frustration, hunger, sometimes alcohol, above all fear, generated a rhetoric drenched in blood. It was often directly related to the harsher realities. 'Sous le règne de Robespierre,' said the carpenter Richer in 1795, 'le sang coulait et on ne manquait pas de pain.' Many of the men of the *armées révolutionnaires* – the Durruti columns of this revolution – had sons at the front.

Much of this violence was verbal, a revolutionary *style*;[1] even in the *armées* moustaches were generally more fierce than actions. There were sadists among them, as among their enemies. We hear of hideous faces sprung from God knows where. Arbulot, a cloth shearer of the Gardes-Françaises, was a very dangerous husband and neighbour who took great pleasure in the September Massacres. Far more common were men like Joseph Morlot, a house-painter of Faubourg du Nord, said by his *comité civil* to have two natures, normally kind, gentle and honest, but, stirred by momentary dangers, capable of evil. Certainly the guillotine passed into popular parlance under many loving nicknames – though militants preferred those with a message – the people's axe, the scythe of equality. Beyond the endless sanguinary talk was an unquestioning acceptance of execution and massacre as the only effective remedies. 'Y a-t-il guillotine aujourd'hui? disait un élégant petit modéré', ran a police report of April 1794. 'Oui, lui répliqua un franc patriote, car il y a toujours trahison.'

Treason was as permanent as the Sections. The essence of sans-culotte political action was what Lefebvre called, somewhat clinically, its *punitive will*. We must be one nation, not two in opposition, said the popular society of Dijon – so, the death penalty, without exception, for everyone known to be an

aristocrat. But who were these omnipresent aristocrats? There were the obvious enemies – nobles, refractory priests, constitutional monarchists; after the crisis of August 1792 the signatories of the Petitions of 8,000 and 20,000. But with every new twist of the conflict against the Girondins, every economic crisis, every new betrayal, the list grew longer. *Accapareurs*, those who speculated in the people's corn and the people's currency, rentiers, the *oisifs* who lived off unearned income, were the very devils behind the *crise des subsistances*: Dussautoy of Section des Lombards was arrested in Year II because he was indifferent to the Revolution and because he was a grocer. In that year, the real enemy seemed to be *l'aristocratie bourgeoise*. Were these *égoistes* to seize the corrupt inheritance of the two Orders which had been destroyed?

Guerre aux possédants, then – but not *all* possédants. Potin, stationer and *commissaire de police* of Section du Contrat Social, wanted to apply the *loi agraire* (division and redistribution of property, advocacy of which was a capital offence) but only to persons with an income over 4–5,000 livres a year. Property based on personal labour was the key; *exploitation*, vaguely comprehended as an *immorality*, was the enemy. But there were so many merchants, so many egoists betraying the Revolution consciously or in their *insouciance*. Lyons, in particular, very capital of the *aristocratie mercantile*, second city of France, which in 1793 'fought against liberty' was detested. 'Lyons n'est plus', proclaimed the Convention after the civil war and from the phoenix *Ville Affranchie* its conquering Commission issued that *Instruction* in November 1793 which is a classic of sans-culotte doctrine, which shaped the opinions and prejudices of republican artisans and shopkeepers into something like a social theory:

'L'aristocratie bourgeoise . . . eût produit bientôt l'aristocratie financiere: celle-cieûtengendré l'aristocratie nobiliaire, car l'homme riche ne tarde pas à se regarder comme étant d'une pâte différente des autres hommes: d'usurpation en usurpation, on en seroit venu au point que l'on eût regardé comme nécessaire de les consacrer par quelques institutions nouvelles: voilà le clergé et ses dogmes réssuscités . . .'

And on to the restoration of the monarchy and all the other 'monstruosités inhumaines' of the unequal society. Vigilance, then, is the citizen's duty and permanent revolution, in heart and mind and public act. . . .

'Tant qu'il y aura un être malheureux sur la terre, il y aura encore des pas à faire dans la carriere de la liberté . . .'

It is no accident that this remarkable proclamation, perhaps
the most moving and the most terrifying document to emerge from
the entire Revolution, was made in the broken capital of the
federalist revolt. The enmity of the Girondins had been sealed by
the September Massacres. Their furious attacks on Paris in the
winter of 1792–93, their struggle against the Jacobin 'Mountain'
in the Convention, their obstruction of the king's execution, their
association with the traitor general Dumouriez, damned them out-
right and damned with them the moderates, the prudent and the
wealthy who feared for property. The intensifying *crise des
subsistances* widened the gap. The paper currency, the assignat,
dropped to 36% of its face value in June 1793, to 29% in Sep-
tember. The prices of 'secondary necessities' – firewood, candles,
soap, sugar – rocketed. In Paris bread was held to 3 sous a pound
by a subsidy of 120,000 livres a day, but it was 5 sous in Lyons in
the summer of 1792 – with 30,000 silk workers unemployed. In
the spiralling decentralisation characteristic of the Revolution
before the autumn of 1793, competing authorities fought for
supplies, set maxima, ordered requisitions from a suspicious
farming community. The cost of living outstripped wages, there
were sudden shortages; worse still, sudden panic fears of
shortage. Into this poisonous atmosphere burst the crisis of
April–May 1793 – England's entry into the war and savage
food blockade, military defeat in Belgium, the murderous
Vendée rebellion of 'royalist' peasants, a levy of 300,000 men,
Dumouriez's defection to the enemy and the emergency
measures rushed through the Convention – *représentants en
mission, comités de surveillance*, a Committee of Public Safety.
Montagnard deputies on mission in the spring of 1793 ran into
a civil war.

The popular demands were for the *cours forcé* – legislation to
make the paper currency the only legal tender, price controls
over grain and other necessities, redistributive taxation on the
rich to support the armies and feed the poor – the comfortably-off
recoiled sharply. Both Jacobins and Girondins, committed to
liberal doctrines, had rejected popular demands during the food
troubles of November 1792, but to save their revolution many
Jacobins were ready to compromise. Perhaps because they were
more markedly a minority, Jacobins and sans-culottes in provin-
cial cities rapidly closed ranks.[2] Already in 1792 crowds in Lyons
had set up a guillotine, imposed a *maximum* and 'revolutionary'

taxes. Moderates had regained power, but in the spring of 1793 Montagnards on mission ousted them and installed Chalier, who preached a programme which in Paris would have been called *enragé*. On 19 April the Montpellier Club engineered a decree through the Department of the Hérault which ordered the creation of an *armée révolutionnaire*, a militia of ideologically pure militants, paid to ensure trustworthy social recruitment and supported by taxes on the rich, which was to ensure grain supplies and crush counter-revolution. Montagnards pressed it on the clubs in the cities. But the revulsion against the conscription of 300,000 men gave moderates their opportunity. In a series of coups organised through the local Sections, Jacobins and Montagnards were ousted from Caen, Bordeaux, Marseilles, a little later from Toulon. In Lyons Chalier formed a committee of public safety to levy 6,000 men and 6 million livres, shut down the Girondin press and tried to exclude moderates from the franchise. At the end of May he summoned the local Sections to form the *armée*. Moderates, with royalist support, swept the Sections, and after fierce fighting in which many were killed, overthrew the Jacobins. After the Jacobin counter-coup of 2 June in the capital, this 'Sectional' movement snowballed into the widespread but short-lived 'federalist' revolt and the secession of Lyons and Toulon to the Counter-Revolution.

In Paris (whose actions carried most of the localities) the situation was more complex. The social issue was raised early, before the military crisis broke and threatened to create a new force, independent of Jacobins and Girondins alike. In January 1793 the warring factions in the Convention were suddenly confronted with a petition from the Sections demanding the *cours forcé*. Rebuffed, the *sectionnaires* returned within a month. Scorned again, they reappeared on 12 February, to demand price-control for grain. This time the deputies exploded in anger. Marat in particular was venomous. He called for the arrest of the petitioners as subversives. To the alarmed Montagnards this was a dangerously anarchic movement, concerted by a loosely-knit group of agitators they denounced as *enragés*.

Most obnoxious to Jacobins and most remote from Montagnard mentality was Jacques Roux, the slum priest of the teeming and thoroughly sans-culotte Section of Gravilliers, whose men were more plebeian than those of Saint Antoine. His mission work, his charity, his passionate commitment to the poor had won him a

following. Preaching political terrorism and social welfare, he was cold to the new liberal doctrines, cherished an older 'moral economy'. In the context of the egalitarian republic of 10 August his programme implied a social revolution more radical than any yet proposed. 'Ce n'est pas assez d'avoir déclaré que nous sommes républicains français,' said the February petitioners; 'il faut encore que le peuple soit heureux.' Roux demanded the death penalty for speculation and usury – 'l'agiotage dévore la terre de l'égalité' – and through the summer, in Sections, societies, Cordeliers, his *Publiciste*, he fought a violent campaign, switching from objective to objective as events dictated.

Independently of Roux the journalist Jean Leclerc preached a similar doctrine. Property was a trust, the land belonged to the nation; he was to propose the nationalisation of the trade in necessities. Close to Leclerc was the actress Claire Lacombe with her female society the *Républicaines-Révolutionnaires*. Lacombe's disconcerting women in the summer of 1793 were in the thick of it, much occupied with symbolism and sensibility, the Marat cult, the *bonnet rouge*, which they tried to thrust on affronted market women. Slightly less obnoxious (possibly because he did not run a journal) was Jean Varlet, a postal official with private means whose income totalled 5,800 livres a year. He had been politically active in 1792 and was to be one of the major organisers of the *journée* of 31 May. A passionate egalitarian, committed to the peculiarly sans-culotte doctrine of the absolute sovereignty of the Section, he drew great crowds to his portable tribune outside the Tuileries. In the summer of 1793 he drafted a *Déclaration solennelle des droits de l'homme dans l'état social* which demanded the eradication of the enormous inequalities which corrupted the Republic, and urged that 'les biens amassés aux dépens de la fortune publique par le vol, l'agiotage, le monopole, l'accaparement deviennent des propriétés nationales.'

At base, these *enragés* had the same ambivalent attitude towards property as the sans-culottes and, indeed, many Jacobins. Roux himself was quick to point out that, when he denounced monopolists and speculators, he was 'bien éloigné de comprendre dans cette classe infâme un grand nombre d'épiciers et de marchands qui se sont rendus recommandables par leur civisme et leur humanité'. The enemy was not property itself, but *les gros*; the line of demarcation was a moral one, where quantity literally became quality. The 'contradiction' is evident, but one can make

too much of it. Once property ceased to be an absolute, much might happen.

These men were dangerous because they expressed the deepest egalitarian instincts of sans-culottes. Basic was the *droit à l'existence*; the people and their armies must be fed, whatever the cost. This led them to the concept of property, at least in the necessities, as a trust not an absolute right. Deeper still was a vital thrust for a real equality in daily life. The legal equality, the equality of opportunity of the Jacobin, was not enough. To it they opposed *l'égalité des jouissances*. The Commune, in the autumn, ordered that only one kind of bread would be made in future, for rich and poor alike – *le pain d'égalité*. A man with two plates, said someone in the Contrat-Social, to loud applause, must give one to the man who has none at all. This almost medieval notion of distributive justice runs through their every thought and action – even the *levée en masse*, in which the sons of the rich were to march to war as well as the eternal sans-culotte (and the *authorities*, of course, to march in the van). If the corollary of all this were not the *loi agraire*, it was something sufficiently like it to scare the *possédants*. 'La liberté n'est qu'un vain fantôme quand une classe d'hommes peut affamer l'autre impunément. L'égalité n'est qu'un vain fantôme quand le riche, par le monopole, exerce le droit de vie et de mort sur son semblable,' said Roux. The sans-culottes who had gone to defeated Lyons had their answer – 'Tout homme qui a au-delà de ses besoins, ne peut pas user, il ne peut qu'abuser; ainsi, en lui laissant ce que lui est strictement nécessaire, tout le reste appartient à la République et à ses membres infortunés.'

The influence of these men overlapped that of orthodox supporters of the Mountain in all the citadels of popular power. Although the radical deputy Léonard Bourdon challenged Roux's position in Gravilliers, he was strongly entrenched there, as was Varlet in the Droits de l'Homme. Both had some influence in the Commune, though Roux's seat was disputed. Both, with Leclerc, were probably most at home in the Cordeliers and Roux's command over the remaining *fédérés* implied an alarming deflection of the spirit of the 10 August, at least to good Jacobins. Most alarmed were those in Commune and Convention considered closest to the *menu peuple*. Hébert saw his *Père Duchesne* undercut and Marat reacted even more sharply. The largely unpolitical populace was quick to hero-worship – Pétion, Danton, even Mirabeau in his day. In Marat they found a legendary defender. Over and above

any political nostrum, he seemed to 'care'. His sincerity, his genuine compassion for the poor, above all his *straightforward* violence (so unlike Hébert's) made him in truth *L'Ami du Peuple*. But it was his raging, tearing campaign against black-marketeers and profiteers which really established him – and this was, in good measure, a reaction to the *enragés*. For all his ferocity and all his independence, Marat's social policy was as empty as the Mountain's. His solution to the crisis was an appeal to philanthropists to import necessities and undercut shop prices. Being Marat, however, he also suggested stringing up a few hoarders at their shop door, 'pour encourager les autres.'

The very day this *boutade* appeared, 25 February, the city was convulsed by *taxation* raids which, beginning at the big wholesalers in Roux's Gravilliers, spread over the city with whirlwind speed and remarkable uniformity. On the eve of the outbreak deputations of women to the Convention had demanded the *cours forcé* and death for speculators, pointedly reminding legislators that they had just voted the levy of 300,000 men. Despite thunders from Robespierre and the Jacobins, Club and Commune were heckled from their own galleries and the National Guard was reluctant to act. That Roux was responsible cannot be proved; that his propaganda inspired the action can scarcely be doubted. This demonstration of power was followed by another. On 9 March, when news of the military collapse in Belgium came through, Varlet impetuously tried an insurrection against the Girondins. With some support in the Cordeliers and a couple of Sections, his followers destroyed Brissotin printing presses and swirled around Convention and Jacobin Club demanding the arrest of Girondin deputies. Commune and Faubourgs would not move. The limits of *enragé* effectiveness were clear. Without Montagnard backing they could not hope to carry through a political *journée*, but their moral hegemony over Section militants seemed complete.

The crisis of the Revolution drove both groups into uneasy alliance. By April Robespierre was convinced that only the 'immense peuple des sans-culottes' could save the Republic; he preached the *armée révolutionnaire*. On 20 April, when the Commune announced itself in a state of 'insurrection' until food supplies were assured, cheering Montagnard deputies swore to stand with it. On the 11th the *cours forcé* was won, and on 4 May, after a massive demonstration by the men of Saint Antoine, the

first, largely ineffective, *maximum des grains* passed. As if in response, sans-culotte militants began to demand a purge of the Convention. The levy of men for the Vendée, however, the Commune's adoption of the Herault plan and Chaumette's assurance that, this time, sans-culottes would be spared, gave the moderates a chance to organize a sectional movement along the lines of the provincial coups. In the first half of May the struggle came to a focus in the Sections.

The 48 Sections of Paris, originally created as electoral units under the municipal law of 1790, were transformed by the revolution of 10 August. Their assemblies, sitting in permanence and exercising manhood suffrage, controlled the life of the Sections, their police administrations, *juges de paix* and those *comités civils* whose number and functions multiplied as public control expanded – over welfare, poor relief, price control, food supply, war production. The National Guard became a section organisation. The Section controlled its own battalion, with its cherished battery of small cannon, maintained close liaison with the volunteers at the front. More dramatic still, on 21 March 1793, it was empowered to elect *comités révolutionnaires* to exercise revolutionary vigilance. This decree had actually been anticipated in the spring as in the previous summer but, under the new law, even more after the sweeping Law of Suspects of 17 September, these *comités* with their terrifying powers and their control over *certificats de civisme* – denial of which meant civic death – became the very spear-point of the Revolution. In March the most militant and often the more plebeian of the sans-culottes had been elected to them, and their control was a vital issue in the relationship between the popular movement and the revolutionary government. In the passionate anarchy of 1793, however, the Sections emerged virtually as sovereign powers.

Nothing was more congenial to the temperament of the sans-culotte militant, for he was by instinct a direct democrat. Representative government was a species of continuous betrayal; deputies should be *mandataires* not *représentants*. When *sectionnaires* invaded the Convention and sat with their mandatories, The People spoke. Paradoxically, the men who held such views manifested extraordinary respect for the Convention, even when they were training cannon on it; it was the will of the French people. This feeling may have been stronger among the rank and file than among Section leaders; it was certainly powerful among

those men whom the Convention called directly to its service, such as the soldiers of the *armées révolutionnaires*. The resultant conflict of loyalties could be a factor in some crises. At the Section level it was less sharp, and all could share that sense of immediate participation in popular sovereignty which found fullest expression in the ultimate right of insurrection. This was an awful and exhilarating moment, in which they knew for sure what their daily lives so often put to question – that they were men: formal declaration like some medieval *diffidatio*, the drums, the tocsin and the forest of holy pikes moving forward – 'Le Peuple Souverain s'avance . . .'

These 'anarchists' however, were no individualists. The will of the people, like the Republic, was one and indivisible. Fear of betrayal by those cleverer, better off, better dressed than they were led them to seek security in the unanimity of their own kind. *Publicité* was an obsession, the ballot a coward's trick – 'Point de scrutin fermé ou la cabale triomphe!' Denunciation, vile under the old régime, was an honourable duty under the Republic. Étienne Barry of Section Guillaume-Tell (formerly Place Louis-XIV) wrote a whole essay on it in 1793. Their favourite symbol was the ever-watchful eye. Union was essential, faction intolerable; militants agonised over the multitudes of the indifferent.

That this was the moral totalitarianism of an embattled minority is clear. Much of it, of course, was the rationalisation of necessity. But running through much of their political talk – and in some ways its most striking feature – is a deep disillusionment with the *hommes à talent*, for they cherished a pathetic belief in the civic virtues of education – 'Ce qui nous afflige,' said the *commissaires* of Section de la Montagne (formerly Palais-Royal), 'c'est de vous rappeler qu'un grand nombre de ces hommes instruits, tels que Choderlos, ne se sont pas servis de tous leurs moyens pour combattre les ennemis de la République . . . de voir enfin qu'ils se ménagaient tous les partis, pendant que les sans-culottes qui ne savaient ni *a* ni *b* soutenaient avec energie les vrais principes . . .'

In the spring of 1793 that energy was badly needed, as moderates came storming back into the Section assemblies. Attendance at the assemblies, very low before 10 August 1792, had risen sharply after that revolution, but slumped again soon, except for important elections. As passive citizens entered, many of the more affluent withdrew, leaving control to a militant minority.

Permanence meant that meetings ran on late into the evening, which enabled working men to take part, but also favoured minority coups. Organised groups could annul, even reverse, resolutions and unseat committees. Strongholds of the wealthy would petition for revolutionary taxation. After the moderate invasion of May such freaks became rarer, as eastern and western Sections tended to fall to their 'natural' majorities, but in disputed districts, and they were many, coup and counter-coup became the order of the day.

Sans-culottes developed the technique of *fraternisation*. 'Deputations' running into the hundreds would march with song and banners from sans-culotte strongholds into those of moderates, fraternise with allies and join with them to unseat *honnêtes gens*[3] and thrust right-thinking militants into power, celebrating the happy event with the fraternal kiss, a chorus of slogans and the *Marseillaise*. Naturally, moderates (generally an even smaller minority) responded with a brotherhood of their own and from May to September many Sections became battlefields, sometimes literally, with halls full of broken chairs and heads. The backbone of the popular drive were the societies. On 25 April the *Deux Sexes* called its sister societies, now numbering over a score, to organise a central committee, which finally met at the *Evêché*, the bishop's palace. It ran into difficulties, not least the sharp suspicion of the Jacobins, but it was the prompt and disciplined co-operation of society militants which created in the course of May what was virtually a sans-culotte 'machine'. Its dynamo was the sworn confederacy of 18 May between the Sections of Gravilliers, Marchés, Contrat-Social (formerly Postes), Lombards and Bonconseil (formerly Mauconseil); from this base bands of brothers set out to 'regenerate' their neighbours. In the battle, sans-culottes entrenched themselves in some twenty Sections and fought the moderates to a standstill.

It was this energised popular movement which the militants, almost wholly *enragé* in spirit, brought to the service of the Jacobins. The final call for insurrection was answered by 33 Sections. The shadowy central revolutionary committee at the *Evêché*, which launched the insurrection on 31 May, was headed by Varlet and its programme was *enragé* – expulsion of Girondins from the Convention but also a general maximum, an *armée révolutionnaire* and a total purge. It ritually deposed and then reinstated the Commune and was ultimately able to mobilise the

National Guard of some 20 Sections, with over 20,000 armed sans-culottes from 32 Sections, Saint Antoine, Gravilliers and other central areas in the van. It was this force which the Mountain was able to exploit, during the drama of 2 June, to secure the arrest of a number of Girondins and its own political supremacy.

It was this force also that the Committee of Public Safety was anxious to hold back. As the brief federalist revolt blazed up in sixty departments against the coup, as the Vendée grew more menacing and enemy armies closed in, France seemed to dissolve into chaos. The Committee, desperately anxious to restore revolutionary unity, played off the street and the Section against the Convention and tried to rivet attention on its celebrated Constitution of 1793, which enshrined political democracy and nodded briefly towards the social aspirations of *sans-culotterie*. But patriots were being tortured and massacred in the west and moderates were killing Jacobins and sans-culottes in provincial cities. Royalists were emerging from the shadows in Lyons and Toulon. Through this bloody and anarchic summer the Committee fought a losing battle against the anger of its supporters and its own natural passions.

The battle in the Sections raged on after 2 June. At Beaurepaire, a bastion of the wealthy, hundreds of sans-culottes from other Sections fought pitched battles nightly to win control, only to lose it again in July. Five Sections were captured in June, but moderates blocked an attempted purge of the signatories of the petitions of 8,000 and 20,000, and in mid-June no fewer than 27 Sections voted against the *armée révolutionnaire*. When the sans-culotte Hanriot was nominated as commander-in-chief of the Parisian National Guard, moderates and *possédants* rallied around Raffet of the conservative Butte-des-Moulins, a Guard officer at the time of the Champ de Mars massacre, and in the first round they carried the day in many Sections. The Commune could hardly let the armed force pass to an enemy, though the government committees did not budge, and there was furious counter-activity before the second round. Sans-culottes resorted to their favourite weapon of the direct voice vote and to even more forceful tactics. Section de Marseille, where Raffet had won by 120–74, declared the vote '*nul*, en ce qui concerne Raffet, mais *bon et valable* quant à ceux qui, après lui, ont obtenu le plus des suffrages'. In Poissonière the vote was reversed by those who, to quote the report, had the courage to remain until two in the



morning, to spare the Section regret and dishonour. Moderates replied in kind and it was in an orgy of electoral malpractice that Hanriot carried the day by some 9,000 votes to 6,000.

Not until September, when the national crisis reached its paroxysm, were Sections regenerated wholesale. On 4 September Pont Neuf, heart of the conservative city, fell to the sans-culottes, who were so elated that they ordered Jean Benoit Schell, a painter, to record the scene for posterity – it emerges in a hostile report after Thermidor—

'Onvoit dans cetableau les deux Officiers Municipaux qui haranguent le Peuple. Le President nommé fillette bon patriote est pris au collet par un individu en bonnet rouge portant la rage sur sonvisage . . . Des femmes présentent lepoing au President et au Sécretaire avec menaces . . . À gauche . . . onvoit un homme sur trois chaises empoigné par deux individus . . . Il est àpropos d'observer que Cochois, Hury, Chazeray et sa femme, Debraix, Thilly, Le Maire, Amiel et Parent Sont peints d'après nature ayant voulu conserver la mémoire de l'évènement et transmettre leurs figures àla Posterité . . . L'on remarque encore un vieillard avec un chien qui a eu la constance de Serendre chez le Peintre pour Figurer dans ce tableau . . .

But even patriotic and far-sighted old men with dogs had to live. Bread and meat supplies were irregular; the Maximum of 4 May was not working properly; an inquiry in mid-June showed prices outpacing wages. Once more, the *enragés* focused on the central issues of *subsistances*. The Committee tried to divert attention to the new constitution and the Commune fell in behind. Once more Jacques Roux swept to the head of a popular drive. As petitions flowed into the Convention, he spoke at the Cordeliers on 20 June, demanding the addition to the constitution of a clause punishing speculation and usury with death. The galleries roared and the Club voted a delegation to the Commune. At the Commune Roux lavished praise on Claire Lacombe's women and proposed his article: 'La liberté ne consiste pas à affamer ses semblables.' Again the crowds cheered, but a ceremony of congratulation on the constitution was projected for the Convention on the 23rd and the mayor, a radical, Pache, shuffled off the issue. The crisis came to a head on the 25th.

Roux presented himself at the bar of the Convention at the head of a deputation from Gravilliers, Bonne Nouvelle and the Cordeliers. His demands were nothing new; they were the *enragé* programme which was simply the programme of sans-culotte

militants. But the tone of his speech was unheard of. The Sovereign People addressed its mandatories with a totally unprecedented insolence. 'Mandataires du peuple, depuis longtemps vous promettez de faire cesser les calamités du peuple; mais qu'avez vous fait pour cela? L'acte constitutionel va être présenté à la sanction du souverain; y avez-vous proscrit l'agiotage? Non. Avez vous prononcé la peine de mort contre les accapareurs? Non. Avez-vous déterminé en quois consiste la liberté du commerce? Non. Avez-vous défendu la vente de l'argent monnayé? Non. Eh bien! Nous vous déclarons que vous n'avez pas tout fait pour le bonheur du peuple'. He accused the Mountain in particular of tolerating abuses which would have made despotism blush.

The Convention howled him down. Quick to admit the Gravilliers deputation, it chased Roux from the hall. He, however, carried both the Gravilliers assembly and the Cordeliers by acclamation. On the 26th, however, laundry women broke into *taxation* riots over soap prices which continued for two or three days. The Jacobins and the Committee, at the trough of the national crisis, became seriously alarmed. Robespierre pursued Roux with venom and the whole apparatus of the Mountain was turned against the *enragés*. The Montagnard press denounced *désorganisateurs*; the Commune rebuked the laundry women, Hébert in particular emerging as a staunch defender of property. On the 29th the Commune dismissed Roux from editorship of its *affiches*.

This furious Jacobin onslaught exposed the weakness of the *enragés*. Unorganised themselves, they had no centre of organised power, merely sympathisers within such centres. They could rely only on surges of opinion among the militants. That they were the most accurate interpreters of that opinion seems undeniable, but the hopes of militants had to centre on the Mountain. When men like Robespierre, Chaumette the Commune's *procureur*, Hébert his deputy and the *Père Duchesne*, called down wrath on Roux, at the very moment when the democratic constitution was being promulgated and when enemies were gaining ground an all sides, '*l'Abbé* Roux ... prêtre infâme ... tocsin du pillage ...' stood little chance. On 30 June no fewer than twelve leading Jacobins, including Robespierre, Billaud-Varenne, Collot d'Herbois, Hébert, went to the Cordeliers and harangued them in relays until they voted the expulsion of Roux and Leclerc, sparing only Varlet. Within Gravilliers itself Léonard Bourdon set his hatchet

man Truchon to work. This Truchon, a lawyer, was to be arrested
in May 1794 for having maintained, among other things, 'qu'il
fallait pour les places des hommes éclairés et aisés et qu'ils aient
du temps à perdre'; he swung the Gravilliers assembly into a 'free
and unanimous' acceptance of the constitution and an implicit
rejection of Roux. To deliver the coup de grâce, Marat himself on
4 July launched a thunderous denunciation of all the *enragés* in his
paper. Jacques Roux was broken.

But was he? On 13 July Charlotte Corday stabbed to death
L'Ami du Peuple and an inheritance went begging. A cult began to
develop at once as the Cordeliers hung the martyr's heart from
their ceiling; with equal speed Hébert, Roux and Leclerc each
proclaimed himself the true successor. A wave of terrorist demands
came in from the Sections, as news broke of more defeats and the
killing of Chalier at Lyons. At the same time, from that same
anonymous 'peuple' came renewed demands for the *levée en masse*.
Roux responded first – 'Marchez donc, braves sans-culottes, seul
espoir de la République!' he wrote on 17 July, but Hébert took it
up, too, with characteristic verve – 'Levons-nous . . . pour faire
danser la carmagnole aux ours de l'Allemagne . . .' By 5 August
the Commune had taken up the call. At the same time a sudden
dearth set several Sections to municipalising bakeries; the
Commune ordered bread cards on 21 July. In this sudden tension,
with wild rumours of a second September massacre flying, the
popular attack concentrated on the Committee of Public Safety
itself – that 'Capet à neuf têtes', as Leclerc called it. 'Foutez-nous
le camp bien vite' ran a placard by Lebois, *ami des sans-culottes*.
More serious, there was an erosion of Montagnard loyalty in Cor-
deliers and Commune. Vincent, the dour and ambitious secretary
at the War Office which, under Bouchotte, was becoming a
stronghold of the sans-culottes, demanded that the constitution be
implemented. More serious still, around the fete of 10 August,
when departmental delegates were ceremoniously to receive the
constitution, Hébert himself, hitherto a pillar of strength, began to
join in the campaign against *endormeurs*.

Robespierre, who had joined the Committee on 27 July,
launched a passionate counter-attack in a series of speeches
increasingly violent in tone. He pulled off his master-stroke on 8
August, when Simone Evrard, Marat's widow, was paraded
before the Convention and delivered a searing attack, almost
certainly written by the Incorruptible, on the *enragés* – 'Je vous

dénonce en particulier deux hommes Jacques Roux et le nommé Leclerc . . . des agens stipendiés par nos ennemis . . . émissaires de de l'Angleterre et de l'Autriche . . . Dieux! quelle serait donc la destinée du peuple si de tels hommes pouvaient usurper sa confiance . . . Législateurs, vengez la patrie . . . la vertu . . . en frappant les plus lâches de tous leurs ennemis.' *Veuve Marat à la Convention* was a terrible weapon; the Convention ordered the Committee of General Security to investigate the two writers and the constitution passed safely into its Ark 'for the duration'.

But the government could not stave off the pressure for long. The demand for ruthless action was mounting in the Convention itself; men like Billaud-Varenne and Collot d'Herbois were as violent as any sans-culotte. On 26 July the death penalty for hoarding was decreed. On 23 August the *levée en masse* was proclaimed in memorable language. Half a million men were to be conscripted, fed and equipped. Inevitably attention riveted again on the organisation of the economy and in mid-August, as the assignat slumped to below a third of its face value, a drought reduced grain imports into Paris from the customary 1,500 sacks daily to 400. Something like a fever gripped many Sections. In a putsch at Gravilliers the partisans of Roux regained power, and in a furious squabble the *enragé* was arrested and almost immediately released. He began to call for an insurrection; so did Leclerc, whose allies, the Lacombe society, became loud and active in the streets. In this complex crisis Hébert moved decisively. In a powerful speech to the Jacobins on 21 August, on the morrow of his defeat in an election to a ministerial post, he delivered an onslaught on the ruling powers in the guise of an attack on Roux. He was backed by many in the Commune, the War Office and the Cordeliers. He took over wholesale the *enragé* programme. The ease with which he did so is a measure of the extent to which that 'programme' was simply the programme of the sans-culottes. The Jacobins themselves were moving massively towards a policy of ruthless *guerre à outrance*. This was not simply a response to pressure from below. In effect what was happening was what had nearly happened in many provincial cities in the summer, a 'fusion' of Jacobins and sans-culottes in the face of an apparently immovable enemy, with the '*enragé*' programme absorbed, disciplined and organised into the Montagnard scheme of revolutionary government. Into this situation on 2 September came the news that Toulon had surrendered itself and its fleet to the British.

The *journée* which began early in the morning of 4 September was an affair of wage-earners to begin with. Masons and building workers, demanding bread and increased wages, poured into the workshops and called the men out. The first concerted movement started near the sans-culotte stronghold of the War Office. By the afternoon 2,000 men were locked with the Commune in the Place de Grève. Chaumette, after running to and fro between Commune and Convention, made his remarkable speech calling for an *armée révolutionnaire* and Hébert told them to rally for a march on the Convention on the morrow. That assembly had already voted a severe forced loan on the rich and was busy about terror decrees. In the evening, deputations from 30 Sections joined the demonstration and on the 5th, in mass parades, hectic committee meetings and high emotion, with deputies outfacing sans-culottes in intransigence, the Convention began to vote a whole series of measures which made Terror and other sans-culotte demands the order of the day and inaugurated the revolutionary government. 'Le peuple', wrote a police agent after the General Maximum passed a little later, 'a reçu avec transport les décrets de la Convention Nationale'.

For those who had claimed, with some justice, to be the voice of that 'peuple', it was the end. On 5 September Roux was arrested quite arbitrarily at the Jacobin club. He ran his paper for a while from prison and supported Leclerc's attacks on the 'new inquisitors'. When the Jacobins demanded the arrest of the latter, he shut up shop and disappeared, apparently to the front. Varlet, resisting the abolition of the permanence of the Sections, was arrested on 18 September. Claire Lacombe was hounded by Jacobins with a peculiarly masculine malice and her society was formally abolished in October. Jacques Roux finally killed himself in February 1794. There was some stir in Gravilliers, but little resistance. Nationalist feeling rallied to the government in its new form, but more important, the *enragés*, isolated from each other, had been voices expressing sans-culotte demands. When those demands found an apparent satisfaction, when the Convention itself was committed to a 'people's war', the spokesmen were left exposed. Only the Montagnards could give that satisfaction and deliver that commitment and the ease with which they broke the *enragés*, once they had made the decision in September 1793, is a striking illustration of where power really lay in the Revolution.

The anarchic Terror of the autumn of 1793, however, seemed

the very apogee of sans-culotte power. A colossal, rolling purge of Parisian institutions swept them to local authority. Vincent, the potent secretary at the War Office, filled the bureaux with them. A host of minor offices passed to militants and proven patriots. In the provinces their success was more patchy, but in area after area deputies on mission, often as considered policy, filled the committees with sans-culottes. The bureaucratisation of the popular movement was rapid; it was later estimated that half a million people held official posts of one kind or another.

The economic gains were even more substantial. The *Maximum Général* fixed prices at 33% above 1790, wages at 50% above. In fact, in many of the ports and workshops under direct government control, this meant a reduction in wages. The luxury trades had been hard hit by unemployment (and supplied many job-holding militants for that reason) but the crippling labour shortage and the rising cost of living had boosted earnings. In Paris and many other places the maximum of wages was not, and probably could not be, applied. Bread, thanks to the *armées révolutionnaires*, requisitioning and massive state intervention culminating in the establishment of a food commission in October, was secured and its price subsidised. Trade and much of the economy came under control. In district after district 'revolutionary' taxation of the rich financed expenditure. The sans-culotte movement was being rapidly swallowed up in the Jacobin machine, but the benefits were real. The assignat, down to 29% of its face value in September, rose to 51% by the end of the year.

The blood debt was being paid, as spectacular political trials sent old enemies to the guillotine and the people's axe set about its business. In civil war areas repression was yet more spectacular — the drownings in the *noyades* of Nantes under Carrier, the shootings at Toulon, above all the mass executions and apocalyptic rhetoric at Lyons, where detachments of the *armée révolutionnaire* of Paris served and where Parisian sans-culottes sat on the governing Commission. Over 6,000 men served in the *armée révolutionnaire* of Paris, and they considered themselves an élite at least equal to the celebrated Section *canonniers*. Ronsin, a former actor, headed them, and he filled his offices with old friends; Mazuel, an old soldier, thought the cavalry 'his', and there were plenty of professionals, adventurers and the spiritually mobile alongside the soldiers' fathers and bold *moustaches* who had left their shop-counter and workbench, full of patriotism, wine and

civic indiscipline. These *armées* and their operations (30,000 more served in the *armées* of the departments) have recently been brought to life in a vivid study.⁴ They were a microcosm of the Revolution itself. A single, short-lived, easily-categorised institution, under scrutiny, suddenly dissolves into a myriad complexities, like water under a microscope. All the standard categories melt away – 'economic' and 'political' motives, 'anarchistes' and 'gouvernementaires', *buveurs de sang* and men of virtue as the Revolution imposes its own incomprehensible logic, above all its *mobility*, physical, social and mental. The *armées* certainly had a unity, but it was a unity compounded of one commune's fears for its food supplies and another's for its property, of one man's yearning for a desk and another's for the sweet life, one's lust after doctrinal purity and another's after women.

The *armées révolutionnaires* were novelty and they brought novelty. *Jacobins de village* sprang from invisibility to take over the community, preach revolutionary virtue, denounce the *notables*, tax them and close their churches. Some areas escaped with a mere shuffle into verbal conformity, others were convulsed; in the Nièvre, under Fouché, there was something like total revolution, social levelling, *sans-culottisation*, revolutionary taxes – and de-Christianisation. Over much of France the Church, whether constitutional or refractory, lost its hold. Already the cult of Marat, borrowing freely from both Catholicism and the Enlightenment, was catching the hearts and minds of sans-culottes. From September, after the celebrated meeting between Fouché and Chaumette at Nevers, the cult of Reason took hold in Paris, at first slowly. Never very effective among the rank and file, it spread rapidly among militants, partly from mere fashion, and soon Section after Section was turning its churches into Temples of Reason or closing them down, marrying off its priests, renaming its streets and its children. The climax came with the Festival of Reason in Notre-Dame and the November closing of the Paris churches. As Archbishop Gobel resigned, the campaign spread over the departments. The movement itself was short-lived (Robespierre was appalled and was to launch the Supreme Being as a celestial punitive action) but in many areas of France, and particularly among the men, it expressed attitudes which were to prove permanent. The Convention itself signalised the new era with its metric system and the new calendar organised on similar principles. The *décade* replaced the week, the months were

renamed and made uniform. Significantly, the supplementary days made necessary to complete the year were called 'sans-culottides'. In this new order sans-culotte *mores* seemed dominant.

In all this there was a deadly contradiction. How could bureau-cratisation and a sans-culotte movement coexist? Was the Terror, particularly in its social and economic aspects, a temporary expedient or a way of life? During the autumn the great Com-mittees remorselessly imposed their will. In October they took wide powers. By the famous decree of 14 Frimaire an II (4 December 1793) they gave the Terror a 'constitution' and erected an authoritarian and centralised power. How long could a sans-culotte movement survive?

In the life-and-death struggle of the autumn, however, few militants thought such thoughts; their minds were full of power, vengeance, victory. By winter victory was theirs. The enemy within was crushed and the foreign armies rolled back. They advanced on the 'slave peoples'. By the new year the talk in the streets and prints of Paris was of an invasion of England, pay-master of the Counter-Revolution. For even there, they heard, men were calling themselves *Citizens* and summoning a Con-vention.

It was in this year that someone wrote that curious document later found among the papers of Vingternier, the very militant who had answered the impertinent question: what is a sans-culotte?—

'*God Save the People! God-dam the Aristocrates!* Dieu sauve le peuple! Dieu damne les aristocrates! S'écriait dernièrement un vrai Sans-Culotte anglais, ami du fameux docteur Priestley . . . voici la fin du discours qu'il prononça, après avoir bu Sa part de quelques Bols de Punch . . . Brethren and friends, will you to assure the revolution? Knock down the Snake Brissot, the Vipere Guadet, the reptil Vergniaud, the rascal Barbaroux, the Sweet Pétion, the Dog and hypocritical Rolland and all others Scelerates of the Clique Gensonné, Boyer-fonfrede, Rabaud, Buzot, etca, etca, etca, etca, and that I'll do!'

It was clear, from even this translation, that *something* was happening across the Channel.

Apprentices to Liberty[1]

If any place was to be a Faubourg Saint Antoine to an English Revolution, it was surely Sheffield. In December 1791 'five or six mechanics . . . , conversing about the enormous high price of provisions' and abuses in government, formed the Sheffield Constitutional Society, dedicated to universal suffrage and annual parliaments. By March, when they were in touch with the Society for Constitutional Information, they were 2,000 strong. They organised themselves into groups of ten, which like good freedom-loving Saxons, they called *Tythings*; each tything elected a delegate and so on up a hierarchy of meetings to a Grand Council. By the autumn of 1792, as England slithered towards war with France, they could bring out 5–6,000 in a street *mascarade* to celebrate the 'sans-culotte' victory of Valmy.

Self-consciously disciplined, they made what became a routine statement, that their intention was educational, that they acted in the hope that 'men of more respectable characters and great abilities would step forward'. In Sheffield, this seems to have been little more than a gesture to the deferential proprieties. After a singularly futile correspondence with the high-toned Whig Friends of the People, they strongly opposed any further dealings with them – 'from the known respectability of many names which appear among them'. They chafed at the slowness of metropolitan colleagues and denounced, in a familiar northern accent, the apathy of 'the great bodies of the kingdom which we little folks in the country look up to'. They moved into the villages around like arrogant missionaries. Rouse the shoemakers with the price of leather, the innkeepers with the threat of a standing army, exhorted their journal – tackle even the farmers – 'as ignorant as the brutes they ride to market. . . . An Angel might waste his eloquence in vain in talking to them of the importance of Rights, Liberty, Franchise . . . but let the poorest Devil that ever wagged his tongue but mention Tythes . . . it would appear more

melodious in their ears than the sweetest strains of the nightingale . . .'

For Joseph Gales, a Hartshead printer, was one of them; he had launched his *Register* in 1787 and started a new style in provincial journalism, printing Priestley and Mackintosh and preaching democracy. During 1792 his group brought out *The Patriot*, a democrat's journal, full of Alfred, the Norman Yoke and Locke, but also bubbling with 'French ideas'; it published a translation of Volney's *Ruins of Empires* – an evocative free-thinking fantasy of 1791 – which now began its long career in British popular journalism. *The Patriot* went far, even to America. It enjoyed the rare distinction (along with Hannah More) of translation into Welsh.

The London Corresponding Society itself, dazzled by this northern sunburst, decided to fashion its organisation 'in imitation of the societies in and about Sheffield'; a 'few poor mechanics', struggling in 1793 against the 'Aristocratic Tiranny and democratic Ignorance' which 'seem to pervade and over Awe the town of Leeds', appealed to Sheffield for help. It was John Harrison of Sheffield who set the Birmingham and Coventry clubs on their feet. Stockport, which in 1792 shared Sheffield's impatience with the Londoners – 'The sentiments', it said of one address of the LCS, 'hardly rise to that Height we expect from men sensible of their full claim to absolute and uncontroulable liberty' – turned easily to the cutlers.[2]

For there was a power in Sheffield, an intransigence, a sense of identification with a local community, which were rare. An army colonel, touring the provinces in 1792 to find sites for barracks, found the town 'bad beyond conception'; military officers that summer walked the roads arm-in-arm to provoke 'the inhabitants'. There were assaults in the street and a counter-attack on the barracks was averted only by Dissenting ministers who had the ear of the crowd.

> Facts are seditious things,
> When they touch courts and kings,
> Armies are raised . . .

They were to sing, in *God Save Great Thomas Paine*, one of the many parodies of that familiar patriotic song which passed into universal use during these years. 'It is surprising and delightful', enthused friends, 'to find so much information among the mechanic part of the population.'

Sheffield was generally, if a shade optimistically, described as a town of small masters and skilled craftsmen, where a man could rise. Despite an increase in population from an estimated 12,000 in 1750 to 35,000 in the central area in 1801, the threat to free-man and craft regulations was in measure contained; trade societies were strong – the Master Manufacturers of Razors and the Journeymen Spring Knife Cutters proved themselves cohesive in a wage conflict in 1796 – and the skilled, specialised and semi-independent artisan, working for one or more merchants, using a public wheel and keeping his price lists, was a representative figure. There were few gentry in the area, but several technically-advanced ironworks. The father of Ebenezer Elliott, the Corn Law Rhymer of the next generation, was an ironworks clerk; the Yeomanry used to back their horses through his window for he was an active *Jacobin*. Dissent, without producing an élite in the style of Norwich, was entrenched, and ministers were active in the anti-slavery agitation, a point of contact between 'respectable' and popular movements. The Sheffield society was full of literate and self-conscious artisans and tradesmen, 'not quite of the lowest order', to quote the recurrent phrase of socially astigmatic magistrates.

Gales probably did most of the public writing, but the secretaries, artisans like William Camage and William Broom-head, were active and intelligent organisers. 'Admirable papers' flowed into *The Patriot*, 'with not one word in five rightly spelled,' but otherwise publishable. John Thelwall the lecturer called the Sheffield men a 'Sanscullotterie', literate, intelligent and resource-ful. He claimed they had 'no leader' but that men of substance '*think* . . . with them'. This may have been true, at least at one stage. Paine himself, of course, visited the district in 1788 to see about his bridge, but that was when he was friendly with Burke and expected much from the King of France. Samuel Shore, a local ironmaster, and an active Wyvillite, professed to welcome the entry of artisans into politics, though a fellow reformer, by the end of 1792, was heading a Loyalist Association which practised social intimidation. Some Dissenting ministers stood by the accused in state trials; there was talk of a Quaker doctor, and a Baptist preached a sulphurous sermon to their Fast Day demon-stration in 1794. But spies reported that, while Dissenters gave 'small donations', they stood clear of the society itself.

Outside supporters were never very visible and must soon have

been disconcerted. The society's first act was to bring out a cheap edition of the *Rights of Man*, Part I, at 6d; by the spring of 1792 the Yorkshire militia were being unsettled by their 'little books'. Their petition to the Commons in 1793, which challenged the House's right to that title and for which they collected 10,000 signatures, was thrown out as insolence. At their mass meetings they favoured Henry Redhead Yorke, an able young man without ballast, who had been one of the British Club at Paris, had seen Louis XVI before the Convention and had been active in Holland. He scorned petitioning – 'The people should lay aside leaders, discard factions and *act for themselves . . . revolution in sentiment* must precede revolution in government and manners . . . the commanding voice of the whole people shall *recommend* the five hundred and fifty-eight gentlemen in Saint Stephen's Chapel to go about their business . . .' Yorke was imprisoned for one of his speeches to them, and both he and their delegate to the British Convention, Matthew Brown, a player turned lawyer, were guilty of those histrionics which historians find the besetting weakness of English *Jacobins*: in truth, hardly less startling than the recurrent magisterial panics or some scenes in Commons and Privy Council (where Sheridan himself was feverishly interrogated for treasonable correspondence with the Jacobins in 1794), these histrionics were necessary to men breaking a hard-set mould of deference. After an apocalyptic sermon in February 1794, thousands of them voted that the landing of Hessian troops in this country would dissolve the compact between government and governed and swore to maintain each other even if . . . 'we follow our brethren in the same Glorious Cause to BOTANY BAY'. For many, this was no hyperbole, for they were not volatile men. In all the muddle, heroism and buffoonery of the treason and sedition trials of 1794–95, the Sheffield men mark themselves out in laconic intransigence – 'I have not come here to learn my lesson, but to tell the truth.' In 1794 Gales' journeyman printer, Davison, arranged for pikes to be made in the town. They were intended for defence against loyalist raids, but he and his friends were prepared to make Sheffield the arsenal of the *patriots*, 'to make them formidable'. These men were not politic or 'political', in the sense of studious of the art of managing men to achieve the possible. They had no intention of being either.

What was peculiar to this formidable movement was the explosive nature of its first appearance; it seems to spring to life full-

grown. During 1792 about a score of societies become visible in most of the major centres and some small towns. Regional differences however were very great. At an opposite pole to Sheffield, for example, stood Manchester, already something of a 'shock city', with its nascent factory proletariat, its pushful merchant-entrepreneurs, its population mushrooming and earning, much of it, fabulous but uncertain money as pulse after pulse of technical innovation transformed the textile industries. The town had been rigidly Tory for a couple of generations and in the struggle over the Test Act in 1788–90 a strong Church and King club, unscrupulous even for the eighteenth century, had entrenched itself. Perhaps, as its snarling press and quick recourse to the underworld suggest, it already felt a shadow, but in 1790 it exercised power and Thomas Walker's Constitutional Society was struggling from the first.

It was precisely here that Paine's true audience appeared–that 'alliance of the industrious against a parasite aristocracy' which was to haunt the early nineteenth century. The popular societies, the Patriotic and the Reformation, 'mechanics and labourers' meeting in pubs, emerged in the May and June of 1792 and enjoyed (if that is the word) a brief year of life in the shelter (at times literal) of the Manchester Constitutional Society, where radical manufacturers like Walker and Thomas Cooper set the pace. Walker brought out Paine's Part I as early as August 1791; his society was the first to greet the Paris Jacobins, who hailed the Manchester men with fair accuracy, as 'brethren and friends among the same classes'. With the town newspapers closed against them, the society launched the *Manchester Herald* in March 1792, a lively journal which strongly supported France and was involved with the artisans of Sheffield and London. The royal proclamation against seditious writings in May, however, unleashed local enemies. In June there were attacks against Dissenting chapels and men of the popular societies were picked up for 'cursing the king'; raucous propaganda against 'levellers' was accompanied by a campaign of intimidation and boycott. At the September crisis 186 publicans, under pressure, pledged themselves to exclude *Jacobins*. The popular societies, hit hard, took refuge in private houses, notably Walker's own. Some of them were there when a mob was directed against it in December, to be driven off by gunfire. In 1793, however, six government indictments sank the *Herald* and Walker was trapped in a frame-up.

Although he was acquitted in 1794, the societies disappeared from sight and many men, not only the well-known leaders, took ship for America.

Dissent after 1790 does not seem to have been politically very vigorous – Walker chafed at its 'overstrained moderation'. More important, the popular societies effected no lodgement. Among the men arraigned with Walker were a paper-stainer, a hatter and a weaver; they do not seem to have penetrated the factories and the hard core of militants was a mere handful. Serious and partially-effective movements reappeared in the Manchester area and Lancashire generally in the years of dislocation and hunger from 1795, but they seem to represent a new beginning. In 1796–97 the most striking movement was the semi-insurrectionary United Englishmen, with close Irish connections and factory operatives in its leadership. Indeed, in 1796 and 1797 in Manchester one can already taste the acrid flavour of the early nineteenth century, start to shed inhibitions and to talk about a 'working class'. These shadowy men certainly inherited the *Jacobin* ideology, but they inhabit a different world.

'There is a contrivance between the landowners and the merchants to hold the people in vassalage . . . they have swallowed up the people . . .' said a Norwich man in 1793, and in these years it is the *polarisation* of English political society, which left artisans isolated, that catches the historian's eye. Leicester was a textbook model. Richard Phillips, a liberal bookseller with his circle of young intellects, the *Adelphi*, found a natural place in the coalition of Whigs, Dissenters and hosiery entrepreneurs which fought the Tory corporation in the Test Act battles. But in 1792 with the Revolution driving moderates over to the enemy, food riots coincided with the royal proclamation of May and Phillips' new journal, the *Herald*, excluded from the respectable market by the coup of a competitor, became a *Painite* organ. In the autumn crisis the new Loyalist Association was made up almost equally of Tories and ex-reformers, and Phillips' working-men's society ran straight into the storm, lost their editor to prison and foundered. George Bown, one of the original *Adelphi*, kept going despite imprisonment, and semi-legal clubs emerged in Leicester in 1794, 1796 and 1799. There was drilling in 1794 and one of their arrested men killed himself; in 1796 the LCS had to warn them off revolution and republicanism. By 1799 Leicester's correspondence was no longer with London, but with Nottingham

(where at the election of 1802 crowds sang the *Ça Ira* and paraded a Goddess of Reason through the streets), York, Sheffield and the north; one can already glimpse the Luddites.[3]

In staggering contrast was Norwich, which in 1793 rivalled Sheffield as the pace-maker of English *Jacobinism*. Textiles sustained many artisans of independent temper; Dissent was strong, rooted in a craggy tradition, but surprisingly liberal (a Welsh Baptist minister at Lynn brought out a defence of French atheism and Mark Wilks at Saint Paul's was the *Old Cause* made flesh). Moreover sophisticated and liberal professionals cultivated a tradition of urbanity, while merchant dynasties like the Gurneys patronized earnest endeavour. Clubs of weavers, shoemakers, shopkeepers, proliferated; by the summer of 1792 over 2,000 men were organized in forty small tavern-clubs while at the Bell, 'people of consequence' bought and distributed books. At the head of the federation stood a working man, Bagg, who had 'read a great deal of history'. There was that same, almost *communal*, feeling that one senses in Sheffield, but gentler; proposals to Address the Sovereign provoked uncontrollable mirth. During the terrible year of 1795 Norwich was producing *The Cabinet*, an intellectual journal of *Jacobinic* tendency, while its artisans spread their organisation over Yarmouth, Lynn, Wisbech and Lowestoft. It was *this* kind of alliance (which is what we grope after when we use words like 'pre-industrial') which succeeded, in sharp contrast to Manchester's.

It is a mistake, however, to focus too closely on visible and audible public organisations. Birmingham, for example, should have been a natural for artisan *Jacobinism*, with its myriad small workshops and 'every man . . . stinking of train-oil and emery'. It was, comparatively, silent and it has been assumed that the Priestley Riots, which were locally an Establishment coup against a powerful Dissenting interest, 'decapitated' the movement.[4] In fact artisans organised a society in November 1792, characteristically with the help of Sheffield. When John Harrison was beaten up, they were not so 'decapitated' that they could not write pamphlets and approach the lawyer Erskine. In March 1793 they circularised every manufactory with a questionnaire against the Septennial Act, taxation and the Corn Bill, and the Rev. David Jones collected £85 towards trial expenses in one month in 1794 (which, if Birmingham applied the restrictions common elsewhere, suggests a membership of at least 1,500). From the fragmentary

records of the Birmingham society (like so many others, they had to live in a twilight world of semi-legality almost from birth) there radiates an odd self-satisfaction. Birmingham *Jacobins* cultivated the myth, common to reformers, that their city was 'the very seat of persecution . . . where Mob is King', since it flattered their heroism, but in fact successive secretaries had to admit that Church-and-King sentiment was 'much alloyed' (good Birmingham phrase!). They concentrated on 'the quiet diffusion of principles' and they seem to have been, equally quietly, effective.

Interesting in this respect because in terms of politics (the parliamentary *pas-de-deux* of gentry families apart) it was virgin territory, was South Wales, still largely monoglot Welsh at the popular level. Clustered around Independent chapels of Cromwellian foundation which were evolving towards a liberal *Presbyterianism*, and focusing on Cowbridge Book Society and Rhys Prys' academy at Bridgend, was a small-scale society ranging from petty cloth-manufacturers through preacher-schoolmasters to tramping artisans. They circulated journals, *Poor Richard*, the latest translations from the French, in something like the Norwich style. Ardent antiquarians many of them, poets, language-revivalists, they were in contact with effervescent London–Welsh societies which went over en bloc to the Revolution. John Jones (*Jac Glan-y-Gors*), a London tavern-keeper, brought out two Welsh pamphlets which were pure Paine. Edward Williams (*Iolo Morganwg*), stonemason, poet, antiquarian and historical forger extraordinary, invented a bardic guild and took the lead in the revival of the *eisteddfod*, which was re-animated in 1792–93, quite consciously and deliberately as a vehicle for *Jacobin* propaganda with appropriate competition titles and medals struck by a French engraver. This was the society which had produced Dr. Richard Price (Prys' son) and David Williams, the friend of the Girondins.[5] Politically they overlapped with radical Baptists, whose ministers in correspondence with confréres in the U.S.A. were prone to call themselves 'downright Sans-Culotte Republicans'. (The persecution of South Wales Baptists after the French landing at Fishguard at 1797, while unjust, was not pure hysteria). One of the ministers, Morgan John Rhys of Pontypool, crossed to Paris in 1792 on a campaign for Protestant liberty, with French bibles subsidised by the Welsh associations. Driven home by the war, he published in the following year the first political periodical in the Welsh language, which

drew on the Sheffield *Patriot*. Rhys fled to America during the mass arrests of 1794, where Gales, also in exile, helped him launch a liberty settlement,[6] but the *Presbyterians* at home tended to focus on Merthyr Tydfil, which was rapidly growing into an important centre of the iron industry. John Thelwall, during his 'exile' in Brecknock, was always welcome among the 'staunch old Republicans' of Merthyr, who at the peak of the repression held reading circles on Paine and Voltaire in mountain hide-outs. It was this group who, in the next generation, supplied the first phase leadership of local Chartism. The most important minister in the Merthyr area during its pell-mell industrialisation was a Unitarian who had been imprisoned in Carmarthen for singing a Welsh version of the *Carmagnole*. In this small-town, dispersed society an ideological line of descent, through various brands of Nonconformity, from the American War to Chartism seems direct and unbroken. The only 'society' they ever had was the South Wales Unitarian Association of 1802.

There were many areas like this, where around *foci* sometimes almost invisible to the historian, a small-town print-shop, the house of some liberal gentleman, or a newspaper like Benjamin Flower's *Cambridge Intelligencer*, a coterie would take shape, reproducing the contours of that social grouping which seems to have responded most warmly to the democratic impulse – journeymen, a liberal Dissenter, a country doctor, small masters, a travelling actor. The village *Jacobin* (often the Eternal Shoemaker) passed into memoir literature. The most remarkable feature of this period is not really the growth of organised societies, but the unprecedented *diffusion* of political ideas, often related directly, in their turn, to strictly *local* experience. Without this awareness of wide and deep *penetration*, of some unseen but permanent minority which at any crisis might suddenly become a majority, the whole clanking apparatus of intimidation and the recurrent explosions of 'loyalty' are a meaningless hysteria. A traveller who stopped in 1796 at the minuscule country town of Bala in North Wales (a Mecca of Calvinistic Methodism) found the tavern rent by a permanent feud. In one corner sat a parson, some gentlemen's sons and a lawyer; in another, a country doctor, a blacksmith and a farmer. For hours they sourly drank *Jacobin* and *anti-Jacobin* toasts at each other. If Bala could produce 'Jacobins' in 1796, clearly lightning had penetrated the soil.

This new breed of men entered British politics in 1792, the year

of Tom Paine and his *Rights of Man*; it has been called his 'annus mirabilis'[7]. The bare figures, impressionistic but not implausible, give us some dimensions. At three shillings, Part I may have sold some 50,000 copies in 1791; there were several cheap editions. The success of Part II, which bit more deeply into British reality, was phenomenal. The book came out in February 1792; the proclamation of 21 May was directed against it and enormously stimulated sales. There are literally hundreds of statements testifying to its penetration into every hidden corner of society. With the many cheap editions, the estimate in 1793 that 200,000 copies had been 'sold', staggering though the total is, does not seem improbable.[8]

The programmatic statements issued by popular societies in the first three quarters of 1792 were virtually identical. They all focus on universal suffrage and annual parliaments. The *tone* is often Paine's, though they are also steeped in traditional *historicism*, which indicates incomplete assimilation or rejection of at least some of Paine. The social implications are generally not made explicit, though an Address of the LCS in August virtually reproduces Paine's redistributive proposals. There is very little direct reference to France and much abhorrence of levelling and violence. If one uses words loosely, one could call the papers 'Painite'. Indeed, the intention of the Whig Association of the Friends of the People, founded in April, was precisely to combat this type of 'reformism'; Paine became the touchstone; this was what marked off the Friends from what they all too typically called 'Horne Tooke's people'.[9]

For until that crucial autumn the new societies clustered around the SCI; the first external act for most of them was to write to Horne Tooke. In the spring of 1792 the SCI came to life. Losing old members wholesale, it gained new, more radical ones, some of whom were to play a part in the popular societies – men like Thomas Holcroft the dramatist friend of Hazlitt, who had an entry into a range of social groups, from the intellectual deep-freeze around Godwin to the bubbling world of experimental artisans in which the revolutionary mystic William Blake had his being. The SCI and its kin, in effect, identified themselves with Paine. In this very real sense, therefore, the artisan societies grew directly out of the most radical tradition of English libertarianism; they took off where an older movement had stopped in the 1780s; they used Paine to make a necessary break with tradition.

This simplist derivation, however, is inadequate; we commonly overstate the effect of books. Paine's crucial Part II appeared in February; in April the LCS, then but a handful, issued its first public statement. There was an immediate jump in membership to a couple of hundred. Thereafter, until the autumn, its increase was *hardly perceptible*, even though its August Address was practically a précis of Part II. Moreover the great majority of sensational statements on Paine's influence date from the autumn and winter of 1792; most of them were made during the massive 'loyalty' mobilisation of November-December. One would give a lot for a chronological breakdown of those 200,000 'sales'.

In this same period the SCI became more *Gallic* and not merely in its toasts; it subsidised the translation of Collot d'Herbois' *Almanach*, admitted Barère and other Frenchmen to membership and corresponded with the Jacobins. Before the autumn of 1792 the French Revolution, while it ran through everything in England, served as a field of reference for popular societies. It was an intangible but real *presence* in every English discussion. The 'great debate' had been on for two years and more, and in the course of it, Burke had referred to the 'swinish multitude'. But French reality was not the reality of that dramatic Declaration which Paine had printed in Part I. France could be summoned up by popular militants as a myth, but could they warm to a régime based on 'passive citizens'? No popular society sent letters to the Assembly; it was to the Convention of a democratic Republic that they sent greetings – and, more practically, shoes for its armies. Paine's Part II was distinctly tentative on France; America was the settled republic, France an unfinished experiment. The outbreak of European war in the spring of 1792 produced an upsurge of pro-French sentiment, which also rallied many Dissenters. There was outrage at the spectacle of 'leagued despots' conspiring to strangle liberty in its cradle. But the 'cradle' should be noted. Whatever power the Revolution had as an energising myth, it stood at some distance from the British popular movement. In the autumn of 1792 that distance abruptly disappeared.

The records of the London Corresponding Society tell their own story.[10] They are fragmentary, but the overall picture is in fact clear. According to its founder, the shoemaker Thomas Hardy, it had about 70 members when it issued its first public statement in April 1792; there was an immediate accession of strength. Delegates from 9 divisions formed a committee in May. In that

month came the royal proclamation against Paine, and recruit-
ment seems to have slowed. In June Hardy, telling the Sheffield
men that 'we hope to rival you ere long', could report only 10
divisions, and in July, complaining to the Scots of the 'dirty work of
corrupt despotism' (magistrates' blackmail of publicans), he
spoke of a twelfth. There was little visible increase during high
summer, when the society probably numbered two or three hun-
dred, with a divisional attendance and voting record of some 30%
of the membership. In August, shortly before the cataclysm in
France, the society issued its Address which was wholly in the
spirit and partly in the language of Paine's Part II. It was in late
September, and quite suddenly, that men began to pour into the
divisions. Throughout October and November the society was
literally in almost continuous tumult.

Division 10, which met at the Scotch Arms in the Strand, had
been formed in June. It should then have had at least 16 members
(when membership reached 46, sixteen were to peel off to form a
new division). By August, when Paine's Part II had been on the
streets *for six months*, it had inched up to 28 members. In the early
days of October it was registering 100 % attendance and voting
records for an 'unlawful' membership of 62, and its noisy,
passionate, almost anarchic meetings were drawing in over a
hundred, with 'hearers' (if one may adopt the useful Baptist
distinction) as committed as 'members'. Division 2, at the Uni-
corn in Covent Garden, had 62 members and meetings of over
200; Division 3 was more crowded still. These numbers were
turning up at neighbourhood pubs. During November, said
Hardy years later, 300–400 signed on every week. This could be
an old man's fancy, but in fact, a well-informed spy reported 26
'societies' packed to the doors on 24 November (the LCS recorded
27 divisions on 27 November) and said that 350 had joined in the
past week. Hardy at the time said that they could not take down
the names quickly enough. It is perfectly obvious that the
divisional system completely broke down under the pressure.

It was not only a matter of numbers. Attendance and voting
percentages seem to have at least doubled. The average voting
figure for the divisions on record is 40 – and there were nearly 30
divisions by the end of the year. In November there was another
government 'alarm', when a royal proclamation hastily mobilised
the militia and recalled Parliament, and troops were osten-
tatiously concentrated near London. By this time the LCS must

have numbered at least 800 committed militants, a membership, much of it at this point highly active, rolling past 1,200 towards 1,500 and 'hearers', many of them as vocal as members, running to 5–6,000, with echoes reverberating through district after district. Furthermore at this point the LCS had not *yet* gone before the public on any scale. Members came to them.

The change is qualitative. From this point on, while support fluctuated, sometimes wildly, with events, there is an underlying drive upwards until the winter of 1795–96. At that time numbers were three to five times what they were in 1792, and the LCS could gather crowds the like of which had not been seen before and, in many cases, would not be seen again until the days of the Chartists and Garibaldi. Moreover what was happening in London was happening in every society which was unmistakably 'popular', precisely at that moment when 'respectable' sympathisers were falling away in droves. This was the point of breakthrough. For the British popular movement, the French Revolution which counted was that of 10 August 1792.

It is not simply a question of Paine *or* the Revolution, or even of Paine *and* the Revolution. There was a direct connection. First came Paine with (when the implications were fully grasped) a fundamental challenge to a country 'with no constitution'. Then came the 10 August, a French Convention and a Republic based on manhood suffrage, with a sans-culotte as its most vivid image. And in September Paine himself, under indictment, shortly to be outlawed with his *Rights of Man* taboo, crossed, the Dover crowds jeering at him as a 'traitor', to take his seat in the French Convention – in the days of the Massacres, Danton's great speeches and 20,000 sans-culottes marching out to a last-ditch stand against the 'leagued despots'. Paine's parting shot was a call for a British Convention to give Britain a constitution; and it was followed by the 'miracles' of Valmy and Jemappes and the 'sans-culottes' sweeping into Brussels. At this moment Paine was as important in his person as in his books. For this one moment, a new expression of the British libertarian tradition and a new French democratic republic were not merely related, they were identified. And it was at this point, *two years after the offence*, that political artisans took public umbrage at being called a 'swinish multitude'. For they saw the future and it worked.

To the head of the movement, displacing the SCI, swept the London Corresponding Society, Burke's 'Mother of all Mischief'.

Its constitution was almost *Rousseau-ist* in its direct democracy and
unlimited numbers, its penny weekly subscription, local division,
its members' right to recall delegates and to ratify committee
decisions. Members took it seriously. When they debated standing
orders in 1795, the minutes read like a seminar in applied philo-
sophy. Francis Place, in those monstrous notebooks of his which
blind as much as they enlighten, waxed nostalgic over strenuous
tea-parties, but most would recall the pub's upstairs room, all
smoke and strewn pamphlets and beer. 'Almost everybody
speaks . . . a very great noise . . . people grow outrageous . . .' – in
the passionate debates, the wrangling over committees, the
painfully legalistic 'trials' of suspected spies (they acquitted one of
the worst of them), the collection of shoes for the French and funds
for their own prisoners (like nearly all popular societies for the
next two generations, they were hardly started before arrests
turned them into charity organisations), one cannot miss the
excitement, the novelty, sometimes a sense of the *enormity* of it all –
as visible in their bravado as in their nervousness. Reading Francis
Place on his poverty-stricken youthful marriage, on the vital
importance of getting *one room* to sit in, read in, *live* in, one can
feel how a Division added a whole dimension to the lives of
many.

For basic to their politics was a craving for recognised man-
hood, a taste for equality, as sharp as any sans-culotte's. On one
occasion someone used the fatal word 'leaders'. The uproar was
deafening; some people never spoke to each other again. In 1795
the LCS secretaries, John Ashley a prosperous shoemaker and
Alexander Galloway, who was to become the foremost engineer-
ing employer in London, firmly declined an offer by a 'very
respectable group' to pay a higher subscription, if they could
restrict their membership to householders. 'It is the reproach of
this, as well as every other commercial country, that property is
too much respected. As an evidence of industry and œconomy it is
respectable, but it can by no means be considered as a general
test of moral rectitude, and the attempt to arrogate to it more
respect than it deserves, is generally a proof of narrow sentiments.'
Reform would never be won while 'men of different descriptions
are studious of keeping distinct companies.'[11]

The tone, the urbanity, are rather striking and were charac-
teristic of their public pronouncements. Even *Hog's Wash*, the first
popular political journal, which Daniel Isaac Eaton brought out

in 1793, is recognisably in the eighteenth-century line of wit,
seems one with the 'national culture' in a way that the *Poor Man's
Guardian* of the next generation does not. Among themselves they
spoke differently. Many used French forms. *Citizen* was universal;
there were 'honours of the session', the LCS had 'deserved well of its
country', was the only 'truly sans-culotte body'; some committees
invariably 'decreed'. In the dearth and killing misery of 1795,
when John Bull began to *look* like a sans-culotte, there were even
more direct translations – 'the right to existence' and 'the equality
of enjoyments'. But mostly they spoke a pungent English, which at
times of crisis they could rap out in forceful staccato. And equally
typical of many, particularly in London, was the ferocious squib
which the Attorney-General flourished in 1794 – 'At the
FEDERATION THEATRE in EQUALITY SQUARE, on Thursday, the 1st
of April, 4971, Will be Performed, A new and entertaining Farce,
called LA GUILLOTINE! or GEORGE'S HEAD IN THE BASKET!
Dramatis Personæ: Numpy the Third by Mr. GWELP (and many
others, including – perhaps *especially* – the leading "liberals") . . .
Tight Rope Dancing from the Lamp-post, By Messrs CANTERBURY
YORK, DURHAM etc. In the course of the Evening, will be sung, in
full chorus, ÇA IRA and BOB SHAVE GREAT GEORGE OUR ******!
The whole to conclude with A GRAND DECAPITATION of PLACE-
MEN, PENSIONERS, and GERMAN LEECHES. . . .'[12]

There were to be no leaders in this society, which was con-
sciously modelled on the civil society they wished to create. 'The
social compact between us is dissolved', announced seceding
divisions. The essential aim was 'uniformity of sentiments', to be
achieved by a 'correspondence' which took on overtones –
'Our hearts are with *all the family*', ran a letter from Portsmouth
dockyard men, 'and we fondly wish to be UNITED WITH
THEM, not only in *distant views*, but in real *personal* union.' To
people like this, even though their leaders gave thanks and medals
to Stanhope and Erskine and circled endlessly around the par-
liamentary opposition, the whole political world was basically
alien and repulsive. The political nation, even its fringe of the
gingerly sympathetic, was distrusted and, among the rank and
file, dismissed. They damned Burke and Pitt as *apostates* rather
than mere enemies. Whigs they detested most of all. For central
to their political discourse, as it was to that of the sans-culottes,
was a permanent expectation of betrayal by the respectable.
When the sympathetic Lord Daer joined the society as Citizen

Daer, Hardy welcomed him, but kept him out of the chair. He wanted an artisan society and he got one.[13]

The executive committee men were small masters and artisans like John Baxter, the Shoreditch silversmith who wrote an 860-page history of England to derive the right of armed resistance from Saxon precedent. John Bone, a bookseller of Holborn, an intelligent and quirky man, at one time founded a society of his own. He devised a Book Plan in 1795, to unify the nation's clubs – 'When our political matter is exhausted, let us publish an abridgement of some History with Notes – suppose of Greece, Rome or our own country. Let us not stand still . . .' Richard Hodgson the hatter may have made his own translation of Volney.[14] There were plenty of Duplays and Ducroquets. Characteristically, while Francis Place could lead a strike of journeymen among the breeches-makers (no sans-culotte he!) Thomas Hardy had to face one by his. They certainly seem to have been more literate than their French confrères. Around them mushroomed a whole new world of popular journalism. Citizen Richard Lee, who ran the Tree of Liberty in the Strand poured out pamphlets and broadsheets. The most popular were anthologies from Gerrald and other writers, but it was he who was the major source of cross-Channel ideas. Daniel Isaac Eaton, surviving prosecution after prosecution, became a legend in his own time.

There were other, lesser societies in London. A strong one in Southwark nurtured the talents of John Thelwall. Son of a mercer whose widow failed in the business, he tried his hand at tailoring, law and medicine before he found himself as journalist, poet and lecturer extraordinary. His *Peripatetic*, his friendship with Coleridge and influence on Wordsworth, his distressing poetry, have diminished him to a transient 'influence', but he was an acute social observer with a penetrating intellect, one of the first to grasp the realities of industrial society. Such snippets as we have of his missing travel diaries suggest that we have lost a Defoe or a Cobbett.[15] His great days were in the crowded, tense lecture halls, doing battle, verbal and physical, with John Reeves the Loyalist and his men, armed with erudition, wit and a 'cudgel-proof' hat.

There were some active professional men, in medicine and law, a John Gale Jones and a Felix Vaughan. Joseph Gerrald, a brilliant pupil of the celebrated Dr. Parr, powerfully argued the case for a Convention and died in Australia for his pains. Maurice

Margarot, a wine-merchant's son educated at Geneva and much
travelled, was a flamboyant personality, often in scrapes and
often called a Frenchman, perhaps because he was 'a most
impudent and provoking body'; he certainly seems to have pro-
voked English historians. They warm much more readily to
Thomas Hardy who, though a Scot, seems to embody many
English virtues. Honest, dignified, almost desperately reasonable,
he 'dressed plainly, talked frankly, never at any time assuming
airs'. His wife died of a miscarriage brought on by a crowd attack
when he was in prison and the sight of such a man in the dock for
treason must have convinced many that there was something
rotten in the state.

He needed all his virtues, because in November 1792 a veritable
gale of 'loyalty' began to blow through the land. Appalled at the
mushroom growth of popular societies and their correspondence
with and open sympathy for the French Convention, John
Reeves, a government lawyer of authoritarian and cynical
temper,[16] organised with covert government assistance a Loyalist
Association, and in response to his action and to the proclamation
of the same month addresses denouncing *Jacobins* poured in and
associations multiplied in city, town, corporation and county.[17]
An unprecedented platform campaign mobilised the right-
thinking (who now included many repentant reformers). Hannah
More began her famous series, *Village Politics* and the Will Chip
serials. William Wilberforce marched his spiritual regiments to the
sound of the guns. Paine-burnings lit the winter sky. In some
places there were house-to-house canvasses of 'loyalty'; in some,
indeed, a heresy hunt. An avalanche of denunciation thundered
into the Home Office. Arrests and prosecutions multiplied. The
outbreak of war with France in February 1793 climaxed the pro-
cess.

Place and Elliott were later to call this the first phase of the
'English Reign of Terror'; its nature has been much misunder-
stood. The real reign of terror for England, of course, was the
hideous suppression of the Irish rebellion of 1798. In the home
island, like the White Terror in France, the practically bloodless
but paralysing intimidation was essentially *local* in its incidence.
It dates, in effect, from 1794, since it required the suspension of
Habeas Corpus and the Volunteer movement. The difficulty in
this first outburst of loyalism is to determine how much was
spontaneous (as much was) and how much merely conformist or

indeed mercenary (as much was). It is important not to anticipate the very different atmosphere of the later 1790s.

The problem is bedevilled by men like Evan Nepean of the Home Department. A celebrated statement of the time, much quoted, refers to 'hordes' of itinerant Methodists descanting on the rights of man. This rigmarole derives from a single letter by a deranged correspondent in Anglesey, who was immediately disowned by the Lord Lieutenant and the magistrates. Nepean, knowingly, not only included it in the reports he prepared for King and Cabinet, but embroidered on it. It helped to revive the pursuit of itinerant preachers which ultimately drove ultra-Tory Calvinistic Methodists to secede from the Church to gain the dubious protection of the Toleration Act! Freeling of the Post Office was equally flexible, and both men worked closely, under cover, with Reeves and with some police officers with a sense of mission.[18] Official action, before the suspension of Habeas Corpus, was difficult, since Fox's libel act of 1792 had strengthened juries, which in London were notoriously anti-authority. Government had already begun to purchase the London press, to subsidise the provincial, to employ spies and to intercept the post, but not until the 'alarm' and multiple arrests of 1794 could serious repression, in particular the cat-and-mouse arrest, release, re-arrest of poor men, begin. In 1793 there was so much occult dabbling by under-lings that it has become impossible to disengage the truth.

Much of the 'wholesome reading' was useless; singularly ineffective was a bowdlerised Burke (shorn of porcine reference) which must have maddened both parties equally. Hannah More was more successful, but the enterprise seems to have excited authors more than readers. Paine was fixed as a traitor in minds prepared to receive this impression, and where no *Jacobins* had been seen (few artisan societies had yet held public meetings) they were made to seem outlandish. The war itself is no less puzzling. There was a distinct change in attitude around 1797–98, when the struggle assumed that heroic character which made it a traumatic experience for the British nation; before that date all is uncertain. Both anti-French and anti-war feelings were strong in 1793; the latter strengthened in the winter of 1793–94; there was utter war-weariness in 1795. The essentially 'instrumental' significance of Paine's writings for political artisans is perhaps indicated by the fact that his arrest by the Robespierrists in 1793 made not the slightest difference. During the Terror the British

popular movement became more 'French'; the killing was written off as a psychological legacy of tyranny, much as many Dissenters dismissed French atheism as the wages of French Catholicism. It was not the Terror which disenchanted these men, but the Directory (Napoleon many came to admire). There is no sure footing here. Certainly *God Save the King* had to fight at first. At one ironic moment in 1795–96 theatres on both sides of the Channel were cockpits, with audiences bawling songs at each other – the *Réveil du Peuple* against the *Marseillaise* in Paris, *God Save the King* against sundry rivals in London. The ultimate victors, of course, carry their own significance.

What can be said is that the loyalty campaign of winter-spring 1792–93 rallied a powerful and effective bloc of opinion. In some areas life was made unpleasant not only for *Jacobins*, but for doubters of every stripe. The prime effect was to curb the *public* expression of dissent. Artisan societies, conscious of their novelty, were quick to withdraw into themselves; militant loyalism aggravated this neurosis. During the revival of 1794 many societies were 'unearthed' which had lived under cover for several years. Hardy himself in the summer of 1793 suggested that the LCS suspend operations for a while. At that time, however, the situation was already changing; strength was flowing back. By the spring of 1794 a government oppressed by military failure was more alarmed than ever. For in that spring it was faced by what looked like a national campaign for a British Convention.

In May 1793 Grey's motion for parliamentary reform met total defeat in the Commons. The erosion of opposition within the political nation was continuous from 1792; ultimately only the small Foxite group remained as a point of entry into the system for the popular societies. The northerners had prepared 'humiliating' petitions in support of Grey and the Friends of the People only under protest; they accepted (some welcomed) exclusion and proposed the anti-Parliament of a manhood-suffrage Convention. The Scottish movement had already held a meeting under that name, but by 1793 the very word was explosive. The more cautious (and ultimately more optimistic) LCS dismissed Paine from its publications, filled them with Blackstone, the historic constitution, even 1688, and tried to go on working in 'traditional' style. In popular journalism, however, the tone was harsher and more French; *Hog's Wash* was drawing on anti-monarchical verse from the seventeenth century. Rising prices, patchy unem-

ployment, the first wartime shortages and dislocations sharpened
tempers. By midsummer, it was clear that the loyalist demon-
stration had failed. New popular societies were appearing, mem-
bership totals climbed, correspondence was resumed. As the
military campaigning season closed in defeat, there was a sharp
increase in tension. The *Hessian* scare made its first appearance in
the winter, to grow into a regular 'fear' by the spring of 1794,
Government, foiled in 1792–93, would resort to more direct
measures and fill the new barracks rising on every hand with
foreign mercenaries; the Hessians, with their echoes of the
American War, marched like a ghost army across a ravaged
landscape. The artisans' worst fears were horribly confirmed
when the Scottish judiciary began its merciless attack on
reformers, which reached its first climax in August and September
1793, when two professional men, Muir and Palmer, were given
long terms of transportation after appalling trials. Government,
overriding English protests, warmly supported the Scottish
judges. This was the tocsin. To the popular societies the days of
English liberty were numbered. Their Convention campaign was
a series of defiances flung at the approaching menace.

The first line of defence was Scotland, and at very short notice
Margarot and Gerrald, with Matthew Brown from Sheffield,
rushed as delegates to a new Convention held at Edinburgh in
November, which was deliberately and defiantly histrionic,
adopting French styles and dating its minutes First Year of the
British Convention. Margarot, after the meeting had been broken
up by main force, made the most of the dramatic possibilities of
his trial, while Gerrald, on bail, went back to London. The public
meeting held by the LCS on 24 October to choose its delegates was
its first, and had drawn crowds many of whom were simply
curious; by December the situation was changing dramatically.
The release of an imprisoned SCI man turned into a street demon-
stration, and Thelwall, with much éclat, launched a series of
fund-raising lectures which developed into a guerilla against
authority. In an atmosphere of mounting exhilaration and fear
the SCI came back again to life and on 17 January 1794 voted 'to
oppose tyranny by the same means by which it is exercised'.
Three days later, at a crowded meeting of the LCS in the Globe
(where the floor gave way), Citizen John Martin, an attorney,
used harsher words – 'We must choose now at once either liberty
or slavery . . . Will you wait until Barracks are erected in every

village and till *subsidised* Hessians and Hanoverians are upon us?'
A fiery Address delighted the sci, which voted that the lcs had
deserved well of their country and ordered 40,000 copies into the
provinces.

The response was immediate. Clubs emerged growling from
obscurity, complaining of intimidation, at Newcastle, Bristol,
Halifax and several other places. As a sick Gerrald went back to
Scotland to face his sentence of transportation, something resem-
bling a national campaign got under way. Stormy mass meetings
were held in the open air, notably at Sheffield and Halifax; York-
shiremen called another delegate meeting for Bristol and
demanded a national convention. In London the lcs shot up to 48
divisions and over 5,000 active members; 'even the rich', accord-
ing to one report, came to sit among 'the honest men with
leathern aprons'. At the end of March the London committee
sent out a call for a British Convention.

The issues thrust to the fore were the threat of a suspension of
Habeas Corpus, legislation against the right of assembly and the
landing of foreign mercenaries; at the mass meetings the talk was
all of Hessians, Botany Bay and the 'dissolution of the compact'.
A secret executive was readied in London and the survivors of the
Edinburgh convention were trying to concert secret measures.
There was some arming in Sheffield and, more obscurely, in
London; in Scotland there was a real plot, while attorney Martin
was arguing that the oath of allegiance to a perjured monarch no
longer covered armed resistance, but this was triviality. What
most seem to have had in mind was some form of civil dis-
obedience; the appeal was to traditional English libertarianism.
But much of the talk was tough, particularly after patriotic
toasts, and at joint meetings the skittish sci drew back. Thelwall
thought the Convention had been abandoned, but the nor-
therners, led by Sheffield, pressed on hard and at a great lcs
meeting at Chalk Farm, near Primrose Hill, on 14 April thousands
who resisted harassment by Bow Street Runners and magistrates
voted a thunderous Resolution, which asserted that any attempt
to annul the last remaining laws in defence of English liberty
would dissolve 'the social compact existing between the English
Nation and their Governors'.

Ministers were by this time seriously alarmed, since the
movement seemed to be gaining momentum and its implications
were grave.[19] They were already deeply frustrated by the inex-

plicable French capacity not only to resist but to triumph. Their
foreboding at the approach of the campaign season was not les-
sened by continuous warnings, from Windham in particular, of a
French raid on the coasts, designed to set off a rebellion which
would, even if unsuccessful, knock Britain out of the war. The
streets and prints of Paris were loud that spring with the 'British
Convention and its 90,000 men' and calls for an invasion; on the
stage Fox was portrayed as the leader of an English revolution.
And it was precisely at this point that William Jackson passed
through England to Ireland on his secret missions.[20]

Jackson, one of the British émigrés in Paris, came as an agent
of John Hurford Stone, then in the employ of the French foreign
service. He was to assess the temper of the nation and make con-
tact with the United Irishmen. He carried a yet more secret letter
from Stone to his brother William, a London coal merchant,
warning him that the Committee of Public Safety, convinced that
at least some of the British were ready to rise, planned just such a
raid as haunted Windham. William Stone, in a panic, drafted a
secret letter to the Committee of Public Safety, warning them that
they had misread the English temper and that the raid would be
a disaster, but assuring them that they had many friends in
England and urging peace talks. His plan was to get the letter
signed by the most weighty of the known 'friends of liberty' in the
country. He went from house to house among the Friends of the
People and other noted reformers, tried to see Fox and Lauder-
dale, saw Sheridan and some Londoners. But Jackson was be-
trayed and his letters to his control in Hamburg opened. On 24
April he was arrested in Dublin. Government must already have
seen a letter which Margarot, in the Hulks awaiting transpor-
tation, had sent to Norwich, talking of rumours that 70 French
sail were at sea and crying 'For God's sake, my worthy friends, do
not relax . . .'

It seems fairly clear from this safe distance that many people in
London, from some ministers to some insurrectionists, were in the
grip of a psychosis. During the last days of April and the first days
of May, Government, working in haste, some confusion and much
secrecy, haled man after man before the Privy Council and its
committees; Sheridan himself, as well as Stone and his friends,
were grilled. On 12 May, at 6.30 in the morning, Thomas Hardy
and Adams, secretary of the scɪ, were seized and their papers
confiscated. Confused police raids went out after eleven other

members of the two societies and the net grew wider daily. Pitt got a Committee of Secrecy from the Commons, on which he, Dundas, Burke and Windham served, convinced it that a 'traitorous conspiracy' was on foot, and on 17 May secured the suspension of Habeas Corpus. There were arrests and pursuits all over the country. The exact number cannot yet be ascertained. It was considerable and may have been very large, particularly after the suspension of Habeas Corpus; not a society or a group in any part of the country escaped; many suffered a devastating blow. In these circumstances, apparently wild talk of 800 warrants held ready and of Fox's fear of the Tower seems less implausible. Certainly in Liverpool that summer there was a minor stampede for the America boats.[21]

When the societies' papers were in, Jackson's were filed with them. There was no connection; the spy's material was useless. Wholesale preventive detention had served an emotional purpose, if no other, but there were a dozen men in the Tower and something had to be done with them. For six months government lawyers, sometimes near despair, wrestled with the problem and there was a hunt for new evidence. Finally in October Thomas Hardy, Horne Tooke, John Thelwall, John Baxter, Richard Hodgson, Thomas Holcroft and a half-dozen others were formally charged with High Treason.

Hardy, however, was lucky. He would stand before an English jury, with the great Erskine at his side. In Paris, at the time of his arrest, political artisans were going up before Fouquier-Tinville and the Revolutionary Tribunal.

CHAPTER FIVE

Anarchistes

'IMMORTELS Cordeliers . . . vous avez juré 100 fois de mourir, eh bien mourez donc car vous n'avez plus de liberté!' So *Robert Cordelier* to the Cordeliers on 21 March 1794, after the arrest of Hébert – *Père Duchesne*, Ronsin, former commander of the *armée révolutionnaire*, Vincent, of the 'sans-culotte' War Office, and Momoro, hero of the sans-culotte Section Marat. His despair was justified. In the destruction of the 'factions' in Germinal 1794 the sans-culotte movement, as a movement, was destroyed.[1]

The political occasion had its origin as far back as October 1793, when Robespierre, disconcerted by the de-Christianisation movement and the anarchic terror, had been warned by Fabre d'Églantine of a 'foreign plot' to discredit the Revolution through its extremists. In December Vincent and Ronsin were arrested as 'extremists', and some of the fiercer deputies on mission recalled. At the same time Desmoulins, Danton and the *Indulgents* began to press for a relaxation of Terror. The return of Collot d'Herbois from Lyons mobilised resistance to this trend around the Cordeliers and Hébert's press, and the exposure of Fabre's financial corruption and that of many of the *Indulgents'* supporters confused the situation further. The Committee of Public Safety returned to a central position as the feud worsened, but when the 'Hébertists' seemed to attempt an insurrection at a low point in the *crise des subsistances*, it struck savagely at both factions and destroyed them. The sans-culotte movement foundered with *Père Duchesne*.

This, however, was merely the occasion of disaster. The contradiction at the heart of the Jacobin-sans-culotte alliance was exposed as early as September 1793. On 9 September the permanence of Section assemblies was abolished; on the 17th the *comités révolutionnaires*, elected by Section assemblies originally, were made paid agents of the government and subjected to the Committee of General Security. Declared 'revolutionary until the peace' on 10 October, the government assumed wider and wider powers and consolidated its position in the 'constitution of the

Terror' – the decree of 14 Frimaire (4 December) – which turned
local officials into nominated *agents nationaux* and riveted an
authoritarian centralisation on the country. The sans-culotte
movement whose essence was spontaneity, initiative, 'anarchy',
could not be absorbed into a government machine and survive.
Often naïvely loyal to Robespierre and Convention, feeling a
closer kinship with Commune and *Père Duchesne*, cherishing above
all the vivid life of the autonomous Section, it went through a
contradictory and confused agony of decomposition – what its
historian calls a *dissociation*. This was the ineluctable paradox of
Jacobinism. To suceed, Montagnards had to discipline the very
spirit which gave them power. Under the reign of Virtue, Saint
Just was to complain – 'La Révolution est glacée'.

Central to the dissociation was the loss of spontaneous auton-
omy. Most ironic was the fate of the *comités révolutionnaires*, whose
members (*commissaires*) were the most militant – and most 'sans-
culotte' – of sans-culottes. Become salaried officials of the
Committee of General Security, they broke away from the control
of the Section assemblies. When Section de Popincourt, in Saint
Antoine itself, rebelled against its *comité*'s practice of co-optation,
it was snubbed by the Commune and denounced as a 'faction
désorganisatrice' by its neighbours in Montreuil. The *commissaires*'
power and arbitrariness provoked personal faction, often inflamed
by covert moderate intervention. In Section de la Réunion the
comité expelled a young clerk, Didot, for excessive zeal. He
denounced 'cette autorité monstrueuse inquisitoriale' and tried to
organise resistance among the *quarante sols* in the name of sans-
culotte democracy. He was promptly arrested, along with like-
minded 'anarchists' in Section de Bondy.

The *quarante sols* were the recipients of the 40-sous subsidy
ordered by the Convention in September, to enable poor working-
men to attend Section assemblies. Their role in the Didot imbrog-
lio was a symptom of strain. Their numbers were never very large,
since the grant of 5 September was quickly perverted into a means
test, many militants denouncing 'patriotes salariés', many wage-
earners demanding the money. In Section du Maison-Commune,
where there were over 3,300 voters and over 4,000 on poor relief,
only 195 men were paid the subsidy; in L'Homme Armé, with a
population of over 10,000, the number never rose above 90 and in
many Sections was lower still. Their entry, however, was sympto-
matic of a notable change in the character of assemblies and societies

visible in the early months of 1794. Attendance at assemblies remained rather low, in absolute terms, unless personalities or *subsistances* were involved. The assemblies, of course, had lost much of their sparkle; they had become cogs in a war machine. Saltpetre, *cavaliers jacobins, certificats de civisme*, relief and welfare, the digestion of interminable speeches and reports occupied most of their time. But observers noted with surprise and pleasure the appearance of people never seen in public life before. Particularly striking were the women and young people. In Cité, said one police agent, 'ce sont les femmes qui font la loi'. But precisely because they were simple patriots, all too ready to believe what the great Maximilien and his men told them, Jacobins expressed alarm. They would become tools of *intrigans*. It was soon clear whom the Jacobins had in mind. From November 1793 furious Montagnards began to denounce the *sociétés sectionnaires*.

These stemmed ultimately from the sans-culottes' fear of the *hommes à talent*. Under the law of 9 September permanence of Sections was abolished; they were to meet twice a week, later twice a *décade*. Nominally directed against the threat of moderate coups, this law in fact destroyed the very conditions of existence of the popular movement. It was circumvented. Section de Montreuil in Saint Antoine organised a society open to Section inhabitants under scrutiny, which was to meet whenever the Section assembly was not meeting; it was in fact a substitute assembly. At least 26 such societies appeared in the autumn of 1793. In Gravilliers and Contrat-Social the new societies ran up against older ones, which, with the help of the Jacobins, secured their suppression. But the movement could not be contained. Attempts at a Parisian federation irritated Jacobins and Cordeliers. In January a startled Commune banned a proposed youth organisation. Members of the societies, walking the streets in medals and *bonnet rouge*, were denounced as a new caste. In November 1793 the Jacobins began to refuse affiliation to societies founded since 31 May 1793; the Cordeliers themselves followed suit.

Their sectional character was said to expose them to infiltration by enemies. More significantly, they were said to inflame class division where none should exist. The worst enemies of the new societies were a Jacobin Dufourny and the Incorruptible himself; there were sneers at 'new' patriots, patriots 'de nouvelle couvée'. Government, which had allotted a surveillance role to popular

societies in October, was openly hostile by December. Couthon wanted no society to exist outside the Jacobin network.

Many militants, however, would have nothing to do with the Jacobins. Among those powerful, educated and all too fluent men, they felt naked; they huddled close within the kind of society which had given them victory in the Section battles. In response to Jacobin sneers and their own instincts they purged themselves again and again. In December, in Révolutionnaire (Pont-Neuf) they contented themselves with excluding signatories of the Petitions of 8,000 and 20,000; in Arcis they would admit no notary, clerk, man of law or merchant. By February in the Picques society they were imposing the most rigorous moral standards, directed as much against the indifferent as the hostile. Within the societies, *sans-culottisme* was becoming a cult, a sect, confronting the 'tartuffes en révolution' who filled the political world outside.

They began to take over the assemblies. They acted as a caucus, preparing measures and fixing jobs; the all-important *certificats de civisme* tended to pass to their control. The very rigour of their purges provoked the most 'non-political' hatreds. The situation was nowhere simple. In some Sections the *comité* itself controlled the society and through it 'worked' the assembly; elsewhere society and *comité* were rivals. Class-consciousness and different degrees of patriotic arrogance made matters worse. The chief result was confusion. But everywhere men of the societies drew away from the government machine which was swallowing up their confrères and tried to inhabit an other-world which Jacobins could not tolerate.[2]

The Maximum itself intensified the dissociation. Bread, though poor in quality, was now assured, but the black market threatened other commodities. On 21 February 1794 the Maximum was revised to allow for production and transport costs; a pound of beef went up from 13 to 16 sous and most prices rose stiffly. Workers in Government factories, where the wage maximum was usually enforced, were hard hit; those outside could exploit the labour shortage. Shopkeepers, guaranteed a 10% profit under the revision, became objects of suspicion. At the end of February supplies dried up altogether, as meat and vegetables disappeared into the black market. Queues formed at the butchers at three in the morning; police reports spoke of women weeping in the streets and men running about shouting aimlessly. Section officers raided shops and competed at the *barrières*; shopkeepers complained to the Commune, which began to denounce 'anar-

chists' and to talk of freeing trade, a surrender which in turn inflamed artisans. Caught up in this crossfire were those characteristically 'sans-culotte' officials, the *commissaires aux accaparements*. One of them, Pierre Ducroquet, *commissaire* for poor and crowded Section Marat, a simple man of fervent patriotism, was so maddened by black marketeers that he took direct and spontaneous action, which brought the guillotine on him. For he was swept to destruction in the *Hébertiste* débâcle.

The Cordeliers, infuriated by the government's toleration of the *Indulgents* and prompted by the newly-released and vengeful Vincent and Ronsin, who hoped to carry the War Office and the Parisian *armée révolutionnaire*, turned against the Robespierrist Committees. They reversed their stand on *sociétés sectionnaires* and began to denounce the usurpations of *comités révolutionnaires*; Momoro worked on the sans-culottes of Section Marat and Hébert swung the *Père Duchesne* into the campaign.[3] The food crisis seemed to open a path to power and on 14 Ventôse (4 March), in a scene of confused emotionalism, the Cordeliers veiled the Declaration of Rights in black and proclaimed themselves 'in insurrection'. This action seems to have been purely verbal and symbolic, but on the next night, in Section Marat with Momoro in the chair, Ducroquet, denouncing profiteers, veiled the Declaration and proposed a deputation to the Convention. There was uproar; some would not 'insult' the government and it was the *quarante sols* who carried the resolution, to be rebuked as disloyal 'anarchists' for their pains. A momentary reconciliation between Cordeliers and Jacobins broke down in a rash of street placards. A workman called Robespierre a cannibal; Vincent lashed at *cromwellistes*. Dufourny snarled back at the *sociétés sectionnaires*, who went into another paroxysm of self-purification, as crowds, many of them women, flocked to their meetings. At Bonconseil only 7 of 26 candidates were admitted. A veteran revolutionary of 68 was refused because he called his interrogators *messieurs*; a man three times Section captain was rejected as 'un peu faible'. In Lombards women took sides and patriots left the meeting in tears. There was hardly any connection between the popular anguish and the Cordeliers' political campaign, but the Robespierrists decided to finish with faction.

On the night of 23–24 Ventôse (13–14 March) Hébert, Ronsin, Vincent, Momoro, were arrested. In one of Fouquier-Tinville's more remarkable *amalgames*, Cordeliers, men of the *armée*

(military plot), foreign *exaltés and* royalist agents (foreign plot), *subsistances* officers (plot to starve Paris), were swept to the guillotine on 24 March. Twelve days later, it was the turn of the *Indulgents;* within a week, Chaumette, Archbishop Gobel and the widows of Desmoulins and Hébert (together!) went to the scaffold. The Republic of Virtue had begun.

To the guillotine, as a *Hébertiste*, went Ducroquet. 'Au grande Sir Constance il faut un grand Caracter', he wrote to his wife, '. . . tout mon Crime et d'avoir été trop a nimée pour le bonheur de ma patrie et Désiroient voir tous les Citoyens Contemps . . .' His mother, writing from Amiens in a letter he never saw, was a little uneasy because she thought she had seen his name in the journals – 'Ce nom de Ducroquet ma Saisy.' Many others were aghast at the names now proclaimed traitorous. Danyaud, a humble patriot, hearing the 'Hébertistes' called traitors in Caen, passionately denounced rumour-mongers and was arrested; he had not read the papers. Jean le Creps, hero of all the *journées*, was arrested because he had once served in Vincent's War Office. The police, unable to find Jean Marquet, printer of the *Père Duchesne*, arrested his father instead.

The number of so-called *Hébertistes* arrested was small, perhaps thirty. But the moral shock was shattering. Moderates rushed to denounce 'extremists'; Marat's memory was reviled. In Section Révolutionnaire (Pont-Neuf) the very men who figured so proudly in Schell's painting went to prison; Section Marat was purged. In many areas in the provinces it meant the abrupt end of sans-culotte hegemony. Even in police reports one senses a sudden 'withdrawal'. Section assemblies went grinding on about saltpetre and welfare, but the *silence* on some issues was deafening. On the night of the executions crowded meetings listened in silence to Saint Just's speech on faction, voted the stock congratulations and passed to the next item on the agenda. In L'Homme Armé a sixteen-year-old recited a patriotic piece – 'Des femmes, en pleurant, disaient: Grand Dieu! comme cet enfant parle bien!' After months of clamour, what is most striking is the sudden, deadly silence. 'Moi et mon mari,' said Le Creps' wife, 'nous allons nous retirer de toute société et nous n'allons plus voir personne. . . .'

Government moved remorselessly on, for what had been on trial in Germinal was *sans-culottisme* itself; if *Père Duchesne* had been 'unmasked', what was left? On 7 Germinal (27 March) the

Parisian *armée révolutionnaire* was dismissed. Some detachments protested, but most trailed back to their shops. A few days later general rationing was rejected, trade control was relaxed and the *commissaires aux accaparements* – indeed, the very word *accapareurs* – disappeared. The War Office and its bureaux were abolished. The Commune was purged; mayor Pache was arrested and the municipality became totally Robespierrist. Maximilien (le Cruel, as the imprisoned Gracchus Babeuf called him) resumed the campaign against the *sociétés sectionnaires* as early as 16 March. Once again Jacobins exploited moderates' complaints and male prejudice against women in politics. Rather pathetically, the societies tried to 'redeem themselves' by another purge, which made matters worse. There was a visible loss of self-confidence; many transformed themselves into educational societies. But the Jacobins were not to be denied. In Section Brutus the Charlemagnes, father and son, both government men, proposed that the society dissolve itself; its job was done, now all must rally around the Mountain. On 30 Germinal (19 April) the society announced its suicide to the Convention. Collot and Couthon insisted that the Jacobins be the only centre of organised opinion. Amid stifled protests and brief outbursts of rage the sans-culottes' retreat became a rout. Between 14 and 24 May thirty-nine popular societies were dissolved.

Sans-culottes within the Jacobin machine disappeared into total orthodoxy. Sans-culottes tainted with 'Hébertism' disappeared into sullen disaffection. The sans-culotte rank and file disappeared into humdrum administration or from political life altogether. The sans-culotte movement, as a movement, ceased to exist.

From this point to the staggering final *journée* of Prairial 1795 the history of what remains of *sans-culotterie*, while fascinating, has a largely 'archaeological' interest. Through the incredible months of the Republic of Virtue and its Great Terror, months of noble speeches, unrealised social and educational programmes, victory at home and abroad, of the Supreme Being and Maximilien in his sky-blue coat, a frenetically accelerating rate of executions, the unnerving 'silence' of the sans-culottes continued. Orthodoxy, loyalty, interminably stereotyped speech, were the order of the day. There were rumbles of trouble. Bouland of the Gobelins got into trouble again as a 'motionneur à la Jacques Roux'; the Marat cult disturbed minds attuned to the Supreme Being. Some of the fiercest militants were coming to share the 'nausée de la guillotine',

some began to denounce the Terror, which now bore little relation to sans-culotte feelings; a third of the victims were from the *menu peuple*. Legray, *commissaire* of Section du Muséum, was arrested for demanding the end of revolutionary government, the restoration of Pache, and the constitution of 1793. Early in Thermidor Barère was denouncing the 'heirs' of Hébert, and Bouchotte was arrested.

Most of the rank and file who remained committed to politics seem to have clung to Robespierre as the last honest leader left, but even this faith was soon dented, for on 5 Thermidor (23 July) a new Maximum of wages (not hitherto generally applied in Paris) was enforced. A carpenter, whose pay had gone up from 6 to 8 livres, found it cut by half; many men were hard hit. There was agitation in the streets, and when the coup of 9 Thermidor (27 July) was launched, many at first thought it a *journée* of wage-earners.

The coalition of ex-terrorists, disaffected members of the Committees of Public Safety and General Security and frightened deputies who outlawed Robespierre and the Commune in which he had taken refuge was faced at once with a traditional call from that Commune to the sans-culottes. It did not go without answer. The *canonniers*, the hand-picked revolutionary élite of the Section forces, responded traditionally. Seventeen companies of artillery rallied, sometimes against the will of the Section authorities. By seven in the evening, there were 3,000 men at the disposal of the Commune and it seems to have been a failure of Robespierrist will which prevented them from defeating the Convention. But the Convention had decentralised the National Guard command, and the direct confrontation between Convention and Commune precipitated an agonised conflict of loyalties in many areas. Most of the west, as might be expected, rallied to the Convention at once, but the Commune had strength in the centre and east. Interestingly enough, many *comités révolutionnaires* went to the Convention while many *comités civils* joined Robespierre. If one looks very hard, one can perhaps detect a quicker rally to the Convention in districts noted for their 'Hébertism', but one needs a microscope. In truth, the overwhelming impression is of confusion, bewilderment and, above all, apathy. There had been too many 'betrayals'; what had died in Germinal was the sense of *participation*. The effect of Robespierrist centralisation, said the Jacobin Chalès, after Thermidor, was to 'dérévolutionner indi-

vidus et sociétés'. The 3,000 in the Place de Gréve, without orders, began to drift away, and when the Robespierrists went to the guillotine and the Commune was massacred, the only unambiguous comment was plebeian – 'Et voilà le Maximum dans le panier!'

Thermidor, after an ambiguous pause, unchained a massive, rolling reaction against the Year II. The White Terror, often led by ex-terrorists and former Girondins, was a revenge terror and many areas were spared, but in civil-war districts and particularly in the bloodstained Midi, murder gangs, by the spring of 1795, were hunting Jacobins, sans-culottes and Protestants and committing prison massacres every whit as ferocious as those of September 1792. *Jacobins de village* were left to the mercy of clawing Catholic women.[4] In Paris men of the respectable classes took revenge, personal and social, and the *menu peuple* were driven out of public life. There was a violent reaction against the style and morality of egalitarian democracy; *tutoiement* and *citizen* vanished. The ex-terrorist Fréron organised his *jeunesse*, young men of 'good' family, often avoiding military service, often after Section jobs for that reason, street-fighters in elaborate clothes and hair styles, who beat up democrats, whipped impudent women, destroyed busts of Marat and drowned the *Marseillaise* with their song of vengeance, the *Réveil du Peuple*. Step by step, the machinery of revolutionary government and economic control was dismantled. As 'society' re-emerged in a rather frenetic gaiety and amorality, the assignat plunged to utter disaster and after the ghastliest winter in memory, with rivers frozen, famished wolves in town streets and a soaring death and suicide rate in Paris and some provincial cities, dearth and inflation drove people into massive hunger revolts suppressed, for the first time, by military force.[5] Brigandage paralysed some districts, and armies with their own supply systems grew into semi-independent satrapies as the Thermidorian constitution restored power to the *notables* and the Directory began its oscillations between royalists and 'anarchists', finally to succumb to Bonaparte.

The immediate effect was to complete the dissociation of *sans-culotterie*. Its withdrawal from public life, begun at Germinal, was confirmed. On 21 August, the 40-sous subsidy was abolished and Section meetings reduced to one a *décade*; times of meeting were later changed to deter working men. Outside Gravilliers and Saint Antoine there were few societies left – Robespierre had seen to

that. On 24 August the Sections were grouped into twelve *arrondissements* and their *comités révolutionnaires* disappeared; the Commune stayed buried. By 1795 attendance at a Section assembly was down to a couple of score as the affluent slowly returned. It was this *disappearance* of sans-culottes which enabled the *jeunesse* to dominate the streets; when the *menu peuple* returned in the spring of 1795, the young men were thrown into fountains and had their hair clipped; in the massive food riots they were, literally, flattened. But in the autumn of 1794 there was a void. On 6 December a handful of men and women met at the Cordeliers and sat in absolute silence.

The Jacobins, drenched in the vituperation of a hostile press, kept hold of a couple of journals and a dozen Sections; with Robespierre gone, they talked more like sans-culottes, but were committed to the revolutionary dictatorship, which exposed them to the attacks not only of resurgent moderates but of old enemies on the left now emerging from prison or obscurity. Men like Gracchus Babeuf, Legray, Varlet, commanded support in several sections – Muséum, Panthéon, Gravilliers – and joined the onslaught on former *commissaires*. Jacobin efforts to rouse the faubourgs ran into the old quarrels in Popincourt, while Saint Antoine withdrew into surly silence. Not until November did Babeuf change his tune and start to call for union and a new insurrection.

For in November, exploiting the reaction against the trial of the Nantes survivors and a Jacobin call for renewed terror, their enemies set about the destruction of the former revolutionary leadership. The *jeunesse* raided the Jacobin club and forced its closure; Babeuf's society was suppressed. Moderates took over Section after Section and the prisons filled with 'patriots'. As the vile winter drew to its close and the Midi drew near to massacre, the *jeunesse* launched a campaign against Marat's memory, destroying his busts, presiding over the removal of his remains from the Panthéon. Saint Antoine, in a sudden welling up of social hatred, began to move and, in half-panicky reaction, moderates drove to take over every Section except Bondy and deafened ears with propaganda against *buveurs de sang*. In at least thirty-seven Sections, and possibly in all, commissions hunted former militants and even rewrote Section minutes to consign unfortunate events to the memory-hole. In eleven Sections at least 200 individuals were arraigned, mostly former *commissaires*

– the 'government sans-culottes' now left isolated, but also soldiers, *cannoniers* and other 'contagious individuals'; hounded as pariahs, many were ruined. Yet, even as vengeful bourgeois took command in Section de la République, 300 *ouvriers*, most of them employees of former Jacobin militants, stormed in protest. The popular movement was coming blindly back into action at a moment when its traditional leadership had been driven into prison or paralysis.[6]

So to generals without armies succeeded armies without generals. The *journées* of Germinal and Prairial in 1795, in consequence, were massive 'spontaneous' and 'leaderless' uprisings by the *menu peuple*. But this was not 1789; in many ways it is the *politicising* of elemental revolt which is their most interesting feature. More central than ever was consciousness of betrayal. For their situation was by now desperate. The Maximum was abandoned in December, foreign trade was freed, public workshops were closed. Local control and rationing were maintained to avert actual starvation, but the assignat collapsed in an insane inflation. The hideous winter and the European dearth of 1795 reduced the bread ration to two ounces a month in some Sections. The death rate in Rouen and Le Havre and probably many other places rose sharply. By the eve of Prairial in Paris dearth had become famine, suicides were a daily commonplace, women and their children were throwing themselves into the Seine. It was famine of the most stark and disgusting kind, for the markets were full of some commodities and the rich were gay. When one woman collapsed from hunger in the street, bourgeois passers-by fed her on cake.

A terrible disillusionment and an awful anger seized the *menu peuple*, particularly the women – 'on les a trop souvent trompées'. Some called for a king, but most looked to a more recent precedent – 'Sous le règne de Robespierre le sang coulait et on ne manquait pas de pain.' By late March 1795 the streets were in turmoil. On 1 Germinal (21 March) crowds swamped the Section assemblies of Saint Antoine and marched a deputation to the Convention which beat up the *jeunesse* and cut their hair (women wanted to eat their hearts). A week later women of Gravilliers, 600 strong, supported by master-craftsmen at the head of their men, tried to force the summoning of an assembly, as sans-culotte pressure suddenly rose in other Sections. Some of the men who came to the fore were former militants, usually of the National Guard; others were new; conspicuously absent were former *commissaires révolutionnaires*. The

instinctive response, clearly, was to reactivate the old Section organisation. This theme was developed by the most famous of the pamphlets and placards which appeared at this time – *Peuple, Réveille-Toi*. It called on them to resume control of the Sections and to demand the constitution of 1793. On 12 Germinal (1 April) this they tried to do. In a disordered insurrection, women running the streets and jeering at the men as 'cowards', Van Heck, a Year II militant, backed by a mass meeting at the Temple of Reason (*ci-devant* Notre Dame), tried to force the Cité Section into insurrection; similar efforts at Gravilliers and Saint Antoine failed to win the National Guard. Ultimately a crowd of some 10,000 swept aside the *jeunesse* and broke into the Convention, where Van Heck demanded food, the constitution of '93, the end of the *jeunesse* and the release of arrested 'patriots'. When Montagnards had talked the crowd out, government struck hard.

Barère, Collot and Billaud, whose fate had been uncertain, were ordered into deportation and eight deputies were arrested. More significantly the mass disarmament was ordered of all those responsible for the 'horrors' of Year II. To militants this was the ultimate humiliation, expulsion from community, degradation to pariah status. Proscription lists of the 'cannibals' were prepared hurriedly and haphazardly, brimming with personal spite and social malice. Some 325 men are known to have been disarmed in 10 Sections, which indicates a possible total of around 1,600. The National Guard was reorganised and its élite units recreated in an attempt to oust the plebs. And in the following month famine, social hatred and suicide reached their peak, as massacres began in the Midi and refugees ran to Paris. Women spat anger at the 'cochons gras' of the Convention. The insurrection of 1 Prairial (20 May), remarkably enough, did not massacre the deputies, but it was full of hate.

Buonarroti, the colleague of Babeuf, later claimed that the *journée* was planned in the prison of Plessis. It is not inconceivable; many of the placards before Germinal probably originated among those clandestine meetings of men of the Year II so assiduously reported by the police. But the prison plan we know of, that of Brutus Magnier, a Robespierrist, differs markedly from the pamphlet most widely circulated in Saint Antoine on the eve of the rising – the *Insurrection du Peuple*. In many ways, this, the sans-culottes' last revolt, was the most characteristic. In it 'economic' and 'political' grievances are one. The objectives set out in the

Insurrection were *Du Pain* and *La Constitution de 1793* – many wore
the slogans on cap and blouse; they planned to release prisoners,
re-establish the Commune and reimpose economic controls. As in
1789 the movement grew out of bakery riots and women were in
the van – very markedly so. This time, said the *Insurrection*, they
were not to work through the Sections and the 'chefs vendus' of
the National Guard. It was to be the ultimate in sans-culotte
spontaneity – 'Les citoyens et les citoyennes de toutes les sections
indistinctement partiront de tout point dans un désordre
fraternel'. Once the people were *debout*, the sovereignty was theirs
and all institutions were suspended. Confrontation would be
direct: no Commune, Cordeliers or Section stood between.
Finally, the heart and soul of the movement was the Faubourg
Saint Antoine.

It was the women who followed the *Insurrection*. After an early
start in the Jardin des Plantes, where women and timbermen tried
to force the summoning of the National Guard, about seven in the
morning the tocsins rang and great crowds of women began to run
through the streets, in Section after Section, calling the men
'cowards'. There were scenes of shattering violence in Arcis,
Luxembourg and some of the wealthier districts. In the Quinze-
Vingts (Saint Antoine) a huge crowd of women burst into the
committee room, smashing tables and furniture; they broke the
commandant's sword, pulled him around by the hair and dragged
out the cannon from the armoury. In several Sections they beat
the *générale* themselves. By the hundred, in companies, they
marched to the Convention, to fill the galleries and drown pro-
clamations of outlawry with cries of 'Du pain! Du pain!' Finally,
the women of Saint Antoine, led by Catherine Vignot, a *charbon-
neur* in her men's clothes, beating a drum, burst in with a terrible
clatter.

The men were slower off the mark and much more traditional.
Despite the *Insurrection*, in Section after Section there was a des-
perate struggle for the soul of the National Guard command. The
Convention called out the Guard itself to reinforce its regular
troops; the western districts were loyal, but many battalions
arrived hopelessly divided, with the revolt's slogans in their caps.
The three battalions of Saint Antoine, gathering crowds, marched
down, leaving their commanders behind. An enormous crowd
milled about the Convention. The women were driven out by
whips and bayonets, but men, in a series of attacks, broke down

the doors, killed a deputy, paraded his head on a pike, and flooded into the hall. In scenes of rage and utter confusion, 'unknown' men bobbing up as temporary leaders, they read the *Insurrection*. The people were *debout*.

But they made no attack on the government committees, which were organising counter-measures. Hours of muddled but effective 'fraternising' outside and of 'decrees' inside, where Montagnards were given rope to hang themselves, gradually got the crowds to disperse and, near midnight, loyal troops cleared the hall. The arrest of fourteen deputies was ordered. The next day, realising they had been duped, sans-culottes staged a yet more disordered revolt. There was a brief attempt to revive the Commune. *Cannoniers* of Saint Antoine got their brothers to train their cannon on the Convention; one match was actually lit. But no one fired (the gunners, of course, were male). Once more they were bamboozled by *hommes à talent*. By the third day, the movement had collapsed; only Saint Antoine remained. Military forces ringed the suburb in a regular siege. The first attempt to penetrate was a fiasco, but a more formidable invasion was prepared, and with the whole population under threat of outlawry and amid agonising scenes the Faubourg surrendered.

This gigantic, final, at once impressive and futile insurrection unleashed the severest repression of the Revolution. An unprecedented military commission tried nearly 150 people and condemned 36 to die. In Paris alone, getting on for 4,000 people were arrested and disarmed. Most were amnestied, but they were marked men; the leading figures were singled out, ostracised, hit by repeated, pounding, police operations. Many were ruined. *Sans-culotterie* was pulverized. After Prairial in 1795 there was to be no serious popular rising in Paris for a generation.

CHAPTER SIX

Acquitted Felons

THE treason trials of 1794 confronted the artisan societies with the problem which dominated their lives, that of alienation from the English nation.

By 1796 it seemed insoluble. In that year John Ashley, secretary to the LCS, gave up. He was doing well as a shoemaker, but public affairs utterly depressed him. His wife was a methodistical shrew, and he had taken up with a woman once 'in high keeping', to the disgust of his friend Francis Place. In 1796 Ashley crossed to France. He tried to persuade Place to go with him, along a well-known clandestine route which used Dutch boats. What must intrigue anyone familiar with the later Place is the fact that he nearly went; it was his wife who stopped him.[1]

Place had joined the LCS *because* of the trials, as did other indignant and sensible men. It took courage. The sensationalism of the arrests set off an explosion of loyalism more spontaneous than that of 1792. Press, ballads, broadsheets clamoured; there was violence in the provinces. Some gloated over the death of Mrs. Hardy, patriotically terrorised by a crowd celebrating the naval victory of the First of June. Eighteen divisions, 'panic-struck', did not meet, and many country societies, crippled by arrests, shut down. The secret executive, complete with spy, went 'on tramp', and energies were drained in a desperate hunt for funds.

Six months later, when Hardy and the others were acquitted, there was another explosion. Ballads, broadsheets, even some newspapers, hailed his release. Crowds in the provinces cheered the mail-coaches; Baptist congregations burst into 'Praise God from whom all blessings flow'. Crowds chaired the shoemaker to his lodgings, and in some places there were bonfires. It was all very like a naval victory. The assessment of 'public opinion' at this time is a Bedlam job.

The trials, of course, the dignity of Hardy, Tooke's cheek, the unscrupulous brilliance of Erskine and the discomfiture of the high and the mighty are one of the *moments* of British history,

touching the nerve of the free-born Englishman. But, despite the acquittals, nothing could be the same. An iron curtain shut off the artisans from English political society. They knew themselves to be 'acquitted felons'.[2]

The LCS was back in action in November, but recovery was slow.[3] It published a *Vindication* and called for peace and social reforms; in December it even brought out one number of a journal, the rather inaptly-named *Politician*. Its *Seasonable Caution* against agents-provocateurs was more realistic, for it was riddled with spies. After its assistant secretary, Joseph Burks, was approached by government men in January 1795, the society sent a stinging rebuke to the Home Secretary, offering his agent a seat on the committee: the chairman who signed this letter was himself a spy. During the worst winter of the century suspicion poisoned disagreements, and in March there were wholesale defections, which reduced the society to 17 divisions.

At this point there was another sudden reversal of fortune. The hunger, misery and anger of 1795, which reached their climax in the mobbing of the king in October, sent membership figures soaring. Doubling the number of its divisions, the society renewed its country correspondence in May. There was a highly successful mass meeting in June, and in October, on the eve of the crisis, when it held a huge meeting at Copenhagen House, 200 were joining every week; its paper membership passed 10,000, with perhaps 2,000 active.

During these few months of 1795 the artisan societies seem, for the last time, to be fully visible. This impression is itself an illusion, for after the shocks of 1794 there were always at least two faces to the movement. In October, in a characteristic gesture, the LCS published its correspondence.[4] It seems painfully cautious, warning everyone off riot, republicanism and religion, deploring the July disturbances in London as an aristocratic plot, refusing to print correspondents' names. The provincial societies were more timorous still. There was however an underground correspondence and the rage, mockery and fierce polemic which poured from such presses as Citizen Richard Lee's suggest what it was like.

The published letters bring to life a movement slowly recovering from the hammering of 1794, diminished and defensive but not yet demoralised. Some convey the genuine atmosphere of parish-pump *Jacobinism*. 'Roused from our stupor', the men of

High Wycombe reported a society which had grown from three to only twelve men in five weeks. 'The ignorant and Aristocratic inhabitants having misconstrued our *intentions* into criminal *designs*, alarmed many well intentioned Citizens.' But – 'THE MAYOR was induced to pay us a visit'. Having heard their case, he pronounced himself a friend to liberty – 'You will not be interrupted, therefore persevere and OBTAIN YOUR END.' Whitchurch (Salop) had even higher authority. 'In this aristocratic town,' ran their report, '. . . even in such a desert . . . CITIZENS . . . men have listened to the voice of truth . . .'

At another extreme were Sheffield, 'more hearty in the cause than ever', and Norwich, where there were 19 divisions, a rapid increase and a heavy publication programme, including J. T. Callender's Scottish-Republican *Political Progress of Great Britain*. Birmingham blasted 'theological bugs', and all denounced the 'liberticidal war'. Portsmouth was legalistic about king, lords and commons, but its *nobles* were not hereditary and its commons were *deputies* subject to recall. Their town was not, as many thought, one of the 'hives of Aristocracy'; on the contrary, the complexion of the inhabitants was 'purely Democratical', but they feared to speak from 'the certainty of being discharged from their relative situations in the Dock Yard for so doing'. From the north one man reported that the populous villages around Bradford and Leeds were full of real patriots, that in Wakefield patriots were strong, 'though not quite so bold as in Sheffield'. Leeds, celebrated for its patriotism, had not been heard from for some time, but a few merchants there still helped to relieve the distress of 'victims of ministerial vengeance'. He had not much hope of Bradford itself, 'first in the west riding for a domineering aristocracy'; the society there had been broken up by the suspension of Habeas Corpus, and while there were many patriots, 'there appears to be a majority of aristocrats'.

The vocabulary speaks for itself. The public voice of the LCS however was impeccably English. Its major publications of the year were the report of its own June meeting, the *Duke of Richmond's Letter*, which dated from the 1780s and a very workmanlike *Report on the Representation*, prepared by the Friends of the People for their motion in 1793, which the LCS published in thousands at threepence. The only discernible attitude to national politics, apart from opposition to the war, was a profound distrust of Whigs; the people were not to be the 'hobby-horse

whereby they might stalk to power'. Otherwise, the published objective of the society was 'to rescue the Democratic part of the Constitution from the all-devouring jaws of Aristocracy'.

A very different picture emerges from the myriad pamphlets which came spitting off the London presses. Vigorous, pungent, scurrilous, often effective, they were anti-monarchical, anti-war, sometimes anti-merchant. Like their enemies, they conducted a brisk polemic over the France of the Thermidorians in terms of the France of Robespierre. Often critical of property, those issued by Citizen Lee were sometimes violent. Variants of *The Rights of Swine, The Happy Reign of George the Last, Address to the Hog Drivers of Europe* and many others, with songbooks and woodcuts, were strong meat. Lee used a French dressing; his were the specific references to 'equality of enjoyments' and he had a sans-culotte fondness for the guillotine.

The LCS was clearly in ferment. The secessions of March 1795 stemmed from a quarrel between John Bone's Division 12 and Joseph Burks' Division 16 over charges of spying made by the latter. Some hated the thought of a formal constitution for the society, while others insisted on it. The divisions broke off to form new societies. Bone's people, the London Reforming Society, were strong on book clubs and education; the issue of the Whig *Report* was their idea. The Friends of Liberty of Burks included John Baxter, who had been tried with Hardy, and Thomas Williams, who may have been the deist of that name. Grand in style and French in temper, they met at Shacklewell and favoured Henry Redhead Yorke. Baxter in this year wrote *Resistance to Oppression*, which attacked the life-and-death power of landed property, and his group were probably more 'anarchist'. As early as 1793 one division had called for the expulsion of 'levellers', and in September 1795 a strong group of Methodist members demanded the exclusion of atheists and deists and seceded when the executive refused. One spy thought the LCS might lose six divisions and several hundred members on this issue alone.

Running through all arguments was the problem of policy, of how to cope with political excommunication. Some favoured an honest fight in the open in traditional style – an adventure which appealed to men like John Gale Jones, John Binns the London-Irishman and John Thelwall, now running a lecture campaign with much power and success. Francis Place, on the other hand,

advocated withdrawal. The 'system of alarm' would ultimately disgust the political public, and the uneasy coalition of Tories and Whigs would fall apart; the society must ready itself for the day. In effect this meant contracting out, creating what one man called their own Common Wealth of Reason. This could be *spiritually*, a more radical course than any; touching a natural instinct among many, it would drive them back to 'first principles'. It was Place who organised the cheap publication in 1796 of Paine's barrack-room-lawyer Bible criticism, *The Age of Reason*. The third line was insurrection. In practice this meant conspiracy with the French and Irish. Despite some pamphlet rhetoric, this was not a force before 1796–97. For at the end of 1795 they were offered one last chance to break into the political world.

The crises of 1795–96 were decisive. By the summer of 1795 an English version of the *pacte de famine* was appearing in the pamphlets. The Hog Drivers, having failed with Americans and sans-culottes, were turning their blockade on the people, driving food from the table, peddling their poisonous mixed *M* flour and slaves' potatoes, starving a man into a Johnny Crapaud, the better to enslave him. Government had in fact taken over the grain trade in 1793 for its unprecedented blockade; uncertainty, the withdrawal of merchants, the deceptive quality of the inadequate 1794 harvest, diminished imports, so that the European dearth of 1795, following a ghastly winter and a meagre crop, produced catastrophe. Prices rocketed to unimaginable heights; in the Eton and Oxford records they were the highest since the sixteenth century; in many places, grains disappeared. The sufferings of the poor were appalling.

Wave after wave of food riots, price-fixing actions, seizures of grain, broke over region after region, reaching a climax in the autumn. Millers and corn factors were attacked. In several places the militia mutinied; much military and naval strength was pinned down to the transport and protection of supplies. Every district fought for its own; it was feared that Birmingham would sack Burford. Crowds in the country, often backed by their magistrates, stopped the movement of food; *taxation* in the cities was condoned by the magistrates there. In county after county J.P.s threatened to apply the old obsolete laws against forestallers, engrossers and regrators – the English *accapareurs*; Justice Kenyon himself held that, though the statutes had been repealed, the offences were still offences at common law. The paternalist

economy came back into its own in many areas in direct assaults
on free commerce. It was in May that the Speenhamland magis-
trates introduced their scheme of wage supplements tied to the
price of bread. A minimum wage plan failed to pass the Com-
mons, but government gave the nod to Speenhamland, and the
'system' spread over a wide area – the English Minimum as
opposed to the French Maximum.[5]

By autumn in some places passions were fierce. 'You did not
shoot us when we were rioting for Church and King . . . now we
are rioting for a big loaf, we must be shot at and cut up like bacon
pigs!!!' was the cry from Birmingham. The LCS found an
enormous crowd turning up at its meeting at Copenhagen House
in October. There were three tribunes, but still half the people
could not hear the speakers. This vast assembly, with its hordes
of women and children, left an abiding impression; it was
probably one of the largest gatherings ever assembled in the
capital. Thelwall kept them calm and they voted a *Remonstrance*
to the king – 'Why, when we incessantly toil and labour, must
we pine in misery and want?' But three days later, when the king
drove to open Parliament, huge crowds carrying tiny loaves
in black crêpe and shouting for peace, hooted him. One man
jumped on the coach and tried 'to lug him out by the collar';
someone shot at him with an airgun or sling.

At once, there was a crashing reaction. Public opinion was
incensed, and loyal Addresses poured in. Government seized the
opportunity. An immediate proclamation against seditious
assembly was followed by the celebrated *Two Acts*. Incitement
to hatred or contempt of king, constitution and government
became treason; no meeting of more than 50 people could be
held without permission; a clause, aimed at such as Thelwall,
allowed lecture halls to be classed as disorderly houses. Resistance
to magistrates was made punishable by death.

Whatever the circumstances, this was the most serious in-
vasion of traditional liberties since the Stuarts (who reappear in
popular pamphlets). The Foxite opposition, before its secession,
took a campaign to the country. Wyvill went back into action.
The LCS held two more monster meetings. There were others in
the counties, notably the gathering at York, where Wilberforce
overwhelmed Wyvill's men and an enraged Colonel Thornton
flung his regimentals to 'the rabble' and was chaired to Guild-
hall. It was all useless. The government, edgy though they were,

had a firm base in the political public; the protests among the
unenfranchised were confused and contradictory. There was no
fusion of social and political discontent. The acts went through,
and in some areas public dissent was immediately stifled and
noisy individuals packed off to the fleet. While local authorities
resorted to price-fixing and wholesale intervention in many areas,
government returned the oversea grain trade to the merchants,
but in hasty interventions and broken pledges made raids on
foreign markets, stored grains and released them massively when
prices looked dangerous. In blundering good fortune, ruining
many merchants in the process, they got themselves over the
hump by mid-summer 1796. And by that time, the popular
societies knew that, as an organised force, they were finished.

The failure of this English *crise des subsistances* to have any serious
political effect is striking. It reflects, of course, the basic strength
and resilience of English society, the absence of any revolutionary
situation. It is significant that, whereas in some areas people were
on the edge of starvation, in many others workmen rioted because
they could not get the good white bread they had grown accus-
tomed to; they refused to accept substitutes. Nor was the demo-
cratic movement itself in any meaningful sense revolutionary.
Granted this, it is still significant that democrats failed to derive
any permanent political benefit. Remoteness from power seems
to be one factor. Sans-culottes, in a revolutionary situation, had a
limited but real *power*; much of their debate and action was
concerned with the exercise of that power. Never at any stage of
its existence did the English movement concern itself with power,
except as its victim; it could not. Its most dramatic expression
of dissent was the Convention campaign of 1794: a defensive
gesture. Its most impressive demonstration of mass support was
October 1795: a remonstrance.

It could not integrate 'economic' grievances into a political
attitude, as sans-culottes did. It had no purchase within the
political world. The most remarkable feature of the *Two Acts* is
their easy acceptance, not so much by Tories, as by the judiciously
liberal, the salt of British libertarian earth. Over in Philadelphia,
according to Cobbett, the Jeffersonian editor Bache rushed to
meet every English boat to hear of the overthrow of this utterly
'un-English' government. It is easier to understand him than those
commentators whose even flow is not a whit deflected by the *Two
Acts*, the repeated suspensions of Habeas Corpus, the seditious

meetings act of 1801 and the rest. The prompt acceptance of
so much emergency legislation by a nation which so preened
itself on its constitution puts one in mind of the Robespierrist
paradox of Constitution and Despotism of Liberty. British govern-
ment from 1794 to 1802 was, in fact, 'revolutionary until the
peace'. That this policy had massive support is clear. Both its
extent and the degree of 'immobility' within this 'state of siege'
have been exaggerated, the latter grossly. Most significant for the
popular societies was the acquiescence, from whatever cause,
of the customarily liberal. 'Men of property will not come boldly
forward and declare their detestation' – this becomes a perman-
ent theme in popular correspondence. Within a year or so came
the national crisis of 1797–98, naval mutinies, Irish rebellion,
bank crisis, threat of invasion – and the menace this time came
not from a 'sans-culotte' republic but from the ambiguous
régime of the Directory, which made a mockery of Jacobins,
royalists and sans-culottes alike. The almost tribal patriotic
response (which affected artisans as much as anybody else)
so identified the internal with the external state of emergency
that *Jacobins* were left in the predicament of Elizabethan Catholics.
They lacked, however, a credible Rome. The last debate in the
executive of the LCS took place in April 1798, on what action to
take in the event of a French invasion. The secretary, one of
Place's 'sectarian fanatics', denounced the French régime and
proposed that they all join the Volunteers; he was opposed on the
ground that one could not make a policy out of defending the
bad against the worse. This singularly 'modern' argument was
terminated by wholesale arrest. In terms of external reference, not
until Spanish 'sans-culottes' rose against Napoleon was it again
possible for populism to be unambiguously patriotic. It was in
1808 that John Bone brought out *The Reasoner*, which was both
British-nationalist and *Jacobin*. Curiously, it was to be through
Spanish revolution that the word *Citizen* re-entered radical
discourse.[6]

Citizens in 1796, however, could hardly open their mouths in
public. The *Two Acts* were the full stop. Most serious was the
collapse in morale, the kind of hopelessness to which Ashley
succumbed. 'Some thought it dangerous, some thought it useless
to meet again,' said Place and the thousand active LCS members
of February were down by a half in June. The society tried to
hold itself together with a magazine, full of Thelwall and worth

reading, but a strain on resources; Place resigned from the executive over it. His own plan to publish *The Age of Reason* provoked further disagreement, and in the autumn there was a sudden drop. An attempt to hold a public meeting in 1797 led to the arrest of the entire committee and the character of the society changed overnight. By this time it had shrunk to a sect of some 200 passionate men, and only the 'hards' – Thomas Evans, a land nationaliser, Binns, an Irishman of '98, were left. During 1796 most of the provincial societies disappeared from sight.

There were still thousands of *Jacobins* around, of course, but they contracted out. One can detect what the French, in Lefebvre style, call 'biological' reasons; briefly, heads wearied of stone walls. Hardy retired after his trial; Ashley went to France. Place had more or less pulled out by the end of 1796. Thelwall, after heroic efforts during that year and a brief idyll with Citizen Samuel Coleridge, went into 'exile' at Llys-Wen in Breconshire. There were notable migrations. Misery drove thousands, particularly in the north, into the army and many of these, as government was soon aware, were *Jacobins*; there were 15,000 Irish in the fleet at the time of the mutinies. The emigration to America, despite appalling difficulties and official hostility, was striking. Apart from the celebrated names who take the headlines – a Priestley, a Cooper, a Gales – there was a modest but highly distinctive movement, at its peak between 1795 and 1800. Of several hundred British (excluding the many Irish) who took out citizenship papers in Pennsylvania alone between 1795 and 1802 hardly one was illiterate, and nearly a third *affirmed* in lieu of swearing an oath – a vastly higher proportion of free-thinkers and religiously unorthodox than was customary. Most were artisans. Their motives were no doubt 'economic' but, particularly in this group, it is impossible to disentangle them; they voted with their feet. Federalists hated them, and the Alien and Sedition Acts were directed as much against them as against the Irish. Cobbett in Philadelphia, then a scurrilous Tory, was apoplectic about them, accusing Daniel Isaac Eaton of taking a squaw – a 'yellow-hided frow' – and gloating over Citizen Richard Lee's imprisonment. They were active in the liberty settlements, British-Republican Sparta in New York state,[7] Welsh Beula, the new Scotland that the son of John Millar the social philosopher tried to create. They were so concentrated in key areas that one

Federalist asserted that Jefferson's victory and the 'revolution' of 1800 was their doing.[8] Back home the growth of Methodism and various brands of evangelical religion has been seen by some as a form of spiritual migration. Certainly it was in 1797 that Alexander Kilham led the first of the 'democratic' breakaways from the parent Methodist body, in the New Connection, or 'Tom Paine' Methodists.[9]

For public political life had become impossible. The chief effect of the emergency legislation was to free local magistracies from restraint. Central action concentrated on public expression of dissent. Any sort of meeting was dangerous; there was a constant dribble of arrests; many men passed in and out of prison on a shuttle. Numbers detained without trial for long periods in the major centres were not large – 80 men or so during 1798–99 – but there was no time when society committees were not missing men in jail or on the run. In the counties the situation could be worse; short, repeated terms of imprisonment without trial were common in some districts. It is not possible to give any very coherent account, since the reconstruction of this period requires analysis in depth, region by region, which has as yet hardly begun.[10] It is possible that the 'terror' was concentrated in particularly tense localities. Samples from Glamorgan and parts of Lancashire indicate a wide regional variation, but show that as early as 1796 some magistracies had adopted the French method of singling out 'leaders' and hitting them repeatedly, in arrest, release, re-arrest – which meant ruin to a poor man. More common to many areas was what men who do not have to raise a family in wartime on artisan's pay call 'petty' persecution. The *presence* of authority had become overwhelming. The posts were unsafe, little 'political' money ever got through; taverns and houses of call were watched; there were systematic surveillance, boycott, political sackings and denials of poor relief. The cat-and-mouse game was never the automated machine Fouché made it in France, but in some areas it made life sheer misery for anyone who had opened his mouth too wide in 1792–95.

The immediate effect was to break down communication and 'denationalise' the movement. It was to re-establish contact that the LCS sent out travelling delegates early in 1796. John Binns was recalled from Portsmouth when he was shadowed; John Gale Jones was more successful in a tour of the Kent dockyard towns

which skated just inside the law, but when both men went to
Birmingham in March, they were arrested. The effort to raise
funds was agonising. Only £90 got through the post, but Erskine,
significantly, was now demanding 1,200 guineas. Beaufort
Buildings, Thelwall's lecture theatre, was prised from him. Still
optimistic, he took off on a tour through East Anglia, the Mid-
lands and the North; it became a trek through Apollyon's
country. At Yarmouth 90 sailors attacked the meeting with
cutlasses; he was pursued by claques, armed associators and
dragoons. Too much attention can be paid to physical assaults like
these and the sensational attacks of earlier years, which have been
much publicised. Most of them were straight cash-on-the-nail
(or beer-on-the-bar) transactions in traditional style. Far more
serious was the pressure of social intimidation on the 'artisans,
shopkeepers, Dissenting ministers and schoolmasters' with whom
he lodged. He was editor of the Derby *Courier* for a fortnight
before it drove him out. He was pursued by it even to Llys-Wen,
where the curate preached against him. He was rescued there by
one of those awkward, independent, local bigwigs, whose
silence in most places made the intimidation possible.

For the impulses visible during the consolidation against
Dissent in 1790 and the Reeves campaign of 1792 were organised
in permanence by the Volunteer movement. In origin in 1794,
this was proposed as an internal security militia. The instructions
to commanders, particularly those supposed to be secret, read
like civil-war documents. Carefully-selected and purged as
regularly as any sans-culotte society, the force was to reflect, with
precise accuracy, the power structure of its locality; it was to be
the Establishment under arms (in Glamorgan they kept out
Methodists and tried to keep out all Dissenters, which inflamed
the local ironmasters). Lavish uniforms, balls, social functions
were integrated with morale rallies and woollies for the troops;
on the other hand, parades and drills were to concentrate on the
'disaffected parts'. Some units had specific surveillance duties;
some made a speciality of union-breaking. But it was the spec-
tacular, attractive and *continuous* public demonstration of
'loyalty' which was the prime function. Fortunately for the peace
of the English provinces, reality was much messier than theory,
and the genuine patriotic enthusiasm of 1798 deflected doctrinaire
zeal. But the force never lost its 'white-guard' character. Men
were transported not only for denouncing the barracks now

rising in many localities, but for laughing at the Volunteers at drill.[11]

It was this *localism* which was so terrifying. In Glamorgan men were being 'sent aboard men o' war' in one parish for 'offences' which provoked mirth on the bench in the parish next door. The almost permanent suspension of Habeas Corpus and the emergency powers gave magistrates frightening authority, restrained in the last resort only by a man's 'good sense'. The increasing and self-defeating ferocity of the penal code bred a kind of cold war in some districts. Clubs were driven in on themselves, turned into prisoners' aid societies. More seriously, it was in the localities that authority came thrusting into a man's private life. The poor never stood much of a chance against eighteenth-century law; now they were stripped naked. Regional variation was total – some areas were completely unaffected. Areas of rapid industrialisation could be bad, largely because of an incredible jungle of rivalries and prejudices among all manner of social groups. Clerical magistrates seem to have been particularly severe, and the savage outbursts of anti-clericalism and sheer hostility to religion itself about 1800 were obviously some kind of symptom. It was in this poisoned atmosphere that the early labour movements took their first growth. 'We are John Bull's youngest bastards' – a deadly ditty first written for the Reeves society as an attempt to smear Dissent with Jacobinism – seems to have caught on about this time among operatives.[12] The fact that the British labour movement grew in this atmosphere was to be central to its early – and not only its early – history.

This was what made Ebenezer Elliott reply, when asked the source of his politics – 'I have not forgot the English reign of terror'; even a sober-sides like Place uses the same words. It was true of only some of England's regions, but they happened to be the regions where the future was being made. It is from some such psychology, one suspects, that the Napoleon cult sprang, manifest in such a striking folksong as *The Bonny Bunch of Roses* – a lament for Bonaparte in the guise of a patriotic song – a half-understood message from a half-hidden world. It was the soldier of the revolution with his ragged 'sans-culottes' at Lodi they warmed to – 'The Hero of Italy' with his 'Veterans of the Great Nation', as he was called in 1798 by the Secret Committee of England in their letter to the French Directory. For, as public *Jacobinism* fades, the underground tradition strikes root.[13]

A clandestine movement, by definition, has no 'history'; we have to thread a tentative way between the exaggerations of informers and the equally exaggerated depreciation of Place. With the arrest of the committee in 1797 and the appointment of Thomas Evans as secretary, the LCS slipped into a semi-legal existence. It was overshadowed by groups calling themselves United Englishmen and United Britons, which certainly had an insurrectionary wing. The major seditions, of course, were the naval mutinies of April–May 1797 and the Irish Rebellion of 1798. The sailors, without doubt, were rebelling against conditions, in a 'Dam my eyes' revolt, and government could find no *Jacobins*, but the leader at the Nore, Richard Parker, was an educated quota-man, and some of the language of the mutiny – 'The Age of Reason has at length revolved' – was certainly the language of the societies. Immediately afterwards an LCS man was picked up at Maidstone for distributing handbills to soldiers. Maidstone in turn was linked to the United Englishmen of Manchester, who were active among soldiers and militia there.

Throughout 1796 and 1797 there was certainly some kind of movement in Lancashire. Informers were precise about secretaries and delegates of some thirty organisations, with groups, sometimes behind innocuous fronts, in Liverpool, Bury, Bolton, Royton, Failsworth, Oldham, Stalybridge, Mottram, Ashton, Stockport – the list reads like a roll-call of nineteenth-century 'disturbed areas'. There were connections with other shadowy nuclei in the West Riding, Glasgow, the Midlands and even Cornwall. In London John Binns and his brother, with other LCS men, together with Colonel Despard the Irish martyr of 1803, were members of a secret group at Furnivall's Inn cellar in Holborn.

The Irish influence is remarkable and grew stronger with the migrations. The United societies were direct copies of the United Irishmen. Their central committee was finally moved to Liverpool for convenience, and the last public statement of the LCS, in January 1798, was a declaration of sympathy for the Irish nation. There was also some link with France. Talk of French agents in moonlit fields cannot be verified, but Father O'Coigley, on a mission to France, passed through the northern clubs to London where early in 1798 he, together with John Binns and Arthur O'Connor (brother of Feargus O'Connor the future

Chartist) was arrested. Raids followed in Lancashire, and in April 1798 the executive of the LCS was finally broken up.

The hard core of genuine revolutionaries was probably very small. From this time on there was always some knot of conspirators at work somewhere. Much more serious was a widespread state of permanent spiritual disaffection, a range of semi-insurrectionary, loose-textured organisations in perpetual 'cold' revolt. The Manchester groups did not derive from the original artisan societies of 1792, rather from a barely visible corresponding society of 1796. According to one report, admittedly dubious, 'gentlemen' and 'mechanics' had quarrelled in that year, and it was the latter who formed the United Englishmen. They were certainly bitter men. There was talk of killing the king and perhaps more realistically, of shooting a local magistrate who had said he would as soon kill a thousand *Jacobins* as take his breakfast – evidently kin to Place's cotton-manufacturer who wanted the 'sons-o'-bitches' to eat nettles. This is already Peterloo country.

These men read Paine and Thelwall, and it was particularly among such groups, who in Manchester now numbered factory operatives among their leaders, that the French Revolution was finally 'naturalised' and anglicised. In much of the thinking of this period English experience acquires resonance and a certain universalism from French example. For it was in these times to try men's souls that many tried to set their thoughts in order. Thomas Spence, for example, the gentle five-footer from Newcastle, who sold tracts, medals and hot sassifras, preached a phonetic alphabet and called himself 'the unfee'd Advocate of the disinherited seed of Adam', propounded a programme which the *enragés* would have recognised, but which was rooted in the soil of England. Literally so, since he saw the root of evil in private property in land. He had a vision of a pluralist society, with parish associations taking over the land and forming a 'beautiful and powerful Republic' which tyrants, 'scalped of their Revenues and the Lands that produce them their power', could never otherthrow. This feeling for the commune was accompanied, as among some *enragés*, by a quite unusual sympathy for the rights of women, a defence of their status within marriage and a plea for easier divorce – 'What signifies reforms of Government . . . if people cannot have their domestic grievances redressed?' Spence himself was an original, and the Spenceans were more a sect than a party, but their

doctrines echoed. Thomas Evans toughened the creed into a land-nationalisation programme very familiar in tone – 'First, settle the property . . . and that one settlement will do for all . . . all attempts to reform without this are but so many approaches to actual ruin . . . that will not disturb the relative classes of society . . .'

Few went as far as Evans; most remained within the Painite artisan 'contradictions', and there was little awareness of the peculiar problems of an industrial society. For this one has to turn to Thelwall's *Tribune* and *Rights of Nature* of 1795–96. He dismissed land nationalisation as a myth and defended the right to property of a man who earned it in sweat. But he counted accumulation of capital as well as land an evil and, while he is sometimes contradictory on the point, did not simply exclude industrial accumulation from the argument, as Paine was prone to do. He was earthier than Paine, defending journeymen's associations, demanding profit-sharing between employers and employed, advocating universal education as an instrument of social betterment. He broke with the traditional defensive attitude towards an inherited standard of living and went beyond the *droit à l'existence* – 'I affirm that *every* man and *every* woman and *every* child ought to obtain something more . . . than food and rags and a wretched hammock . . . that, without working twelve or fourteen hours a day from six to sixty . . . they have a claim to . . . some comfort and enjoyment . . . to some tolerable leisure . . .' He was acutely aware of the possibilities of industrial production, and one can sense in his work an unusual feeling for that 'revolution of rising expectations' which was to take generations to register in the minds of British working men. Moreover, monopoly and the hideous accumulation of capital carried in their own enormity the seeds of cure, because they pressed men together – 'every large workshop and manufactory is a sort of political society, which no act of parliament can silence, and no magistrate disperse. . . .'

This was the reading the United Englishmen pressed on their friends, and their search for 'first principles' took them further. The most striking feature of 1796–97 is the growth of deism and free-thought. The *Age of Reason* was followed by Volney's *Ruins*, which the LCS distributed wholesale in its last days. There seem to have been a Holbach and a Voltaire in penny weekly parts. W. H. Reid, a defector, has left a vivid picture, probably over-painted but essentially authentic, of a Temple of Reason in White

Cross Street in 1796, of a famous club chased from pub to pub out
to Hoxton, crowded to the end. In the summer of 1797 LCS men
took their tribunes out among the open-air preachers along City
Road, to Islington, Hackney and Bethnal Green, carrying the
Infidel gospel. In the provinces they were often fierce. Handbills in
Sheffield in 1800 spoke of 'Man, . . . a poor degraded animal,
possessed of Reason and dare not use it, consigned by Tyrants to
slavery in this world and by Priests to damnation in the next.'
They denounced religion, 'worn by hypocrites as a mantle for
their villainy . . . My belief in religion – I believe in the equality
of man.' Among the Manchester men, an auctioneer Patterson
burned a prayer-book and used Hébertist language about the
Almighty; an operative's wife chastised comrades for going to
chapel. This was certainly a minority cult; indeed it became a
sect like the other religious groups. But they were a good deal
stronger than has been allowed. After 1815 they emerged as a
Republican movement, in their Zetetic clubs linked to Richard
Carlile's journals. They were the most direct heirs of the *Jacobins*
of the 1790s, and in many ways their secularism proved one of the
more abiding traditions of British popular movements.

There were other, more ambiguous, heirs. Reid maintains that
systematic infiltration of benefit clubs became settled LCS policy in
1797; it seems plausible. Conscious policy or not, however, of
crucial significance for the future was the fact that both trade and
political societies came under the ban at the same time. Both had
to live their lives under a cloud of hostility and repression, as old
trade defences were demolished and industrialisation accelerated.
In consequence one can conclude the narrative where it began, in
Sheffield. In the dearth of 1800–1801, troubles were almost as bad
as in 1795. Thelwall briefly reappeared in a *taxation* outbreak at
Merthyr, where two men were hanged. Handbills in the crowds
were suspiciously uniform in widely separated districts – 'We are
the sovereignty', they ran. 'Drag the Constitution from its
hidden place . . .' In the troubled West Riding the focus was
traced to Sheffield. At midnight in the fields there – 'An orator in
a Mask harangues the people – reads letters from distant societies
by the light of a candle and immediately burns them . . .' They
were linked to other occult groups like the dramatically named
Black Lamp at Leeds, possibly even to Despard's military con-
spiracy in London. In the autumn of 1802 two Sheffield men,
William Lee and William Ronkesley, were transported for

administering secret oaths; they were said to be members of a secret association of 1,000 men in the town, run by *Directors*.

During this very period the Combination Acts of 1799–1800, which strove to suppress trade unions, had stimulated clandestine organisation. A government agent reported feverish activity among workmen agitators. They were listing the numbers adversely affected – 60,000 in Lancashire, 50,000 in Yorkshire, 30,000 in Derbyshire. The committees of the new organisations were 'under the management of Republicans'. About this time the surviving clubs and new ones beginning to form were dropping their old, by now old-fashioned, titles – Constitutional, Patriotic – and calling themselves Union Societies. In final irony, some even began to consult Major Cartwright. And this movement, said the agent, originated at Sheffield, 'in the republican society there'.

The *trajectory* is complete. That the first focal centre of newer 'working-class' organisations should have been a focus of artisan *Jacobinism* is both apt and incongruous. There was contradiction, certainly. The *Jacobinism* of artisans was not always relevant to the problems of industrial working men; neither was eighteenth-century *Infidelity* at home in the world of provincial evangelicalism. The ambivalent fact remains that the working-class movements of early nineteenth-century England took their first rise from the democracy of the old régime. For that political attitude, in many ways peculiar to 'pre-industrial' society, which artisans shaped during their brief travail, seems to have been transmitted direct, 'face-to-face', to the men of the nineteenth century.

In a sense, then, perhaps in a sense it would not have fully understood, the London Corresponding Society had fulfilled a function when, in July 1799, along with the United Englishmen and trade unions, it was 'utterly suppressed and prohibited' by name.

Adam's Seed

IT would be futile to attempt a 'comparison' of the French and British popular movements; they cannot be 'compared'. It is the deep and obvious differences which strike an observer, though beyond a certain similarity in chronology and *trajectory*, there are some basic identities in terms of social composition, psychology and ultimate objective which cannot be analysed away.

Most striking in terms of the long vistas is the difference in continuity. In England the Six Points of the People's Charter are the programme published by the Westminster sub-committee of 1780; the complex of connection, contradiction, transmission and transmutation which this coupling suggests can be traced at every level of the working-class and radical movements of the early nineteenth century. In France the sans-culottes go out of history in 1795, and we seem to hear nothing more until the 1830s. It is the hoary old confrontation of 'revolution' and 'evolution'; equality is not *égalité*. Caricatures are confirmed; comes a crisis and the English call a union meeting, while the French proclaim a Commune.[1]

It is not so simple. Certainly the police records of France suggest a breach. After 1796 proscription lists pinned down a couple of hundred 'contagious individuals' of the old movements and they were struck, time and time again, by police action whenever there was trouble, even royalist trouble. Fouché, in particular, operated with a kind of robot instinct for the enemy throat. Varlet was among those banished in 1813; six or seven sans-culottes were being automatically arrested as late as 1816. From 1808 the opposition changed, as military men, the new intellectuals, merchant liberals, entered, but, apart from a couple of isolated individuals, there seems to have been no personal connection between the movements of the Year II and those of the nineteenth century.[2]

Among those individuals, however, was Buonarroti, a descendant of Michelangelo who had served the Committee of Public

Safety in Corsica and who was the presiding genius of many of the revolutionary organisations of early nineteenth-century Europe (and possibly England). More important still, Buonarroti was the author of those revolutionaries' bible – the *Conspiration pour l'Égalité dite de Babeuf*. For he had been one of the Equals.[3]

On 30 November 1795 Gracchus Babeuf published a *Manifeste des plébéiens* in his *Tribun*. The objective remained *l'égalité des jouissances*, but the lessons of the Year II had been learned. The *loi agraire* was a myth, it would not last a day. The only way to ensure equality was 'd'établir l'administration commune; de supprimer la propriété particulière'. Production would go to a 'magasin commun' and an 'administration des subsistances' would see to equal distribution. In the spring of 1796 a small group of *communists*[4] rallied around Babeuf and developed this simplist notion into comprehensive and often fairly sophisticated communal schemes. Some Jacobins and popular militants of the old tradition joined, and a more 'technically' professional attitude to revolution was cultivated. Only the inner circle of Equals was privy to the full conspiracy; around them was a secondary élite of sympathisers, and beyond were the popular masses who were to be energised. After the coup there was to be no futile playing with meaningless assemblies and conventions; the Equals would reshape society until it was fit to operate itself.[5]

In practice the Conspiracy was a shambles; it was quickly penetrated by the police, and Babeuf went to the scaffold. But, as the first overt *communism*, its echoes reverberate, sometimes more loudly than those of the Revolution itself. One can argue 'until the peace' on the precise nature and origin of Babouvist *communism*; it has become an occupational disease and a Cold War issue. That it represents a break with sans-culotte thinking is clear; that it *could* also represent a growth *out* of sans-culotte feeling is also clear. Most striking was the *technique* of revolution, which was 'inherited' through Buonarroti by a generation which included Blanqui – thence, so the argument runs, from Blanqui to Marx and on to the Finland Station. But can it not be argued that this 'technique' was the systematisation of familiar practice? 'Maratistes, où êtes-vous? Vous êtes en petit nombre, oui, mais. . . .' Both sans-culottes and Jacobins were self-conscious minorities compelling the people to be free. In this sense there is in truth a line from the Despotism of Liberty to the Dictatorship of the Proletariat.

If we lower our sights from these grand and bewildering perspectives, we can detect ambiguities which blur the neat categorisation into 'episodic' French and 'evolutionary' English. Buonarroti, at a distance of thirty years, not only 'fused' Jacobins and sans-culottes; he made them both into a species of socialist. It was by means of this book that a new generation took possession of the Revolution. Among them was Bronterre O'Brien, the 'schoolmaster' of Chartism and its most effective theorist, who did in fact approach socialism. He translated the book, with footnotes placing the English middle-class radicals as Girondins. It was this cast of mind which helped put the *bone* in O'Brien's doctrines – contrast them with the triviality and archaism of O'Connor, who actually had a martyr of '98 in the family. And to the objective evidence of the French police records oppose the subjective insight of Buchez in 1838 – 'the custodians of the revolutionary tradition were the victims of Prairial rather than those of Thermidor' – or of Michelet's old artisan who never forgot 'the sun of 1793'.

What *is* true – and it is a truth that transcends much contradiction – is that the traditions transmitted in both France and Britain were essentially *pre-industrial* in a deeper sense than the merely technical. 'Long have we been endeavouring to find ourselves men,' said the sailors of the British fleet in 1797. 'We now find ourselves so. We will be treated as such.' They learned this tone from others. The first *political* statement of this instinct was made by men who, however poor, could not conceive of themselves as 'hands' or a 'labour force', men with the dignity of a skill and the mystery of a craft, men who polished tools and knew the 'fine points', men whose wage was a 'selling price' and whose property was labour, men whose values, even in adversity, were fixed by an earned independence. The statement, once made, was universal – since, to quote another of them – 'a man's a man for a' that' – but its origin should not be overlooked.

This is the central truth, whose implications for the industrial nineteenth century we have perhaps not thought out deeply enough. The ideology of democracy was pre-industrial and its first serious practitioners were artisans.

Short Glossary

accapareur, accaparement: hoarder, hoarding, generally of food; profiteer.

armée révolutionnaire: revolutionary militia of trusted sans-culottes; enforced requisitions and revolutionary discipline.

assignat: revolutionary paper currency.

bonnet rouge: red cap of liberty, symbol of the freed slave, much cherished by militants.

certificat de civisme: documentary evidence of political orthodoxy and civic responsibility.

comités civils: administrative committees of the Sections, primarily concerned with such matters as food supplies and welfare and of minor political importance.

comités révolutionnaires: police and internal security committees, originally elected by Section assemblies and of major political importance.

commissaires aux accaparements: Section officials enforcing the laws against hoarding and profiteering.

compagnons: craftsmen who had completed the customary 'tour of France'.

crise des subsistances: generally, the crisis over supply, embracing the whole complex of provisioning, price-control, profiteering.

décade: the ten day week of the new Republican calendar.

fédérés: armed units of the Provinces sent to Paris in 1792.

Maximum: price control legislation, at first for grains, later for all commodities of prime necessity, including labour; concept could be extended into many areas of sumptuary and redistributive action.

menu peuple: common people.

pacte de famine: conspiracy by interested parties to create dearth and force up prices; usually attributed to those in power with partly political motives.

quarante sols: citizens paid a subsidy of 40 sous for each general assembly of their Section which they attended; intended as compensation for loss of working time.

sociétés sectionnaires: popular societies of the Sections created to circumvent the law suppressing the 'permanence' of Section assemblies in September 1793. A particular variant of the *sociétés populaires*, clubs of broadly popular character formed from 1790 onwards.

taxation populaire: popular price-fixing and distribution by direct action; crowds, more or less organised, compelling traders to sell goods at traditional or 'fair' prices.

tutoiement: democratic use of the second-person-singular.

Reading: A Selective Guide

Begin with E. J. Hobsbawm, *Primitive Rebels* (1959), an introduction to 'pre-industrial' protest, and *Labouring Men* (1964), a collection of seminal articles. Try two parallel articles by R. B. Rose – '18th-Century price riots, the French Revolution and the Jacobin Maximum' and 'Eighteenth-Century price riots and public policy in England', in *International Review of Social History*, iii (1959) and vi (1961).

George Rudé, *The Crowd in History* (1964) is a general survey of this subject by its master. It has an excellent bibliography; follow up, in particular, the author's own superb work in this field.

Sans-culottes

George Rudé, *The Crowd in the French Revolution* (1959): essential, is deservedly becoming a minor classic. His *Wilkes and Liberty* (1962) applies the same technique to an English time of troubles. Rudé's work will lead you into the world of the massive French doctoral theses.

Albert Soboul, *Les sans-culottes Parisiens en l'an II*: a staggering book, virtually a total reconstruction of the political world of the sans-culottes. Rather clinical. Central portions translated by Gwynne Lewis as *The Parisian Sans-Culottes and the French Revolution* (1964). *Paysans, Sans-Culottes et Jacobins* (1966) collects some of Professor Soboul's important articles. With Walter Markov, he has edited a superb document collection, *Die Sansculotten von Paris* (Berlin, 1957) – the important matter is in French.

Richard C. Cobb, *Les armées révolutionnaires* (2 vols., 1961–63): even more staggering; a brilliantly successful re-creation of a world of experience: should be compulsory reading for every apprentice historian. The reverse of clinical. The author's important articles are in *Terreur et Subsistances* (1965). He occasionally lapses into his mother-tongue – see *History* (1957).

Käre Tønnesson, *La défaite des sans-culottes* (1959), close, thorough, nearer to an Anglo-Saxon length.

The armour-joints of these juggernauts are probed by A. Cobban's lively *Social Interpretation of the French Revolution* (1964).

On the Revolution, go to the masters, but good English introductions are A. Goodwin, *The French Revolution* (1953–67), remarkably full and cogent in short space; N. Hampson, *A Social History of the French Revolution* (1963), indispensable and excellent reading; M. J. Sydenham, *The French Revolution* (1965), fresh, sane, controversial and very good indeed.

Artisans

One essential book – Edward P. Thompson, *The Making of the English Working Class* (1963). Less a book than one continuous challenge: depth, pace, sympathy, sense of place, feeling for the texture of reality; flashes controversy on every page. Go, in particular for chapters, Satan's Strongholds and Christian and Apollyon. Splendid reading, with high adrenalin content. Absolutely indispensable.

Older, but useful books – P. A. Brown, *The French Revolution in English History* (1918, reprinted): read the central sections closely. G.S. Veitch, *The Genesis of Parliamentary Reform* (1913 reprinted): worthy and aldermanic.

On particular themes – J. Saville (ed.) *Democracy and the Labour Movement* (1954): H. Collins on LCS, Christopher Hill on Norman Yoke; M. D. George, *London Life in the Eighteenth Century* (1951): marvellous; Caroline Robbins, *The Eighteenth Century Commonwealthman* (Harvard, 1959) comprehensive; Bernard Bailyn, *Ideological Origins of the American Revolution* (Harvard, 1967): brilliant.

R. K. Webb, *The British Working Class Reader* (1955) and L. Radzinowicz, *History of the English Criminal Law* (3 vols, 1948–56) open up whole worlds.

For original material, try G. D. H. Cole and A. W. Filson, *British Working Class Movements: select documents* (1951 reprinted) and A. Cobban, *The Debate on the French Revolution* (1950). Paine, Burke, the poets and a host of contemporary writers are easily accessible.

Unpublished work

I have been greatly helped by the research in progress of my colleague, James Walvin, who is producing a book on British societies; by W. A. L. Seaman's London Ph.D. thesis (1954) on British democratic societies of the period; and by a B.A. dissertation on Sheffield by Mrs. Susan Youngman, a student at the University of York.

Reading

A SELECTIVE GUIDE (1988)

The footnotes to the Introduction list some books and essays which stretch the mind and engage the imagination. Most of those listed below carry extensive bibliographies.

R. R. Palmer, *The Age of the Democratic Revolution: a political history of Europe and America 1760–1800*, 2 vols (Princeton, 1964) carries you through the whole sweep of the 'Atlantic Revolution'. It protests too much but is an exhilarating experience.

No less exhilarating in a different and far more rigorous style is George C. Comninel, *Rethinking the French Revolution: Marxism and the Revisionist Challenge* (Verso, London, 1987) with a slightly pained and needlessly defensive introduction by George Rudé. This is a vigorous counter-attack by a sophisticated Marxist, not only on the revisionists but on many Marxists, which manages to prove that Karl Marx was not himself a Marxist at critical moments. It is a book which must be read.

Biographical dictionaries have now begun to appear. They are imprisoned within national frontiers and therefore lose the flavour of a decade of crisis which was essentially international, but they are very useful: *Biographical Dictionary of Modern British Radicals*, vol. i, 1770–1830, ed. J. O. Baylen and N. J. Grossman (Harvester, Sussex, 1979); *A Biographical Dictionary of Modern European Radicals and Socialists*, vol. i, 1780–1815, ed. David Nicholls and Peter Marsh (Harvester, Sussex, 1988).

Artisans, Peasants and Proletarians 1760–1860, ed. Clive Emsley and James Walvin (Croom Helm, London, 1985), presented to me on my sixtieth birthday, reads uncomfortably like an anticipatory obituary but has excellent essays on relevant themes, notably Michael Durey on Atlantic migrants, James Walvin on the campaign against the slave trade, Clive Emsley on the impact of war and John Breuilly on artisan politics.

Sans-culottes

Richard Cobb's lapse into his native tongue, noted in the original edition, has fortunately developed into a surrender to it. Marianne Elliott has translated his great *Armées Révolutionnaires* as *The People's Armies* (Yale, 1987); people who use English can at last experience directly one of the

most brilliant and infuriating books I have ever read. The author has produced a whole sequence of essays of the same quality, in which 'ordinary people' in revolutionary France, who were often extraordinary, find a Maigret of a historian. Sample *The Police and the People: French popular protest 1789–1820* (Oxford, 1970); *Reactions to the French Revolution* (Oxford, 1972); *Paris and its Provinces 1792–1802* (Oxford, 1975).

R. B. Rose published his *The Enragés. Socialists of the French Revolution?* in 1968 (Sydney) and traces the emergence of a political force in *The Making of the Sans-culottes: democratic ideas and institutions in Paris 1789–92* (Manchester, 1982), Colin R. Lucas, *The Structure of the Terror* (Oxford, 1972) is very revealing and there have been many valuable regional studies, such as Martyn Lyons, *Revolution in Toulouse: an essay in provincial terrorism* (New York, 1978) and the microscopic Morris M. Slavin, *The French Revolution in miniature: Section Droits-de-l'Homme, 1789–1795* (Princeton, 1984)

Women

In France, look at Olwen Hufton, 'Women in Revolution, 1789–1796', in *French Society and the Revolution*, ed. Douglas Johnson (Cambridge, 1976); Mary Durham, 'Citizenesses of the Year II of the French Revolution', in *Proceedings of the Consortium for the History of Revolutionary Europe*, i (1972–74); Darline Gay Levy, Harriet Branson Applewhite and Mary Durham Johnson, *Women in revolutionary Paris 1789–1795* (Urbana, 1979). Women historians in Britain have produced major surveys and some remarkable studies of specific themes and periods, but the 1790s do not yet figure prominently. For a taste of what to expect, sample a perhaps unexpected source, one of the teaching packs of documents which accompanied a television history of Wales. The pack on women was created by women in spiritual opposition to the series, which was presented by males: *Welsh Women's History / Hanes Merched Cymru*, Gwynedd Archives Service-Channel 4-HTV (1985)

Artisans

Albert Goodwin, *The Friends of Liberty: the English Democratic Movement in the Age of the French Revolution* (Hutchinson, London, 1979) is a comprehensive and well-documented study in depth, written in fine, generous liberal style, whose moral tone sometimes recalls the old tag – 'Nordic virtue in rebellion, See Macaulay, see Trevelyan.'

H. T. Dickinson, *British Radicalism and the French Revolution 1789–1815* (Blackwell, Oxford, 1985) is a brief, crisp Historical Association study by a major scholar of the period which is more clinical in tone but sane, balanced and relatively open-minded. The 'British' of the title, however, seem to be occasional visitors.

Mary Thale has produced some valuable documentary material: (ed) *Selections from the papers of the London Corresponding Society 1792–99* (Cambridge, 1983) and *The Autobiography of Francis Place* (Cambridge, 1972), and H. T. Dickinson has edited *The Political Works of Thomas Spence* (Avero, Newcastle-upon-Tyne, 1982).

Clive Emsley has written a powerful essay, *British Society and the French Wars, 1793–1815* (Macmillan, London, 1979) and J. Ann Hone the important *For the Cause of Truth: Radicalism in London 1796–1821* (Oxford, 1982). Two of those books which treat the 1790s as one phase in a sequence are very useful – Edward Royle and James Walvin, *English Radicals and Reformers 1760–1848* (Harvester, Sussex, 1982) and John Stevenson, *Popular Disturbances in England 1700–1870* (Longman, London, 1979).

Wales

D. J. V. Jones, *Before Rebecca: popular protest in Wales 1793–1835* (Allen Lane, London, 1973); Gwyn A. Williams, 'Druids and Democrats' in *The Welsh in their History* (Croom Helm, London, 1982); *The Search for Beulah Land: the Welsh and the Atlantic Revolution* (Croom Helm, London, 1980); *When was Wales?* (Penguin/Black Raven, London, 1985).

Envoi

I must repeat here that two studies have transformed our understanding of those years of the late 1790s in Britain which have been a shadow-land.

Marianne Elliott's *Partners in Revolution: the United Irishmen and France* (Yale, 1982) is a major analysis which firmly locates the British movement within the London–Dublin–Paris triangle.

Roger Wells, *Insurrection: the British experience 1795–1803* (Allan Sutton, Gloucester, 1982) is a remarkable book informed by a penetrating, sardonic, scholarly and combative intelligence hungry for detail. It will plunge you into total immersion of a Baptist intensity. It will bend your mind, break your back and send you reeling for light relief to Gibbon's *Decline and Fall*, but the 1790s will never be the same again.

Notes

CHAPTER ONE

1. The 'breeches-less', a term of abuse adopted as a title of honour; during 1792 it acquired political, social, even moral, significance.

2. By democracy, I mean, firstly, manhood suffrage: any departure from this basic assumption seems to me to indicate a qualitatively different structure of thinking and feeling. Couple with it a notion of an equality which meant something more than equality of opportunity: this seems the most appropriate interpretation for the period.

3. I use the current cant term for convenience.

4. My interpretation of Paine, which may differ from some, is based on a reading of all his works, including the small print, and of every letter I have been able to find.

5. I later abbreviate this to SCI.

6. Shorthand for the long-winded title quoted in the first sentence of this book.

7. William Cobbett went to America in 1793, vaguely 'democratic'; within months he was a John Bull High Tory. The British press was viscerally anti-American.

8. The king.

9. I later abbreviate this to LCS.

10. See the striking picture in Edward Thompson's book, cited in the booklist.

11. This world was first explored by George Rudé; see booklist.

12. By Edward Thompson

13. The Wilkes troubles were ambivalent. Some supporters evidently were or became 'radicals', but the crowds were very 'traditional' and were clearly 'warranted' by 'betters' within the political nation.

14. Every Welsh Baptist minister who wrote to a Philadelphia brother between 1792 and 1800 called himself a 'sans-culotte'; the letters are in U.S. church archives.

15. The author's grandfather, in no sense a Saxon, was given the name for this reason.

16. Nor was he consciously writing in a new style for a new audience, as he later pretended. Paine exploited an unexpected success among artisans as he did the appearance of Burke's book. Common interpretations of this celebrated 'confrontation' seem to me mistaken; elucidation will require a separate study.

17. This term, used by Edward Thompson, is technically an anachronism, but catches Paine's tone perfectly.

CHAPTER TWO

1. Opponents scorned were royalist, Girondin and moderate. This piece, from the Soboul–Markov collection (see booklist) I have translated for immediacy.
2. The word *bourgeois*, of course, was in use at the time; ignore later connotations.
3. See the entertaining portrait of a 'typical revolutionary' by Richard Cobb, cited in the booklist.
4. On the *journées*, George Rudé's pioneer *Crowd in the French Revolution* (booklist) is crucial.
5. I accept M. J. Sydenham's interpretation of the Girondins in his book of that title (1960) but – offering an excuse to which the author must by now be resigned – the need to avoid circumlocution leads me to adopt the term for convenience, varying it when conscience strikes, with Brissotins.
6. See Norman Hampson's social history, cited in the booklist; for English readers, this is uniquely valuable in its coverage of the provinces.
7. Nobody seems to mention Marat's admiration for Montesquieu – hardly a sans-culotte idol.
8. Particularly during economic crises, like the inflation-*taxation populaire* outbreaks in Philadelphia during the American War and the dearth in England in 1795.
9. There is a mass of detail, some corrected by later research, in the still very readable *La Commune du Dix Aout* by F. Braesch (1911); be warned, it is another French *thèse* of Theodore Dreiser proportions.
10. See his remarkable account, in his history of the Russian Revolution, of the decomposition, at grass-roots level, of the 'bourgeois' parties.
11. A close parallel in our own day were the prison massacres, complete with 'plot', in Bilbao, after German bombing during the Spanish Civil War.

CHAPTER THREE

1. On the 'demagogy of violence', see the striking comments of Richard Cobb in the works cited in the booklist.
2. Norman Hampson's social history is particularly good on this, which seems to me crucial to the debate on the 'contradictions' in the Jacobin-sans-culotte alliance. Post-Thermidor evidence is also suggestive; the last word has not been said.
3. Nickname for the well-off and 'right-thinking'; popular political slang, as usual, was defensive.
4. Richard Cobb, *Les armées révolutionnaires* (see booklist); here one can only suggest its quality. It is the most successful 'reliving of an experience' I know; every student of history should sample it.

CHAPTER FOUR

1. A phrase of William Hazlitt, reminiscing about his political youth.
2. A prime source of material is the Treasury Solicitor's archive; much of the societies' correspondence was seized in 1794. Edward Thompson's is the fullest secondary account.
3. A. T. Patterson, *Radical Leicester* (1954). Edward Thompson reports Nottingham's Goddess and unsportingly explains her 'nudity'.
4. Excellent on the Riots is R. B. Rose's article in *Past and Present* (1960); magistrates' collusion is clearly demonstrated in the Treasury Solicitor's Papers, a point first made by N. C. Black in *The Association* (1963).
5. This world has been explored, with scholarship and style, by David Williams, historian of Rebecca and modern Wales. See the special number of the *Welsh History Review* (1967) devoted to his work. My studies in this field are the work of Professor Williams's apprentice.
6. See the *Welsh History Review* referred to above; the Baptist correspondence will be published shortly.
7. By Edward Thompson.
8. I use quotation marks because some of the distribution was free or nearly so; according to the Attorney-General, even children's sweets were wrapped in it.
9. See the correspondence published in N. C. Black, *The Association*. The Whig Friends, a short-lived and unhappy group without support from Whig leaders, pressed for a limited measure of parliamentary reform and would have nothing to do with more plebeian or doctrinaire reformers. At this stage they tended to see the popular societies as a 'personal' faction manipulated by Horne Tooke, moving spirit of the SCI.
10. My colleague, James Walvin, has supplied me with some very valuable figures; these I have tried to collate with my own.
11. All quotations are from published or unpublished papers of the societies.
12. See A. Cobban, *The Debate on the French Revolution* (booklist).
13. The register of one division of 98 members listed 33 different trades, with a couple of small merchants; this was typical. Most society offices were held by artisans and small masters.
14. It is difficult to be sure, since there were several men of this name.
15. C. Cestre, author of a now outdated biography, had them; if found, they would prove valuable.
16. There is a remarkable description of Reeves in Cobbett's American memoirs; the two men remained friends even after Cobbett's conversion to radicalism, which says something about both of them.
17. The young William Hone, later renowned in radical circles, offered his services in his best Sunday handwriting. N. C. Black has a

thorough account of the association in his book of that title, but I
disagree with his interpretation.

18. L. Radzinowicz's history of the criminal law (booklist) has much
material; so have the Home Office archives and other government
sources.

19. Letters between ministers and non-ministerial friends give the
clearest picture; Windham's are particularly interesting for men less
committed than he was.

20. The Jackson story has been treated as part of Irish history (he killed
himself in the dock at Dublin in 1795). His papers are among the
LCS and SCI papers in the Treasury Solicitor's archives.

21. Deduced from later citizenship applications and personal life-
histories, so far, for Pennsylvania only; this summer saw the begin-
ning of serious emigration to the U.S.A.

CHAPTER FIVE

1. The 'Hébertiste' documents in the Soboul–Markov collection are
particularly interesting in that they reflect sans-culotte hostility to
Robespierre and the Jacobins.

2. A most revealing quarrel in the winter of 1793–94 was that between
Mallais, shoemaker *commissaire* of Section du Temple and Talbot,
bourgeois representative of Temple on the Commune, which
involved other Sections and led to a brief but symptomatic exchange
of abuse between 'patriots of '89' and 'patriots of '92'.

3. The celebrated decrees of Ventôse (26 February–3 March) which
promised the property of condemned suspects to poor relief funds,
seem to have had little effect.

4. The most vivid picture of the White Terror may be found in the work
of Richard Cobb.

5. K. Tønnesson (see booklist)has some horrifying evidence on suicide
in Paris; Richard Cobb has documented the sudden rise in the death
rate at Rouen and Le Havre.

6. The fullest account is in Käre Tønnesson's book.

CHAPTER SIX

1. This story has survived Place's censorship of his own memoirs. In
later years, he tended to excise or gloss every incident which might
not be considered wholly 'respectable'. He carefully deleted, for
example, in both his and Hardy's memoirs, any reference to the fact
that either of them, at any time, had ever been 'idle'. His evidence
looms so large in the historiography of the period that this personal
idiosyncrasy should not be overlooked. Deciphering his deletions,

one realises that the young Place was probably a very different person from the public Place of later years.

2. The phrase is Windham's.

3. The most coherent history of the later years of the LCS is Henry Collins' in J. Saville (ed.) *Democracy and the Labour Movement* (1954).

4. I am grateful to John Rylands Library, Manchester, for providing me with a photocopy.

5. Edward Thompson has published some of the evidence; a study in depth is badly needed.

6. In the journals of Richard Carlile, an authentic heir of the 1790s.

7. Now the site of Sing-Sing prison.

8. See secondary studies of the Federalist decade, Pennsylvania archives, Cobbett's *Porcupine's Gazette* and other American publications and the papers of Benjamin Rush, who provided most of the land for the British liberty settlements.

9. On this subject, see the often startling pages of Edward Thompson; I must cowardly confess to an inability to make up my mind.

10. I rely mainly on my own work in particular localities and the impressions of my colleague James Walvin; regional surveys are needed.

11. J. R. Western, 'The Volunteer Movement as an anti-revolutionary force', *English Historical Review* (1956).

12. The original song is printed in N. C. Black, *The Association*.

13. I rely heavily on Edward Thompson who is one of the few people to treat the underground movement seriously; James Walvin has supplied me with some material on Manchester.

CHAPTER SEVEN

1. See the essay on traditions in E. J. Hobsbawm, *Labouring Men* (1964).

2. See the article by Richard Cobb in *Terreur et Subsistances* (1965).

3. The English translation by Bronterre O'Brien has been reprinted.

4. For pre-Marxist communists, italics seem necessary.

5. The bibliography of the Conspiracy is vast. Any standard history of the revolution, Albert Soboul's for example, will lead you into the problem.

Index

128 *Index*